A BAND WITH BUILT-IN HATE

A BAND WITH BUILT-IN HATE

THE WHO

FROM POP ART TO PUNK

PETER STANFIELD

REAKTION BOOKS

For Andy

Published by
REAKTION BOOKS LTD
Unit 32, Waterside
44–48 Wharf Road
London N1 7UX, UK
www.reaktionbooks.co.uk

First published 2021
Copyright © Peter Stanfield 2021

Printed and bound in India by Replika Press Pvt. Ltd

A catalogue record for this book is available from the British Library

ISBN 978 1 78914 277 8

Pages 6–7: Pete Townshend in attack mode, September 1966.

CONTENTS

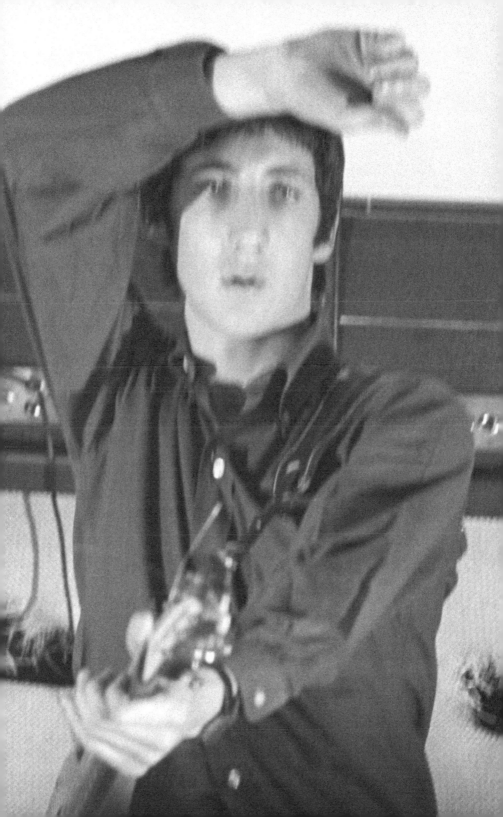

INTRODUCTION:
NIK COHN SAID

Style was their only value and, about that,
they were fanatic.

In a moment of rhetorical exuberance, one half of The Who's management, Kit Lambert, described his charges as being 'armed against the bourgeois' in order to act out a 'new form of crime'.[1] Hyperbole, perhaps, but there is no doubt Lambert had larceny in mind when he started working with the band. With Pete Townshend, he had a co-conspirator willing to translate his felonious ideas into a pop idiom and to put them into practice: 'Ours is music with built-in hatred,' Townshend said in 1968. He had been saying much the same since 1965.[2]

Townshend's spleen, film-maker and critic Tony Palmer explained, 'is directed against not only the social environment which sponsored and then grew tired of him, but also against the perverse snobbery which damns what he does to the oblivion of freakish irrelevance'.[3] Across The Who's first ten years of creative activity, the band repeatedly refused the limits imposed on post-war youth and on their chosen art form: pop music. In their mutinous stance The Who traipsed over the conventions of civility and restraint, and paid deference to no one. They were recusants for the new pop age.

The Who's acts of sedition were especially apparent in the run of singles with which they altered the language of pop, first in maximized attitude with 'I Can't Explain', 'Anyway Anyhow Anywhere' and 'My Generation' in 1965, and then, just as concisely, in a more stylized manner with 'Substitute', 'I'm a Boy', 'Happy Jack' in 1966, and 'Pictures of Lily' and 'I Can See For Miles' in 1967. With their amplified assault on what a pop song should sound like and what it might express, The Who played out the roles of delinquent mischief-makers *and* radical aesthetes, practising an art that was impudent and violent, yet also tenderly disarming.

The Who existed in the contradiction that George Melly had named a 'revolt into style'. Jazz man, raconteur and dandy at large, Melly, in his own words, had 'left the waterhole for the hide in the trees'. From his place of concealment, in articles written for the *New Statesmen*, *New Society* and *The Observer* – which were later gathered together as *Revolt into Style* (1970) – Melly offered his views on the popular or 'pop' arts. His columns gave an intimate and at times sharply critical account of the pop events of the 1960s. Melly considered pop to be a subversive passport to 'the country of now' that was personified by The Beatles' repudiation of old or new rules; a lack of deference more aggressively practised by the Rolling Stones. Into the space created by these two bands, The Who arrived like a malcontent younger sibling and 'succeeded', wrote Melly, 'in making The Beatles sound precious and Stones old hat'.[4]

A Band with Built-In Hate is about the new forms of cultural crimes The Who carried out; how their particular revolt into style took form and acquired its edge. In 1965 Townshend said it was 'a hate of every kind of pop music and a hate of everything our group has done' that motivated him. Melly's book offers the immediate context within which to locate the band's stance of a self-conscious disavowal of the pop ideal – an opposition they refined even as

they chased and courted pop success. If Melly was one of the period's best theorists on pop, its best critic was Nik Cohn, the 'most respected and influential' pop commentator on Fleet Street, according to his contemporary Jonathan Aiken.[5] From the mid-1960s to the early 1970s, Cohn wrote with an unrivalled acuity about pop style – and The Who were his finest subject. In tracing his critical take on the band and pop, I will return to the columns he wrote for *Queen* magazine and the *New York Times*, where he responded with succinctness and an immediacy to the pop ferment. This material, alongside the more considered ideas in Cohn's fiction and books, will help to plot out what pop was and could be, and allow us to think again about how The Who slotted into and then reshaped that story.

Cohn's view of the pop field was singular. Unlike most of his contemporaries in pop journalism, he had strongly held and voiced opinions; pop mattered to Cohn, it was his obsession. He promoted the view of pop as a series of style explosions and flash impressions that were continuously refiguring the everyday. He used pop as a means to inhabit the marvellous, to transform the drab and the boring, to imagine the limits of the possible. He considered The Who to be fellow travellers, young men who were equally fanatic in their obsession with style. The Who made pop into an art worthy of the consideration of a critic with a truant eye and a disposition for the outlandish.

When he described *his* pop ideal, Cohn invariably labelled it 'flash'. The adjective had a peculiarly English application; it was not much used in the pop vernacular of the day by American critics. But it summarized the perfect pop attributes, suggesting in its two syllables the flaring, pulsing surge of the ephemeral pop moment: the splashy, garish display of the pop star; the sharp, concise impression left by the hit of a pop single; the sham, counterfeit emotion used in

pop marketing; and the illicit, underworld attraction of flash-men, flash-coves and flash-Harrys who occupied the pop world, especially those trespassers who tunnelled under or climbed over the cultural and social borders of the suburban greylands that restrained others. To have 'flash' meant you lived in the moment, without regard for yesterday and without thought for tomorrow. You thrived in an accelerating world, ahead of the game, blazing brightly enough to leave an impression – to have made your mark with attitude and style.

As he wrote about the pop moment, Cohn was aware of the contradictions in the stance he struck, warning himself, as much as anyone else, against putting gild on gold and paint on the lily:

Rock 'n' Roll, like all mass media, works best off trivia, ephemera and general game-playing, and the moment that anyone starts taking it more solemnly, he's treading on minefields. As performance, it has been magnificent. Nothing has been better at catching moments, and nothing has carried more impact, more evocative energy. While it lives off flash and outrage, impulse, excess and sweet teen romance, it's perfect. But dabble in Art and immediately it gets overloaded.[6]

The persona of a pop intellectual, which Melly channelled into his journalism, was informed by the artists and critics of the Independent Group who met at the Institute of Contemporary Arts in the early 1950s, among them Eduardo Paolozzi, Richard Hamilton, John McHale, Lawrence Alloway, Magda Cordell and Reyner Banham. This group set the terms upon which an understanding and an articulation of the pop arts and, subsequently, British Pop art would be based. In the round, Melly acknowledged the role of this radical collective on his ideas; and The Who, in all their varied activities, engaged wholly and enthusiastically in the debate elucidated in

Alloway's essay 'The Long Front of Culture' (1959). Alloway argued that the traditionally educated custodians of the rarefied arts – the elite, with their vehement opposition to the popular – now had no choice but to contend with unruly, mass and industrial arts: the pop arts that clamoured for the public's attention.

In the post-war context of austerity, Alloway outlined an aesthetics of plenty exemplified by American commercial imagery and products, and challenged the fixed binary of the low and the high. He championed an acceptance of the transformative impact of commercial products, arguing that consumers can develop tastes every bit as discriminating as those held by connoisseurs of the fine arts. This is not to say that the terms and criteria used in these acts of judgement will be the same, but that the times demanded an inclusive rather than exclusive approach to culture. The fine and popular arts are of equal interest; each, he argued, is worthy of critical consideration. Alloway called for the vertiginous pyramid of taste – the vulgar masses at the bottom, the refined elite at the top – to be reimagined as a horizontal continuum. The Who lived and worked on that line and made high art's link with low consumer culture more visible and more familiar.

You can see the continuum being played out in a story told by The Beatles' publicist, Derek Taylor: travelling with George Harrison, he was asked by an airline hostess if they were economy or first class? Harrison answered that they were travelling first class but as for *being* first class that was a matter for debate.[7] The Beatles were both agents in, and symptom of, the dissembling of class barriers. Melly's *Revolt into Style* documents the shifts in the reception and making of the pop arts that Alloway had identified; the questioning of accepted notions of good taste, and the collapse of class distinctions in life and art, that The Beatles, the Stones and The Who encouraged.

The Beatles had talent and craft in abundance to back up their transgressions, which were often parsed through an adroit ability to play artifice off against authenticity. The Rolling Stones were much more one-dimensional; Melly wrote that they 'were about hatred really, but there was no overt protest in them. They were about aggression expressed in sexual terms ... Sex was still a weapon, a way to appal the suburbs.'[8] The Stones' imperious stance was not shared by The Who, nor did they borrow their aggressive sexuality. The Who exuded little of the camaraderie and friendship of The Beatles; they did not speak in secret codes hidden behind a wall of self-affirming jokes. Instead, The Who's pranks, and Moon's in particular, were of a combustible nature, with the band as likely to turn in upon itself as it was to close ranks against outsiders.

When not attacking each other, The Who mounted their outward assault on convention as if they were participating in an art project. Simon Frith and Howard Horne suggest that Townshend saw his 'musical activities in terms of performance art, which meant seeing The Who's stage act itself as the moment of artistic creation and exploring the constraints on this – the dynamic relationship between star and audience, the effects of chance and accident, the shifting borders between music and noise'.[9] From the moment they were managed and mentored by Kit Lambert and Chris Stamp, The Who drew from a Pop art catalogue to help execute the kind of presentation of self that Frith and Horne describe.

In the 1960s, Pop art – a sometimes transgressive, sometimes permissive intercourse between the high and the low – was conceived by Alloway as having evolved through three distinct phases. Initially it was a concept built on critical debates about commercial iconography, the fine arts and the evolving practice of incorporating the former within the latter, such as comic book imagery or branded products within a painting or screen print. The second phase was

constituted by the practice itself becoming widely recognized and commented on, which led to certain exponents – Andy Warhol, Claes Oldenburg and Ed Ruscha, for example – being called 'Pop artists'. The final phase was when Pop art was absorbed into the market and replayed in fashion and graphic design, films, television, advertising and pop music. It is within this last iteration that The Who first presented themselves as a 'Pop art group' even as they set about dismantling just what such a categorization might mean.

Pop had its first public outing in Britain with the 1956 exhibition *This Is Tomorrow*, organized by the Independent Group. At the heart of the event at the Whitechapel Gallery, in a space curated by John McHale, John Voelcker and Richard Hamilton, were large cut-outs of Robby the Robot from the newly released sci-fi film *Forbidden Planet* (1956), carrying a supine, buxom blonde in a bathing suit, and a life-size cut-out of Marilyn Monroe patting down her billowing skirt from *The Seven Year Itch* (1955). On the facing wall was an oversized CinemaScope collage and in front of that was a jukebox. One critic wrote:

> May I add that quite ceaselessly a juke-box (that beloved tune creator sacred to the pin-table saloon) screams the poorest kind of popular music, punctuated by barbaric yawps and squeals which came, I believe, from a contraption bidding one 'speak' into a speaking-tube. This ensured pandemonium.[10]

If the racket caused consternation on the part of highbrow critics and exhibition audiences, it equally acted as an appealing attraction for local East End kids, who came explicitly to listen to the jukebox.[11]

Popular culture's attraction was a signal concern of Richard Hoggart's *Uses of Literacy* (1957). Published as rock 'n' roll in Britain

This Is Tomorrow exhibition at the Whitechapel Gallery, 1956. Pop art juxtapositions (L–R): a Van Gogh print, Robby the Robot, Marilyn and a bottle of Guinness.

began to gain real traction, the book carried an urgent warning about the deleterious effects of an alien entertainment culture on working-class youth. Melly wrote that Hoggart's book seemed agitated, with the author running round his subject like a sheep dog protecting his flock. But from what? Hoggart imagined it was from the sex and violence of American paperbacks and comics, but Melly felt he needed to look elsewhere – to a Soho coffee bar and an entertainer called Tommy Steele, who had momentarily appropriated American rock 'n' roll and lit up a dour post-war Britain.

IN 1965 THE FOURTH of the James Bond movies, *Thunderball,* was released. That same year Martin Ritt's adaptation of John le Carré's novel *The Spy Who Came in from the Cold* competed for screen space. Neither film recognized the world of the other's existence. The drab, choked London of Ritt's film did not contend with the culture of material abundance displayed in the Bond movie. Beyond personal conviction, what was Alec Leamas (Richard Burton) fighting to protect? What signifier of British culture and history was this representative of the establishment holding on to? Like Hoggart, Le Carré's character was looking in the wrong place for the changes that had already been heralded by Bond's first cinematic appearance in 1962 and by Tommy Steele a few years earlier. As Leamas leaves a London hostelry on a miserable rain-swept night, a Mod in a parka rides past him on a scooter. He goes by unnoticed and the question of what happens when the doldrums of post-war London rubs against the fictions of plenitude and a careering new youth culture goes unasked.

At the age of nineteen, Nik Cohn had his first novel published.[12] *Market* (1965) has no overarching story, no central character, no defining event. It is a study of a class-bound British culture of the kind Le Carré's spy worked to maintain. The local street market is the place where lives flow, eddy and then pass on. Relationships and networks are defined in terms of trade. Whatever is sold in the market's stalls and streets, the transaction eventually leads to the pub. Commerce is lubricated by alcohol; the drudgery of life mediated through bad sex and another bottle. In the market's dingy spaces there are no transcendent moments, nor even a carnivalesque pretence of escape, just the temporary distraction of P. J. Proby on the jukebox, the sound and lights of a pinball machine or the false hope found in the racing papers.

The market is a space where time gets spent like wages and Cohn's register is open only to disgust: 'Marcus had been feeling bad.

That was before the girl and the boy made it, up against the wall, and after the tart piddled on his shoes. He had, stuck in his mind, the thought of that woman's thighs while she was squatting, their scragginess, their infinite lack of sex.'[13] A *Sunday Times* critic wrote that Cohn's 'nose is particularly keen, and he has no intention of letting us forget that urine and intercourse are of the essence of everyday life. The style is hip, hectic, American-orientated.'[14]

Away from the spoilt fruit and vegetables, the possibility of an alternative world is glimpsed. In the shortest of the book's many vignettes, a man plays a Thelonious Monk record while he dresses:

'Bloody hell', he says, 'fuckin' hell'. Washing his hands, he splashes water all down his shirt front. Soaked through, ruined. He tears it off, tugging at the buttons, throws it on the floor. Takes a new one from the drawer, and tries that for size. Perfect, quite perfect. This one is dark blue, shot through with black. Round collared, double back at cuff, and fixed links. Chic. And the gold cuff-links, faced with mother of pearl. He gets them right, fastens his top button, takes off his pants. Then his underpants. Replaces them with, first, a new pair of briefs, pale blue and tight. And over that, long, lean hipsters in blue-green. A tie of rust, again with a backing black thread. Dark green suedes over rust socks. Tactfully echoing the tie. Then the jacket, dark suede. Broad at the shoulder and tapered at the waist. For that long, slim, specially tailored look. Brushes his hair. Smirks.[15]

Above the market's grime and at a distance from its dissolute characters, the stylist emerges – American in orientation and language – a figure auguring change. Following the moves such modernists made was the task Cohn set himself.

In the same year that Cohn's debut was published and the Fleming and Le Carré adaptations were screened, journalist Peter Laurie turned his attention, as so many others were doing, towards the youth of Britain. He began his exposé with an attack on a young woman just into her teens, and made her a symptom of contemporary ills:

> Look at this face. She is fifteen. She is just about to go into a pop concert in Slough in the Summer of 1964. The Rolling Stones are to play, she despises them. She despises a lot of things. Look how white and still her face is, how immobile her mouth. It is difficult finding her sexually attractive. In fact, she makes sure she is not. You cannot imagine her pushing a pram; she makes sure you cannot . . . This is a face that gives nothing . . . These Mod lips are almost painted out. Her body is straight and resistant as a plank. Her eyes, hedged by spiky lines, are watchful, alert, not to be taken in. Whatever she is going to be, she is not going to be a woman in the traditional sense. At least, not for the moment . . . To me, she seems the face of the teenage revolution.[16]

If Laurie had studied The Who in the way that he had gazed at this fifteen-year-old girl, would he have also felt that their faces gave away nothing beyond an antipathy that only partly hid their disdain for his adult, middle-class, conservative world view? Laurie had explored Soho's streets in his search for Mods, and he had done so just a little ahead of the start of The Who's Tuesday night Marquee Club residency. In the autumn of 1964, the band and their new management made Soho their headquarters, among the bars, pubs and café culture that played host to the area's artists, bohemians, entertainers and sex workers, and adjacent to the offices that housed the business end of the nation's entertainment industry.

Lambert and Stamp had been drawn to The Who as a compelling focal point in a film they were planning about London's Mods. While the duo were enamoured by the New Wave of French cinema, led by Jean-Luc Godard and François Truffaut, it was not the freewheeling aesthetic of *Á bout de soufflé* (Breathless) or *Tirez sur le pianiste* (Shoot the Piano Player), both 1960, that they turned to for direct inspiration. Instead, they looked closer to home for their model – to the Free Cinema collective helmed by British film-makers Karel Reisz, Tony Richardson and Lindsay Anderson.

As much as their project helped the film-makers gain an understanding of the new pop culture, and the opportunity to help shape

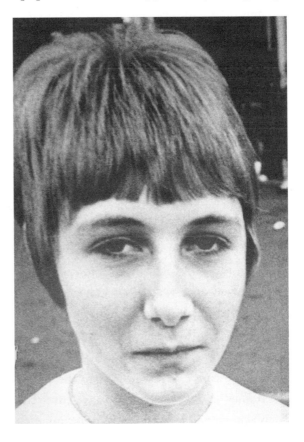

Peter Laurie's 'face of the teenage revolution', frontispiece to *The Teenage Revolution* (1965).

The Who, to inculcate Pete Townshend, Roger Daltrey, John Entwistle and Keith Moon with ideas drawn from the new movements in French and British cinema, it was the interaction with Pop art, from *My Generation* to *The Who Sell Out*, that provided the band and management with the means to best communicate their recently adopted felonious intent. What began as a scheme to differentiate The Who – a gimmick to set them apart from their contemporaries – quickly grew into a creative principle that allowed them to declare their substance and, in counterpoint, to highlight their superficiality; to speak openly of the *art* of making hit records and the *business* of selling themselves.

Following the release of The Beatles' *Sgt Pepper* in 1967, pop mutated into rock and claimed a status as art that it had previously shown no interest in. Pop's *raison d'être* had been to move product, to sell fantasies – 'sweet teen romance' in Cohn's expression. Rock brought self-importance to the table, asking to be noticed and discussed on equal terms with the older arts. The Who, more than any other group, was best able to translate this new demand of seriousness and authenticity by filtering it through a pop sensibility.

During 1967 and 1968 the band focused their attention on America. In the absence of tours by The Beatles and the Stones, they became, along with Cream and The Yardbirds, a major live attraction. The relationship with their audience changed, as did their music. As the shows got bigger, the physical distance between band and fans was negotiated through an implied authenticity based on a return to a primal rock 'n' roll and a mode of sonic attack that acted as a substitute for the loss of immediacy and intimacy in large auditoriums. Always ahead of the curve, Bob Dylan had come back from the sojourn that followed his 1965–6 tours with the stripped-down album *John Wesley Harding*. Taking their cue from Dylan, The Band promoted themselves as the last authentic exponents of

American music. The Grateful Dead, The Byrds (with Gram Parsons on board) and others confirmed that going back to the country was a righteous move. This aesthetic was echoed in Britain by the search for 'Albion' undertaken by the likes of Traffic and Fairport Convention. The Who saw things differently, orienting away from fakery and the ersatz by turning to Eddie Cochran and Johnny Kidd and the Pirates, even as they laid plans for their rock opera, *Tommy*.

In 1969 Nik Cohn surveyed the contemporary market in his book *Pop from the Beginning*. He did not like what he found: 'pop has split into factions', he wrote, 'and turned sophisticated'.[17] Pop had become rock; self-consciousness ruled. The Who's *Live at Leeds* was as much a statement on the excesses of the current scene as *Tommy* had been a summation of its pretensions. The first collection of new studio recordings after the opera was *Who's Next*, a set of songs written for an even loftier project than *Tommy*, *Lifehouse*, which was never to materialize. On the album's cover the band members zip up their jeans after having relieved themselves against a monolith; and on the album itself they sound suitably pissed off. The Who asked its audience to meet the new boss, same as the old boss. They had found the limits of the possible, it seemed.

Forsaking the regency drag and ruffles of their 1967–8 stage costumes, and following the commercial and critical success of *Tommy*, in 1969–70 Townshend donned a white boiler suit and Doc Martens. Even as Daltrey was in the process of turning himself into a rock god with flowing mane and chamois tabard, the guitarist's new attire suggested a rejection of such pop pomposity and a re-alignment with working-class youth. On the streets, British kids were reinventing themselves again with the skinhead subculture; less commented on, then or since, was the simultaneous re-emergence into public consciousness of the Teddy Boy. Pitted against the middle-class, university-educated, lank-haired youth weighed down by

a sodden army-surplus greatcoat – the fan of progressive rock – the Teds appeared as dandies personified. Hated by the music press of the day, and ignored ever since, the rock 'n' roll revivalists were, as much as the skinheads, a genuine expression of working-class youth, albeit one just as deeply and depressingly reactionary.

Though the rock 'n' roll revivalists were going nowhere in particular, their music spoke eloquently within its limits and underpinned every other glam-rock thumper that surrounded them: from T. Rex's re-writes of Eddie Cochran; Roy Wood's various acts of parody and homage with his solo work, with the Move, with ELO and with Wizzard; in Dave Edmunds's still astounding studio-finessed revamps, Slade's Little Richard rabble rousing; and in the reductive poses of Gary Glitter and all the rest. It would also yield Dr Feelgood, Kilburn and the High Roads, The Count Bishops and Eddie and the Hot Rods.

In an era of progressive rock, post-*Tommy*, The Who were caught between a desire to re-stimulate rock 'n' roll's savage heart and, in the context of T. Rextasy and glam, the conflicting need to extoll rock's newly won cultural authority. Like the revivalists looking to recapture the teen spirit of the 1950s, with *Quadrophenia* The Who turned back to their own foundation story in Mod culture, effectively retreating from the contemporary even as they produced another concept album – that most voguish of rock's intellectual vanities. By revisiting the band's formative years, by reflecting on what had happened between The Who and their audience, Townshend had planned to manage the seemingly incompatible positions of being a rock star and in a people's band. He wanted to reaffirm The Who's bond with their fans – some of whom in a few short years would use the early Who as a model for their own groups, not the least among them the Sex Pistols and The Clash.

This book traces the story of The Who from their Mod roots and the Lambert and Stamp film project, through their Pop art phases, their growth as an international attraction and the climax of *Tommy*, on through the teenage wasteland of the early 1970s, the paradoxical retreat from the present and attempt to lurch into the future with *Quadrophenia*. It closes as they meet their younger, punk selves reflected in the mirrored surfaces of the slot-machine arcades of Soho, where a fifteen-year-old girl once again navigates its streets and attractions before age and convention claim her.

1 ATTITUDE AND STYLE:
FOLK DEVILS AT THE RAILWAY HOTEL,
HARROW

> An attitude means a style. A style means an
> attitude.
>
> FREE CINEMA MANIFESTO, 1956

The story of The Who proper begins as a 1964 project by two aspiring film-makers, Kit Lambert and Chris Stamp. What came before was just preamble. In the examples of The Beatles and the French New Wave, Lambert and Stamp saw a way of shucking off their dull jobs as film assistants and grabbing a career short cut to recognition and acclaim. They shared an ambition to become celebrated auteurs, Britain's answer to Jean-Luc Godard and François Truffaut. Pop music and youth culture would be the subject of their film; The Who and the new folk devils, Mods, would be the object of their gaze.

In late 1964, barely months after the spring and summer seaside battles between Mods and Rockers, journalists Charles Hamblett and Jane Deverson documented 'today's generation talking about itself' in their mass-market paperback *Generation X*.[1] Commensurate with the speed at which they recorded, analysed and disseminated their findings, Hamblett and Deverson wrote about the impact an accelerating culture of consumption was having on their subjects:

The problems of today's young are more acutely special than ever before. Thanks to post-war developments in mass-communications alone these problems have become more concentrated, are more universally shared and more rapidly absorbed. Things, people, ideas get used up more quickly – yet are cast aside with the same old primal ruthlessness. This is one of the problems the young must face and conquer: the problem of social and scientific acceleration at the expense of biological time. If they don't, they are in danger of becoming a generation of re-treads, worn out before their natural time.[2]

After an explanatory introduction, *Generation X* begins with sensation. Under the quote 'I'd marry anyone to spite my parents' and the *London Evening Standard*'s headlines on rising meat prices and Margate's rioting Mod 'vermin', a nineteen-year-old mechanic tells his story of the Whitsun holidays: 'It was a laugh . . . the beach was like a battlefield. It was like we were taking over the country.' This youth took special pride in the fact that he and other Mods had punched their way into the public's consciousness and, unlike those who hire publicity men to get their names in the paper, they had done it seemingly cost free. Reading about themselves in the press afterwards was 'part of the kicks'.[3]

The book pulled together interviews with Britain's teenagers candidly discussing things that mattered to them. Despite the promise of the opening, there is little more in the way of scandalous material; their stories are generally about the mundanities of everyday life. Away from the headlines, the teenagers reveal themselves to be conservative, deeply rooted in family and class, yet more open and tolerant of change than their parents.

Following the Whitsun seaside troubles, *New Society* carried out a survey of the 'sawdust Caesars' held for various offences by a

Margate magistrate. When viewed dispassionately, the 44 teenagers and young men retained little if any of the aura of menace aroused by the media's reporting. The majority were charged with threatening behaviour; seven were sent to jail or to a detention centre, generally for three months; the rest were fined. They were nearly all first-time offenders. All but two had left school at fifteen. They were employed in low-skilled jobs, as trainees or as apprentices. Most had travelled from London to Margate in small groups using the trains; some had arrived by car but only a handful had scooters.[4]

What the survey revealed was their sheer ordinariness. Nearly all were still living at home, the vast majority with both parents. Boredom and a 'low level of ambition' defined much of their outlook: 'Most Mods . . . got fed up with the life they led,' *New Society* reported, 'where one week seemed much like the next.' Identifying as either a Mod or Rocker was, they said, a question of style.[5]

Hamblett and Deverson considered class division to be decisive in the story they were telling about today's youth; a point they also made pictorially in the book's photo spread, where an image of Mods fighting on Margate beach is juxtaposed with a shot of Harrow public school boys in straw boaters. Although class structure defined the terrain of their enquiry, that landscape was fast changing; a world being pulled out of the past and into a consumerist future – a space The Who were shaping up to occupy:

Industrial, metropolitan England, with Generation X moving rapidly from the dark, satanic mills of the greedy past towards that New Jerusalem fashioned by the dreamers and poets of the ad. agencies, and manipulated by the Brian Epsteins, the Ned Sherrins, the Hugh Cudlipps, the J. Arthur Ranks and Sidney Bernsteins. Moving via pop records, *Fabulous*, David Frost, Jane Asher, Italian suitings and the tantalizing images on

the small screen toward the new egalitarian society struggling hard to establish itself in the most class-conscious country in the world.[6]

When the media were not creating folk devils and moral panics, it was the seemingly endless novelty of teenage culture that held their attention. Writing for the August 1964 New York edition of *Vogue*, Peter Laurie reported on the scene under the heading 'So Young, So Cool, So Misunderstood – Mods and Rockers'. Laurie assumed the role of translator for his American readers: '"Mod" means modern – Mods are teenagers, sophisticated, urbane, not so much rebellious as contemptuous of the frantic adult that is so interested and horrified by them.' He tracked the teenager's spending habits, recording the speed of fashion changes and decoding the Mod's secret language. The Rolling Stones are their current heroes, he asserted, because they 'emphasize the rejection of adult interference . . . Their shaggy hair, their primitive imbecile faces, their casual doggy sexuality are deliberately assumed to make them shocking and disgusting.'[7]

In a striking conclusion, Laurie explained the phenomenon in terms of British society's rejection of its own youth. The undereducated are excluded from the benefits of the new technological culture: 'They have to make do with the fringe things – music, clothes, style. We piped for them and did not even ask them to dance. It is not to be wondered at if they go away and sing their own songs, dance their own dances, make their own culture that brings the excitement, the civilisation, that we deny them.'[8]

One of Hamblett and Deverson's interviewees drew an even darker conclusion on the present state of things: 'Roll on oblivion. If there's time you might do a sequel to this book and call it Generation Z – for zero.'[9] By that point in time British cinema had

been exploiting the image of disaffected youth for a number of years, and it had invariably located the site of teenage delinquency as the same streets where the film industry's head offices stood – Soho, which in late 1964 The Who would begin to occupy and make into their own centre of operations.

SOHO WAS A PLACE that offered the potential for re-invention and self-actualization, where suburban youth could freely play out multiple identities, as if they were starring in a film. In Colin MacInnes's novel *Absolute Beginners* (1959) the protagonist realizes this idea:

> Then he said meanwhile, what about we take in a film this evening? But that was no good to me, because you don't go into Soho to see films because Soho *is* a film, and anyway, most times I go to cinemas I walk out half way through because all I see is a sheet hanging up there, and a lot of idiots staring at it, and hidden up behind all this there's a boy operating the machinery with a fag hanging in his mouth even when he puts the record on for the 'God Save', and the cattle down there rise up on their corns, but not he, no! *Life* is the best film for sure, if you can see it as a film.[10]

Reality and fantasy clash and then combine in this moment in MacInnes's story. Until The Beatles in *A Hard Day's Night*, that dynamic, as registered in British movies, was absent. British pop culture was imitative; derived from American pictures such as *Jailhouse Rock* and *Sweet Smell of Success* (both 1957) and, in the case of *Expresso Bongo* and *Beat Girl* (both 1959), any combination of examples from the recent cycle of juvenile delinquent films

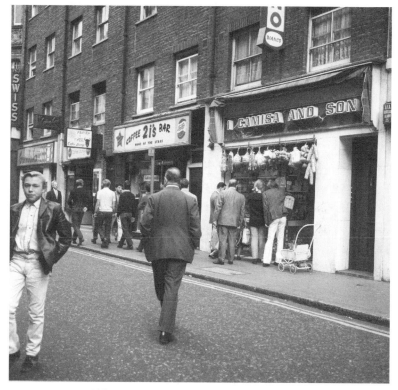

Old Compton Street, Soho, featuring the 2i's
'Home of the Stars' coffee bar, 1966.

produced by American International Pictures.[11] Characters, plot
lines, dialogue and music all mimicked Hollywood teen-pix, yet
these movies are unable to shake off their British accent, their
Americanisms as faux as a striptease artiste's confected stage name.

The opening sequence of *Expresso Bongo* makes manifest Richard
Hoggart's fear that the possibility of a vital British culture was being
submerged under a tidal wave of chromium-plated American culture.
The film begins with a set of nocturnal images of Piccadilly Circus
aglow with its neon hoardings. Across the sequence, a pounding
big-band jazz recording ricochets between its brass and percussion
sections, all redolent of an urban crime drama – an American film noir.

The camera tracks down a studio mock-up of a Soho street before pausing outside an amusement arcade. Inside youngsters entertain themselves at the pintables and a Rock-Ola jukebox blares out the movie's theme tune. Sitting on top of the disc player is a cardboard image of Cliff Richard – Bongo Herbert.

A further tour of Soho's many attractions follows before the sequence concludes by returning to the arcade. Two youths exit the emporium. To their left, two West Indian men provide compositional balance. The youths have greaser haircuts, with shirt collars pulled up; they talk and move with speed. Most of the speaking is done by a boy of East Asian origin, his accent is wholly English but his vocabulary is American. He slows down to buy a Walls hot dog at a street stand, but his mouth never stops moving. The camera tracks him and his pal as they cross the street, and then lets them continue out of frame as it recentres on two teenage girls checking out the discs in the window of a record store. The girls turn and follow the boys. The camera then picks up Soho wideboy Johnny Jackson (Lawrence Harvey) and his direction of travel takes us back into the heart of Soho.

In the same way that French-ness is used to signal a cosmopolitan European exoticism around the sexual transactions on offer – Mimi, Bridgette and Susette are the names of the models selling their services on cards in a display case – fast food, made in Britain by Wimpy and Walls, signifies trans-Atlantic glamour and a culture of plenty. The use of East Asian and West Indian bit-part players suggest that the crossing is not just cultural but racially complected.

To examine some of the cultural exchanges that took place in London in the early 1960s, the theorist Dick Hebdige uses a quote from Len Deighton's 1962 novel *The IPCRESS File*, which has Harry Palmer taking in the delights of Soho one fine January morning. Palmer's pleasures are neither British nor American, but European

– Gauloises cigarettes, grappa, Normandy butter and garlic sausages – as if Soho is a world apart from the rest of London. 'It is perhaps the final irony that when it did occur the most startling and spectacular revolution in British "popular" taste in the early 1960s', writes Hebdige, 'involved the domestication not of the brash and the "vulgar" hinterland of American design but of the subtle "cool" Continental style which had for so many decades impressed British champions of the Modernist Movement.'[12] Soho was a uniquely cosmopolitan space; class, race, and ethnic and national boundaries blurred as like nowhere else in England. At least in the imagination, the whole world could be found in Soho.

Despite Hebdige's suggestion, European cool and the New Wave cinema were never purely products of an Italian or French culture; they existed only in that moment when the American was translated into the local language. Against such cultural and racial blending, British culture performed its essential whiteness. Soho was what Britain was not, it was the Other to the British Self. Lawrence Harvey's portrayal of a Jewish huckster, alongside all the other stereotyped entrepreneurs in the film, compounds the image of Soho as a polyglot district. In Soho, as it was in America, identity is uncertain and motley, class boundaries were fluid and culture was reducible to what could be purchased.

Discussing the morphing of the Beat generation (their term for culturally disaffected youth of the 1950s) into the Mods and Rockers era, Hamblett and Deverson wrote: 'The general settling down which followed the initial, and healthily brief, frenzies of Beatlemania, has left British youth more free than ever before in recent history to develop a mystique which is not a carbon copy of whatever trends happen to have caught on across the Atlantic.'[13] Their point was echoed by Townshend, who implied a similar process was at work within the creative realm: 'When British kids who

were in bands discovered R&B, what they discovered was a new way
to write pop songs which was purely British.'[14]

In a 1957 essay on the new teenage consumers and their idol
Tommy Steele, MacInnes made the Americanization of British
youth culture the topic of interest:

> The battle for a place among the top twenty has been won by
> British singers at the cost of splitting their personalities and
> becoming bi-lingual: speaking American at the recording
> session, and English in the pub round the corner afterwards.
>
> This strange ambivalence is very apparent in Tommy's art.
> In his films or when, on the stage, he speaks to his admirers
> between the songs, his voice takes on the flat, wise, dryly comical
> tones of purest Bermondsey. When he sings, the words (where
> intelligible) are intoned in the shrill international American-
> style drone. With this odd duality, his teenage fans seem quite
> at ease: they prefer him to be one of them in his unbuttoned
> moments, but expect him to sing in a near foreign tongue: rather
> as a congregation might wish the sermon to be delivered in the
> vernacular and the plainsong chanted in mysterious Latin.[15]

Like MacInnes, Melly took the early British rock 'n' rollers seri-
ously, charting their impact, and noting the rapid crossover they all
made into mainstream traditional entertainment forms: the 'swing
towards acceptability', a trajectory that begins with revolt and ends
in compliance.[16] This process, Melly thought, gibbeted and cas-
trated rock 'n' roll performers, who became more of a promise than
a threat.[17] Before that point was reached, he argued, the network
of coffee bars with jukeboxes acted as subterranean hothouses for
young talent and a hidden space where teenagers' secret codes and
passwords could be formed.[18]

In his autobiography, Andrew Loog Oldham recalled his perambulations around the streets of Soho:

> The hookers kept their shrines on the second floor, not on the pavement and in your face, and the streets were reserved for characters, cappuccino action, nerve, real verve and chat, most about music. The streets reeked of chutzpah, and skiffle was dead – long live pop. Alex Strickland's Record Store on the corner of Dean and Compton blared the future, while now it just blares upfront sex and 'marital aids'. Oh, there was Johnny Danger on the third floor holding life's markers – evil indeed lurked behind the facade, but what a facade! When they filmed *Absolute Beginners* they forgot the rum in the punch and, alas, it was all facade. I passed the 2is on my left, still squeezed between a deli and Heaven and Hell. I even managed a fond nod in the direction of Sportique. Walking the streets of *Expresso Bongo*, my heart went boom as I crossed the room.[19]

Beat Girl uses just such a Soho setting. 'The Off Beat' coffee bar stands in for the 2is, home of British rock 'n' roll, where Tommy Steele was discovered.[20] The café in the film sits across the road from 'Les Girls' strip club, which creates an easy synchronicity between youth and sleaze (with a continental frisson). As depicted, the film's youngsters have a closer kinship with Beatniks than with rock 'n' rollers, but they all use the same excruciating Americanisms – Daddy-o. At a rave held deep in the Chislehurst caves, the teenagers define themselves as belonging to a generation scarred by the war. Adam Faith's character calls the caverns 'home from home' – he was born underground in London's tube system as his mother took refuge from the Luftwaffe. He grew up without a father, playing in bomb-site cellars. The titular Beat girl's parents are divorced;

Jennifer (Gillian Hills) lives with her father, who recently married a French woman half his age. The film renders its portrayal of juvenile resentment and estranged youth effectively, and with sensitivity, but filmic representations of youth's rising from an underground, from out of the caves and bomb-blasted cellars, would not fully emerge into the light until five years later, with *A Hard Day's Night*.

IN THE EARLY SPRING of 1964, The Detours, featuring band leader Roger Daltrey, bassist John Entwistle, guitarist Pete Townshend and drummer Doug Sandom, became The Who. They had found a mentor in the figure of publicist and Mod taste-maker Pete Meaden. Inspired by the impact his friend and one-time colleague Andrew Loog Oldham was having as manager of the Rolling Stones, Meaden had a dream, he said, 'of getting a group together that would be the focus, the entertainers for the Mods; a group that would actually be the same people on stage as the guys in the audience'.[21] Daltrey later explained Meaden's theme:

> With our long hair and scruffy clothes, our beatnik, Rolling Stones-type look, no one would bat an eyelid when they saw us together. But Pete was an image maker. He dragged us into the barber's, then put us into white jeans and Ivy League stuff, and the effects were immediate. People started to stare at us, like we were off another planet. So he was totally right.[22]

The final piece of the picture was added when Keith Moon joined the same month as Meaden became their stylist, if not quite their manager.

Already in his thirties, while the rest of the band were still teenagers, Sandom was always something of a misfit and was readily

discarded. Moon was seventeen when he joined, a north Londoner, the others were from the same west London district and had all attended Acton County Grammar. Moon was the only one to have gone to a secondary modern school. Though they were grammar school boys, Townshend, Daltrey and Entwistle were each moving in different directions before finding themselves with the band. After finishing school, Entwistle worked as a clerk, Daltrey became a sheet-metal worker and Townshend continued his education as an art student. Moon's impact on the band was transformative, musically as well as visually. Meaden gave the band a concept of style, a sense of self-presentation that stayed with them throughout the next ten years. Whether or not The Who were Mods, however that rapidly evolving subculture might be defined, Meaden encouraged an alliance between them.

With the new look and line-up, Meaden insisted that the band change their name to The High Numbers. It was a move calculated to play to Mods with its suggestion that the band were elite stylists, part of their movement but a cut above. Lambert and Stamp later pointed out that The High Numbers was also suggestive of the game of bingo – it was 'a nothing name', they said.[23] 'How Mod are this Mod-mad mob?' asked *Record Mirror*. 'Very Mod' was the answer. 'After all,' said Meaden, 'the Mod scene is a way of life. An exciting quick-changing way of life. The boys are totally immersed in this atmosphere.'[24] When the band eventually entered a studio to record a disc for the Fontana label they cut two numbers penned by Meaden, blatantly plagiarizing the Dynamics' 'Misery' for 'Zoot Suit' and Slim Harpo's 'I Got Love if You Want It' for 'I'm the Face'. The songs document Mod attitude and fashion – preppy jackets and white buckskin shoes. Meaden's ploy was guaranteed to be out of fashion before the record was even pressed. Looking back, Townshend considered 'I'm the Face' to have been too

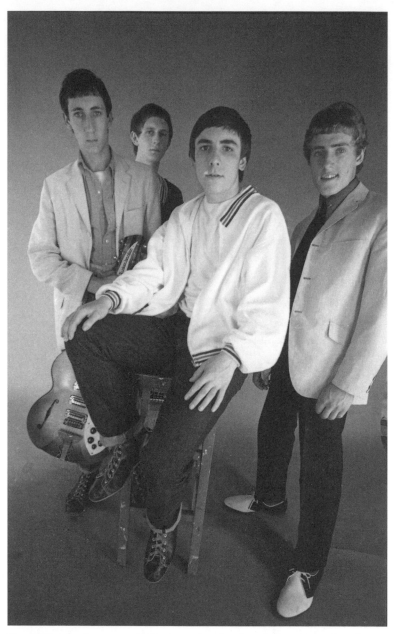

The High Numbers as styled by Pete Meaden (L–R): Pete Townshend with Rickenbacker and boxing boots; John Entwistle in monkey jacket; Keith Moon in monkey jacket, boxing boots and Levi's; and Roger Daltrey with two-tone suede shoes and a three-button hand-me-down.

'self-conscious'. 'The kids in the street didn't need that kind of leader. They knew that information before you even thought of the lyric.'[25]

Meaden's version of the band was too passive; it imagined them as mirrors reflecting back their audience. Under Lambert's guidance, Townshend turned docile mimesis into a dynamic of exchange:

What the Mods taught us was how to lead by following. I mean, you'd look at the dance floor and see some bloke stop dancing the dance of the week and for some reason feel like doing some silly sort of step. And you'd notice some of the blokes around him looking out of the corners of their eyes and thinking 'Is this the latest?' And on their own, without acknowledging the first fellow, a few of 'em would start dancing that way. And we'd be watching. By the time they looked up on the stage again, we'd be doing that dance and they'd think the original guy had been imitating us. And next week they'd come back and look to us for dances.[26]

WHEN LAMBERT AND STAMP first encountered The Who in July 1964 (the same month that saw the release of *A Hard Day's Night*) they were looking to make a documentary on a happening band. The pair had spent much of the previous three years working odd-jobs in film production, often at Shepperton studios as uncredited second assistants to the director on movies such as *Guns of Navarone* (1961), *The L-Shaped Room* (1962), *I Could Go on Singing* (1963), *From Russia with Love* (1963) and *Of Human Bondage* (1964). Inspired by the careers of the *cineastes* of the Free Cinema – who had made their mark with short, highly personal documentaries – and by the meteoric rise of The Beatles, Lambert and Stamp's game plan to make a name for themselves was hardly

original, but it was better than working: 'I was looking for a new group to put into a movie that was, I hoped, going to revolutionise pop film-making,' said Lambert.[27]

The formative event in Lambert's life had been as a member of an expedition party sponsored by the Royal Geographic Society to survey the longest unnavigated river in the world, the Iriri, in Brazil. Lambert would film the expedition and produce a documentary. His CV was light on experience as either an adventurer or a film-maker. He had spent no more than six months over the winter and spring of 1959–60 studying film at the Institut des hautes études cinématographiques in Paris, having enrolled, he said after the fact, on hearing that Jean-Luc Godard and Alain Resnais sometimes taught a course on the programme. Whatever the truth behind his motivation for being in Paris, Lambert soon got bored and went home.[28] He spent seven months in Brazil, one month longer than on his film education.[29]

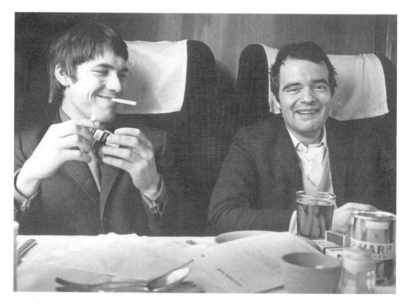

On the move: Kit Lambert and Chris Stamp travelling first class, c. 1966.

The Amazon adventure had gone badly. The expedition had not found the river's source and one of the explorers was killed in an ambush set by a group of indigenous people. The victim was discovered by Lambert, with the top of his head removed. The story made the newspapers back in Britain and Lambert was hounded by reporters on his return to Rio. His biographer, Andrew Motion, records that he avoided his inquisitors by hiding out in the 'stews of Rio', where he contracted a serious anal infection due to overindulgence.[30]

As is often pointed out, Lambert and Stamp made for an odd partnership. Lambert was gay, Stamp heterosexual. Lambert had a private school and Oxford education, and was the son of a respected composer and musician. Stamp was the son of a Thames tugboat captain and brother to the film star Terence. What they had in common was ambition, a dislike of authority, a love of the French New Wave, and no patience for plotting out and fulfilling a steady career path. They were both floundering iconoclasts looking around for a target and the tools to launch their attack.

When Motion (and others) give an account of Lambert and Stamp's search for their film's subject it is described as if the pair were re-enacting the Brazilian expedition, only this time they find the source (the Railway Hotel in Harrow and Wealdstone), document the aborigines (the Mods), and no one gets killed: 'As if he were planning a campaign, [Lambert] bought a large map of London, pinned it on the wall in Ivor Court, and staked it out into sections so that he could investigate them thoroughly. Stamp was allocated the East End, and Kit took the South and then went west.'[31] Lambert was not alone in the hunt for folk devils. In *The Teenage Revolution*, Peter Laurie recalled a request from American *Vogue* to cover the Mod phenomenon. He was told he could get candid photographs of the teenagers at five o'clock in the morning as they left Soho's clubs

waiting for the first tube home. Once there, he found the teenagers cued and ready to pose for his camera: 'Mod hunting was at the time a respectable almost crowded sub-profession of journalism,' he wrote, '*Paris Match* and a film unit had drawn this favourite covert earlier in the evening.'[32]

Though Motion glosses quickly over Lambert and Stamp's change from ambitious film-makers to pop-group impresarios – 'At last, Lambert felt, he had found something to do which suited his intelligence as well as his recklessness' – the pair did shoot film of the band.[33] They never completed a feature documentary, but footage and soundtrack recordings have survived and the material is extraordinary, both as an archival document of the still evolving group and, crucially, of the Mod audience that gave them, in Townshend's words, permission to play.

Lambeth and Stamp may have been absolute beginners as managers of a pop group, but they did have Brian Epstein and Andrew Loog Oldham as role models. Just as importantly, they had the revolutions that were happening in continental and British cinema as inspirational guides to how a pop form could be turned inside out and used to reject the standing orders of a moribund culture; more specifically, they had Tony Richardson and Karel Reisz's 1956 documentary *Momma Don't Allow* as a model for their picture.[34] This short film of North London youths jiving to the Chris Barber Jazz Band evokes the energy of teenagers set loose from everyday constraints, finding themselves through dancing to American rhythms. Reisz and Richardson refused an easy didacticism or patronizing hauteur – the lingua franca of British documentarists. Instead, they focused on making their subject cinematic.

The film introduces three young people who during the week work as an apprentice butcher, a trainee dental assistant and a train carriage cleaner. On Friday night they rip up the floor of the Wood

During the working week the class system contains the teenagers;
at the weekend the dancers reclaim ownership of their bodies.
Momma Don't Allow (1956, dir. Tony Richardson and Karel Reisz).

Green Jazz Club. *Momma* is as much about the camera's movement
as it is about how the teenage dancers control space that elsewhere
they have no ownership over. A young woman is shown cleaning
the inside of a first-class train compartment – during the week the
class-system contains her – yet, at night, with the Chris Barber band
channelling her energy, she breaks loose, surrendering herself to the
music, to its rhythm, to the moment as the film comes alive. While
in this self-defined space, the workaday world no longer exists for
her. She is gone, so lost in her dancing that she does not notice
the presence of a bunch of toffs, who have lately arrived in their
Rolls-Royce to partake in a little slumming among Wood Green's
hoi polloi. Neither accepted nor rejected by the regulars, the toffs
stand to one side, unable to give themselves to the music, to the
moment, and let go of their inhibitions. They are the very definition
of a repressed and outmoded way of life, moving (it can't be called
'dancing') with all the poetic expression of a Dreamland automaton.

The vibrancy of the film's representation of London's youth could only have appealed to the sensibilities of Lambert and Stamp; it had a spontaneity, an immediacy and an exuberance that was echoed by The Who and their audience.

Reisz and Richardson found common cause with Lorenza Mazzetti and Lindsay Anderson: under the marque 'Free Cinema', they had pooled their energies to put together a disparate set of underfinanced documentaries and film essays in a series of programmes at the National Film Theatre during the latter half of the 1950s. The four film-makers believed in 'freedom, in the importance of people and in the significance of the everyday.' Above all they held that 'No film can be too personal.'[35] Attitude was everything, and – even if they had only minuscule budgets for their movies and limited opportunities to show them – they had that in abundance. Free Cinema's *bête noir* was an irrelevant mainstream British film culture that had lost any connection it might have with the everyday. As outsider film-makers, they offered personality in place of anonymity, a raw and urgent authenticity in place of an insincere and polished professionalism, and an immediacy and intimacy in place of distance and cynicism. In their manifesto, which ran to less than one hundred words, they stated: 'The image speaks. Sound amplifies and comments. Size is irrelevant. Perfection is not an aim.'[36] This was a philosophy of intent co-opted wholesale by The Who and their novice managers – 'attitude as style, style as attitude' would come to define them.

Free Cinema's depiction of young people is a radical intervention in contemporary representations of British youth, especially so when weighed against the Central Office of Information's *Youth Club* (1954), a film designed to give a positive spin on an aspect of the government's social policy. The opening scene, which features a wholly anachronistic swing band tune, depicts a pleasure

arcade as a school for apprentice hooligans. The youth club provides an alternative, supervised, social and leisure space with table tennis instead of pinball tables. The club's activities encourage self-improvement and social responsibility; indolence and distraction are to be feared. *Youth Club* promoted a culture that promulgates conformity and self-regulation as ends in themselves. *Momma Don't Allow* refuses such a view; instead it emphasizes the formation of teenage identity within a community of peers and the importance of the present moment in that group's definition. Tomorrow, the future and respectability are not part of the teenagers' agenda. That sentiment would be echoed and amplified by The Who throughout 1964 and into 1965.

In *Absolute Beginners*, MacInnes similarly explored how jazz helped vanquish class and gender boundaries, and pushed things a stage further to include sexual and racial sensitivities:

> I mean certain LPs leave me speechless. But the great thing about the jazz world, and all the kids that enter into it, is that no one, not a soul, cares what your class is, or what your race is, or what your income, or if you're a boy or a girl, or bent, or versatile, or what you are – so long as you dig the scene and can behave yourself, and have left all that crap behind you, too, when you come in the jazz door.[37]

The dives and bars of Soho are a university for MacInnes's hero. In the jazz clubs he is part of a movement that is flowing in 'all kinds of directions – in social directions, in cultural directions, in sexual directions, and in racial directions . . . in fact, almost anywhere, really, you want to go to learn'.[38] But on art and jazz? 'Quite frankly, I don't really care *what* you think, because jazz is a thing so wonderful that if anybody doesn't rave about it, all you can feel for them

is pity.'[39] Townshend would later run with such sentiments, revising MacInnes's ideas only to the extent of updating them to include his Mod audience and the R&B and soul music they listened and danced to.

The dance and club scenes in *Momma Don't Allow* were echoed in the period's fiction films, not the least of these was Michael Winner's debut feature, *West 11* (1963), on which Kit Lambert had an uncredited production role. Based on Laura Del Rivo's 1961 kitchen-sink novel *The Furnished Room*, the story tracks the tawdry life of Joe Beckett, a young man singularly lacking in ambition. His world is the bed-sitting rooms, cafés and pubs of Notting Hill Gate. Ken Colyer and his band provide the musical accompaniment to West London's Beat poets in duffle coats, who take up space around Joe in a number of scenes.

On the duffle as the period's required piece of an outsider's costume, Nik Cohn wrote:

> With their hoods and toggles and utter shapelessness, they were at least defiant in their ugliness. They weren't a gesture like bohemian anti-dress, aimed at whipping up rage and horror; rather they were quittance, a denial of all interest, to be worn with curry stains down the front and the poems of Rimbaud in the pocket, so saying, '*I am above vanity, above flash; I move in higher regions.*'[40]

Less beholden than *West 11* to the emerging trend in British social realist dramas that the Free Cinema members had such a large hand in forming – Reisz's *Saturday Night, Sunday Morning* (1960), Richardson's *A Taste of Honey* (1961), Anderson's *This Sporting Life* (1963) – was Ken Hughes's Soho-set tale of a strip-club compère and indebted gambler, *The Small World of Sammy Lee* (1963). The

film roams around the dives, clubs and streets of London's red-light district. Like other movies from the period it cannot help but make the connection between an old world and the new, here juxtaposing the soot-stained facade of pre-war Berwick Street with an adjacent street's gleaming new tower block. The influence of *Shoot the Piano Player* is written all over *Sammy Lee*. Truffaut's protagonist, played by Charles Aznavour, who is constantly on the move, is interchangeable with Anthony Newley's Sammy Lee. They also look alike. Aesthetically, too, the film emulates its French inspiration with an emphasis on location shooting (albeit with some impressive exterior sets built at Shepperton that included a well-dressed Cecil Gee shop window) and cinematography by renowned documentary cameraman Wolfgang Suschitzky, which emphasized natural light, the use of mobile camera technology and fast film stock.

Sammy Lee is threatened by a gangster's enforcers: pay up or get beaten and sliced up. The younger of the two thugs who aim to collect the debt is played by a lean 21-year-old actor, Clive Colin Bowler. He is dressed in a sharp dark suit with narrow tie – the Italian, Cecil Gee look – while his hair is cut medium-long with a high side parting and back-combed on the crown. He is the epitome of Mod style circa 1962, and a symptom of the media's construction of youth culture as criminal.

Once Sammy Lee stops running, he is dead. His Soho is yesterday, he just hasn't quite figured it out yet. Its present belongs to London's emerging new modernists, its near future will belong to The Who. British films' repeated use of Soho as both location and source for stories had the effect of making the quotidian into something marvellous – transforming a working-class Bradford girl into a Paris *débourreur* or a merchant seaman from Bermondsey into a rock 'n' roll star; and it turned mundane London attractions into spectacles of savage delights. In the opening scene of *Sammy*

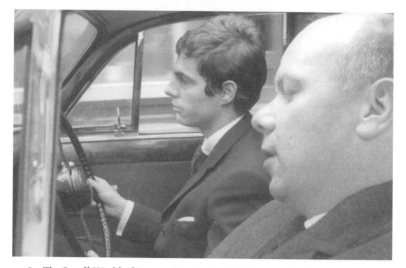

In *The Small World of Sammy Lee* (1963, dir. Ken Hughes), Clive Colin Bowler's enforcer is the very picture of the 1962 Mod.

Lee, as in *Expresso Bongo*, the camera tracks down Soho's streets, recording the shop fronts, cafés, restaurants, strip clubs and cinemas. Playing at the Cameo Moulin is Harrison Mark's *Naked as Nature Intended* ('the greatest nudist film ever,' claimed its poster) and *The Call Girl Business* starring Anita Ekberg (a rebranded Italian sex comedy). The nudist film was produced by Tony Tenser and Michael Klinger, who also owned the Cameo Moulin. After *Naked as Nature Intended* the duo produced dramas on venereal disease and teen pregnancy (respectively *That Kind of Girl* and *The Yellow Teddy Bears*, both 1963) and made a shift into mainstream feature film production through their support of the young auteurs Roman Polanski (*Repulsion*, 1965) and Michael Reeves (*The Sorcerers*, 1967). Prior to these films, they exploited the fad for *Mondo Cane*-styled films, producing *London in the Raw* (1964) and *Primitive London* (1965).

Mondo documentaries presented a compendium of sensational vignettes that depicted a phantasmagoria of primitive rituals thrown

together with images of the modern sex economy, all interwoven
with scenes of butchered animals, rites of passage, bullfights and the
like.[41] The mondo film cycle reimagined ethnographic cinema as
shock and sensation. It was as if the *National Geographic* had been
refigured as a magazine of moving images in Kodachrome and with
no text to dull the senses. The two British films did not bother to
look much beyond London for their attractions. Mods, Rockers
and Beatniks feature, along with hair transplants, wife swapping and
strippers galore. What the films sold was 'Soho', or at least a view of
it from Wardour Street. Iain Sinclair writes: 'Everything in *Primitive
London* is borrowed, short-changed, asset-stripped; everything
is a morning-after memory of something better. As if the film-
makers had absorbed the London visions of Colin MacInnes and
Jack Trevor Story, without reading any of their books.'[42]

Lambert's misadventures in Brazil, whether in his search for
the source of the Iriri or in Rio's demi-monde, would have made
perfect subjects for a mondo release, as would his and Stamp's film
of London Mods. Whatever their original ambition for their film
of The Who, it may never have been more than an impossible aspi-
ration. In James D. Cooper's documentary *Lambert and Stamp*
(2014), Stamp talks about their film as if it would have been an
evolving project shot over many months as they tracked the band's
progress from local heroes to pop stars. If this was indeed their plan
then it was a reckless enterprise. Had The Who flopped, any spent
footage would have little value, fated to end up as part of a bank of
generic images of British youth culture available for newsreels, or
to be leased to an exploitation or mondo film producer who could
then present the band as another of his picture's savage attractions.

In any event, The Who appropriated and repurposed *Primitive
London* by posing for a publicity photograph in front of the film's
poster – which featured a stripper with unruly hair, dressed in

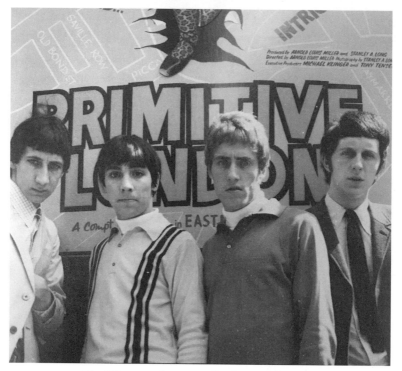

The Who turn the poster for the Mondo movie
Primitive London (1965) into a Pop backdrop.

leopard-print capri pants with matching fur cups over her nipples;
mouth snarling, fingers mimicking claws. The movie did feature
the requisite Beat band – in this instance The Zephyrs, miming to
one of their Shel Talmy-produced discs at the Scene club. As for
The Who, they made their commercial film debut in an equally
inauspicious forum – a documentary on Soho's strippers.

IN 1964 THE BBC radio dramatist Richard Wortley intended to
write a serious account of 'Blue' Soho, mostly through character
studies of some of its strippers, and to use his research as the basis
for a documentary film, *Carousella* (1965). He eventually published

his 'adventures' in 1969 as *Skin Deep in Soho*, three years after his film had been quietly and unspectacularly released.[43] Between the images of the women at work and telling their stories in various domestic situations, footage of The Who playing at the Marquee has been inserted. Perhaps it is an outtake from Lambert and Stamp's hoard of film sold on to help subsidize the band, but whatever its provenance, the sequence is used as a moment among others that marks the presence of wider cultures, activities and aspects of Soho's night-time economy.

The band are billed in the credits as 'The Who!' but, in this context, are effectively no more than another vulgar attraction. There are only seven scant seconds of them, isolated shots of Moon, Daltrey and Townshend and a group shot from the rear of the stage. The soundtrack uses a limp approximation of the Rolling Stones' version of 'It's All Over Now', but the music has nothing to do with The Who. The best guess is that the recording is by The Eyes, masquerading as The Pupils, who, in 1966, produced the cut-price album *A Tribute to the Rolling Stones*.

Despite its appealing New Wave pretensions, *Carousella* did not fulfil Wortley's ambition; the British Board of Film Censors all but killed its chances. They thought it an advertisement for stripping that would have Yorkshire girls travelling down to London for the good life. And where, they asked, was the warning about venereal disease, a prerequisite in such depictions of the sex economy? In the end, provincial censors gave it an X certificate, but the film left only a minor impression before it disappeared, to be archived as just another document offering a glimpse of Soho's lurid underworld.[44]

The movie Lambert and Stamp made of the band playing at the Railway Hotel originally ran for between ten and fifteen minutes. Shot and printed on 16mm film, it was titled *High Numbers* and was used to promote the band to agents and journalists, as well

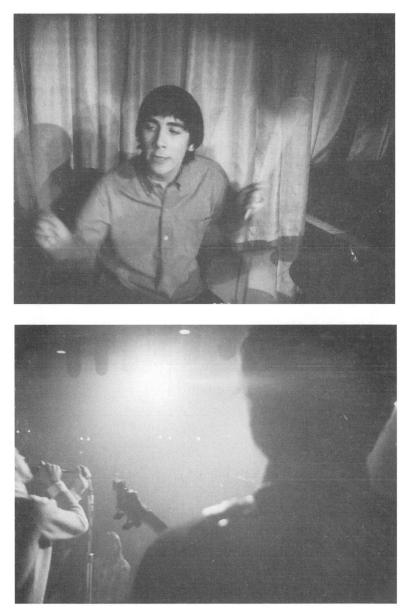

Daltrey, Townshend, Moon and the back of Entwistle's head from the seven-second clip used in *Carousella* (1965, dir. John Irvin).

as being screened before or between some of their performances in the autumn of 1964.[45] The commercially available footage runs the length of two songs – covers of Jesse Hill's 'Ooh Poo Pah Doo' and The Miracles' 'I Gotta Dance to Keep from Crying' – lasting approximately seven minutes.

An art school friend of Townshend and the band's promoter for the Railway gigs, Richard Barnes, wrote about the film's production:

> Kit hired the equipment and he and Mike Shaw together shot a lot of footage of the gig. Kit held the camera and Mike held the light. It was crude as it was all lit by one handheld light and Kit would be all over the place, on chairs, on the floor and up on stage with the hand-held camera. They taped the gig for a soundtrack on a mono tape recorder. As the group were playing they filmed the audience dancing and the kids hanging around on scooters outside as well . . . They later shot more footage of mods dancing in the Scene club and hanging around Soho and Carnaby Street.[46]

The film pivots around a series of master shots of The High Numbers, which initially focus on Daltrey but later highlight Moon leaning into his drums. Intercut are a series of images taken from among the audience. The dancers are engrossed in themselves with little interest in what is happening on stage. There is a blending of bodies in compulsive movement with the divide between stage and floor, between band and dancers, figured as borderless or porous. It is in complete contrast to the scene in *Primitive London* featuring The Zephyrs, where the dancers are but fleetingly glimpsed as if their presence is demanded only in order to authenticate the band. In Lambert and Stamp's film, the Mods are as much the stars of the piece, the focus of interest, as The Who are.

The Who occupy the stage with a studied and diffident confidence. Swaying from the hips, Daltrey is commanding without any hint of supplication. No one in the band appeals to, or seems to recognize, the audience before them, but then they hardly appear conscious of each other either. They look incredibly young; indistinguishable from the crowd of boys and girls, all still firmly in their teens. Sartorially, there is nothing to mark out the musicians from the lads on the dance floor: cropped hair, back combed on the crown, three-button Italian knits, suede desert boots, Fred Perry shirts and white Levi's.

There is a series of photographs of The Who, reproduced in two books by Barnes, which show them monkeying around in the Scene club. It takes a moment to identify the members of the band, to single them out from their Mod peers who surround them.[47] In his biography of The Who from 1971, Gary Herman wrote about this kind of interaction, highlighting the importance of dancing as a means of communication: 'The Mods were the first significant group in recent western history to abolish the idea of dancing with a partner of the opposite sex. They emphasised group-participation rather than the competitiveness of dancing as a courtship ritual.'[48] Dance steps and forms evolved and mutated with such rapidity that conventional moves, shared rules, were abandoned. Nothing appears to be choreographed in Lambert and Stamp's film, which brilliantly captures the spontaneity and inventiveness of the movements, as well as the in-crowd dynamic that Herman witnessed. Some of the dances are mannered, with carefully tailored gestures, while others are wholly individualistic – more amphetamine spasm than practised moves.

Towards the end of the second number a small set of fleeting images are cut in – nocturnal scenes of a man asleep on a park bench, youngsters milling around a jellied eel stand, two Mods smoking. But that is it for any extraneous business, any hint that a world exists

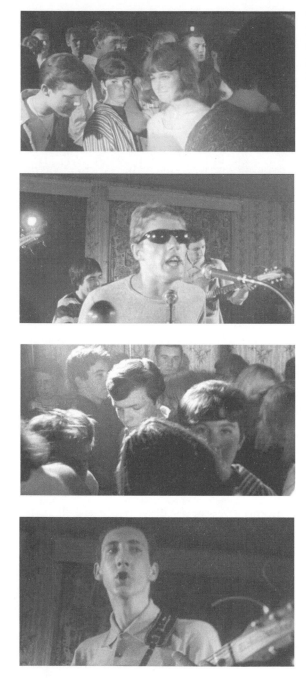

The High Numbers and dancers in Lambert and Stamp's film.

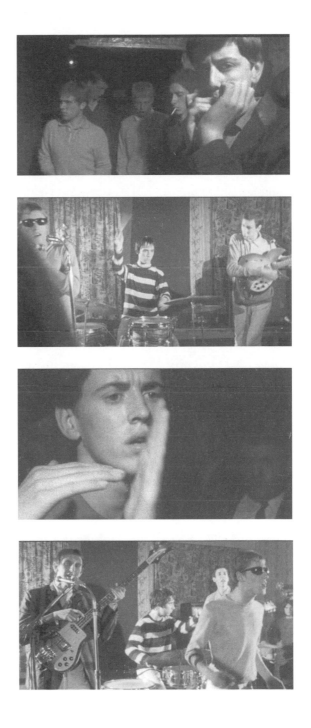

outside the club. What is certain is that, despite Barnes describing it as a 'crude' effort, given the film-makers' limited resources the outcome is lit, filmed, recorded and edited with a level of professionalism that impresses.[49]

IF THE MORE AMBITIOUS film project was still-born when Lambert and Stamp shifted tack and became the band's managers and co-conspirators, they nevertheless retained the lessons learnt from their shared love of the New Wave and its philosophy of *épater la bourgeoisie* – to shock the middle classes. In a delirious process of provocation, across the Channel the young Turks of the French New Wave had brazenly declared their love of American genre movies and their disdain for the traditions and conventions of French cinema. With their show of contempt for the prevailing state of things, these lovers of film were not simply reversing the order of value, upending a cultural hierarchy; their project was subtler and more radical than that.

Truffaut, Godard and Claude Chabrol celebrated and lionized Hollywood film-makers who laboured within and against the system, among them Samuel Fuller, Budd Boetticher and Robert Aldrich. They latched onto mavericks who, by working in the margins, in denigrated genres, had created a highly personal cinema. This was a cinema of vitality and energy, of exuberance and sensation. The attractions may have been cheap, often lurid, usually violent and decidedly male centred, but they addressed their audience through the demotic language of film, not with the pretensions of the fine arts. These films – Westerns, gangster movies, war pictures, film noirs – had no ambition to better themselves, nor were they embarrassed by their cultural status. These were movies without affectation and pretence. The secret knowledge that enabled

the critic to distinguish between a bland anaemic Hollywood con-
fection and a cinema of action with red blood in its veins shifted
the terrain over which the cultural debates of the 1960s would be
argued. It would no longer be pitched between the high and the low
but along the continuum that Lawrence Alloway had advocated.[50]
In the hands of French cineastes, and in the arguments made by
Paris cinephiles, film brought the high and low into a lively debate,
eliding elitism in art and bringing critical discrimination into the
study of the vulgar.

Like The Who, Godard could be simultaneously visceral
and intellectual; and that worked best when he made film lan-
guage express his ideas. When they sent the film rolling through
the camera as The Who played and the Mods danced, Lambert
and Stamp were surely aware of the implications of Godard's Pop
art assemblages. Certainly Andrew Loog Oldham was. His time
watching New Wave films at the Hampstead Everyman is lovingly
documented in his autobiography. As a teenager, he tried on the
gestures and poses of the male leads, aped their dress sense, recalled
the impact the films had on fashion designers. He writes,

> And let us not forget a little *später* pop music from The Beatles
> and the Stones. The French films' sparse, grainy black-and-
> white look would dominate early images of the Beat boom's
> leading lights. The Stones' input came direct from *moi* via the
> Everyman, plus what they brought to the table.[51]

When Melly surveyed the era's key pop impresarios, he wrote
that their talent was an instinct for style. He described Brian
Epstein as 'gentlemanly', someone who had rejected the manage-
rial mode of those 'cynical manipulators' of the mid-1950s; Andrew
Loog Oldham, he suggested, was 'anti-social', a scene maker who

Brigitte Bardot and Jean-Luc Godard on the set of *Le Mépris* (1963).

had redefined the pop manager as equal to the group and a player alongside other creative types – photographers, fashion designers, models; Tony Secunda, The Move's manager, was a 'hustling motor-mechanic of pop, tuning up a group for the grand pop-prix'; and Lambert and Stamp he called 'McLuhanite'. Referring here to the theorist of mass media Marshall McLuhan, he meant that they and The Who were transmitters of information to the teen world, style avatars for their generation.[52]

In a similar vein, Peter Laurie thought the teenagers he was observing were McLuhanite children wandering around in the global village of the damned:

Mods are only comprehensible if one sees them as one-man broadcasting stations distributing wholesale non-verbal

messages about themselves and their rejection of the rest of the world. They are the first generation to cope consciously with a world that depends more on mass communications than personal relationships, and they have adapted themselves with striking success to life as they find it.[53]

The symbiotic relationship between The Who and teenage Mod culture is here built on a reciprocal understanding of McLuhan's dictum 'the medium is the message.'[54] Style, in and of itself, is what's being broadcast. Laurie argued that, for contemporary teenagers, appearance had greater importance than reality. The Mods are 'essentially creatures of display'; theirs is a pose that seems 'almost the point of life'.[55]

The Who's incorporation of Mod styling into their identity, Townshend told Nick Logan in 1972, was significant:

I was actually able to achieve it by actually being involved! What was so great was the unanimity of it, the way I could blend in and be one of them. There was no class thing ... The point was that I was involved in it, and I could write songs as a pilled-up Mod that were straight from the heart, involvement songs like 'I Can't Explain', 'Anyway Anyhow Anywhere', 'My Generation'. But I think that's where they stopped.[56]

The benefit of riding the coat-tails of Mod was that it gave the band a ready-made audience and an eminently marketable identity. The downside was that a Mod audience was limited in size and region – pretty much the southeast of England.[57] The media hoo-hah around the troubles in Clacton, Margate, Brighton and Hastings – so assiduously documented and analysed by sociologist Stanley Cohen in *Folk Devils and Moral Panics: The Creation of the*

Mods and Rockers (1972) – could be exploited to enhance a rebel stance, but it also ran the risk of making the band appear to be no more than a commercial appropriation of Mod, akin to the 1964 Panther Pictorial publication *Dances for Mods and Rockers*, a cash-in that reconfigured Mod as just another teenage fad.

Looking back to 1964, the journalist Richard Williams describes what it meant to have a Mod's attitude:

> I could tell you about the details. About the punch-holes across the toes of a pair of five-guinea elastic-sided Raoul boots, or about the way a soft conga drum cushioned Mary Wells as she crooned 'Two Lovers', a Motown classic from the days when their greatest records sold only a few hundred copies in Britain to people who felt that they were receiving samizdat messages from a parallel universe. About hanging around a West Indian record shop on the bad side of town, hoping for an invitation to a shebeen. About a girl turning up for a summer date in a long black skirt and chunky shoes: so crazy, so cool. About the texture of a long, suede coat, or the smell of a box of blue-label Stax 45s at Transat Imports above a Chinese wholesaler on Lisle Street. About the week when a plain, medium-grey, six-button cardigan was the only thing to have, and it wasn't worth going out if you didn't.[58]

The attitude and style resided in the detail, a connoisseur's appreciation of difference, but it was also located in exclusivity; those few hundred who could read the code in a Motown 45. Williams continues:

> For some, it was already over by 1964. For the people who were Mods then, the whole deal had to be a secret or it was nothing.

And by 1964, too many people were in on it. Too many
people watching *Ready Steady Go!* on Friday nights. Too many
people spending their Saturdays staring at the shop windows
in Carnaby Street. The ones who didn't want to share it, who
didn't want anything to change, who wanted to preserve their
secret, turned out to be conservatives after all.[59]

The 1964 bank holiday disturbances fixed a wider public image
of Mods. Whether or not the image was accurate, it was no longer
a secret. Prior to the media frenzy, what defined a Mod was at best
diffuse and always transient; by the summer of 1964 the term had
become static and fixed. Modernist savants no longer spoke in code
to the few. Cohen wrote:

> By the middle of 1964 there were at least six magazines
> appealing mainly to Mods, the weeklies with a circulation of
> about 500,000, the monthlies about 250,000. There was also
> 'Ready Steady, Go', a TV programme aimed very much at the
> Mods, with its own magazine related to the programme and
> which organised the famous Mod ball in Wembley. This was
> the time when whole streams within schools, sometimes whole
> schools and even whole areas and housing estates were talked
> of as having 'gone Mod'.[60]

Just what information The Who needed to communicate about all
of this, and to which audience, would be worked out in the final six
months of 1964. With Lambert and Stamp running operations, their
broadcasts would radiate from the heart of the capital, transmitted
direct from Soho and the Marquee Club.

2 THE WHO PLAY POP ART

Music was life-confirming, problem-resolving,
and everything that mattered started with a
count-off and a look.

ANDREW LOOG OLDHAM

Through the summer of 1964, The High Numbers (occasionally billed as 'The Who') played regular gigs at the Railway Hotel, Harrow, on Tuesdays, began a five-week Wednesday night residency at the Scene club, Soho, performed at the Trade Union Hall, Watford, on Saturdays, and the Hippodrome, Brighton, on Sundays. These shows were interspersed with gigs at the Goldhawk Social Club, Shepherd's Bush; the Majestic Ballroom, Luton; and the Olympia Ballroom, Reading. Outside of the southeast they made three trips to Blackpool and played their first show in Scotland. The bookings grew and the circuit widened. The most important of these was a new Tuesday night residency at the Marquee, beginning on 24 November and ending the following 27 April. A full 23 weeks in the very centre of things: Soho. The High Numbers were finished, The Who had arrived. The journalist Peter Laurie described the early hours scene as the Mods spilled out of the Soho clubs and into the surrounding streets, yelling greetings and insults to one another: 'For an hour or so the plexus of London was their private patch, before they caught the first tubes home to Putney and Mill Hill.'[1]

Sometime in late 1963 or early 1964, Andrew Loog Oldham covered the same ground in the company of Pete Meaden. The Scene

club was loud, smoky and filled with 'disenfranchised working class' teenagers: 'I stayed close to the edge watching the kids speeding on pills and good music, posing more than dancing, jaws frantically chewing the night away. Three-legged, legless Mod monsters, pilled to the walls of aurafide stress, bound and bonded by sound and dread of the job on Monday.'[2] The Marquee residency gave The Who their first coverage in the music press. *Melody Maker*'s Nick Jones wrote:

> 'Heatwave' – the Martha and the Vandellas hit number –
> is given typically fiery 'Who' treatment. Another of their
> outstanding numbers was an instrumental 'Can't Sit Down'.
> This performance demonstrated the weird and effective
> technique of guitarist Paul [*sic*] Townshend, who expertly uses
> speaker feedback to accompany many of his solos . . . The Who,
> spurred by a most exhilarating drummer and a tireless vocalist,
> must surely be one of the trendsetting groups of 1965.[3]

In a 2009 interview Townshend gave to Mike Evans – a member of The Boys (aka The Action), The Who's regular support at the Wardour Street club from September 1964 to the end of March 1965 – he commented, 'Looking back now I realise the Marquee days were very special. We were all drafted in from the outside world into Soho to sell our ideas.'[4] Beyond helping to grow the band's fan base, what the residency achieved was to foment the idea that The Who had left to others the satellite and suburban outposts of the Railway Hotel, the Goldhawk Club, the Olympia Ballroom or Portsmouth's Birdcage Club as a base for operations, and that they were now refiguring their relationship with their audience and with Mod culture.

Before the Marquee residency, Townshend had already learnt that it was the audience who were in charge, who gave their consent

and allowed The Who to occupy the stage and perform for them. 'There was none of that sense of entitlement that the Kinks or the Stones or the Beatles appeared to have,' he told Jon Savage in 2011, 'which was, we're the stars, you're the audience. It was the other way round. We're the stars, and you can entertain us for a while, if you behave yourselves. That was the tone of it.'[5] In February 1965 the *New Musical Express* reported that a French television producer had described The Who as the 'logical musical expression of the bewilderment and anarchy of London's teenagers'.[6] As the band moved deeper into the early weeks of the New Year, they were no longer just listening in to the transmissions from London's youth; they were now the broadcast itself.

Portsmouth Mod Ian Hebditch recalled the style signals projected by his peers at the Birdcage in 1964 in his history of The Action and the Mods he ran with:

> Jack, pale blue motoring shoes, pale blue mohair suit, claret shirt, side-steps-and-slides with razor-cut accuracy . . . Jim, gold-tonic-shot-pale-blue, beige needle-cord button-down and checkerboard weave shoes by Raoul . . . Arney sweeps in with a couple of his entourage. His immaculate navy two-piece hangs impeccably. The suit, white shirt and officer's tie are barrister – but it's all too perfect, and Arney looks deathly and has diamonds for eyes. He scans the floor momentarily, turns, revealing fine white yoke detailing on the black leather, draped over his shoulders impresario style, then steps back into the abyss.[7]

For this Mod insider, The Who lacked the authenticity of his favourites, The Action, but Hebditch writes that Townshend 'had enough understanding of the Mod psyche to ensure that the

statements the group made in relation to the Mods were reasonably credible.' 'Nevertheless,' he continues,

> The Who's projection of Mod was still a projection of extremes – a caricature . . . Although he [Townshend] shared the Mods' arrogance, it was subverted into a perception that nothing had any intrinsic value. Only if he singled it out could it acquire any limited worth and even that would be defined by the parameters he placed upon it.[8]

Townshend had moved from follower to leader.

Unlike the other bands that drew a Mod audience, as 1964 morphed into 1965, The Who slipped the harness and began to kick over the traces of a shared identity. 'Went to Marquee – saw "The Who". They were v. good' wrote Ron Wood in a diary entry for Tuesday, 19 January 1965.[9] His band, The Birds, like The Action, were in hot pursuit of the trail being laid down by The Who. Reg King, The Action's vocalist, described how The Who's avant-attack was also to be found in their sound:

> The Who were upfront, smash, bang and pin your ears back! . . . We'd start a song in the way any good song should start – bang – it's there. Then build it up and build it up until you got to the end, and there's a crescendo. Everybody's going – oh yes, yes, yes, yes! – Boom! . . . The Who often started at that crescendo point, they never built the song in the same way. They'd often improvise in the middle and then reconstruct towards the end.[10]

For Lambert, The Who's stage act was a carnal experience: 'they have a direct sexual impact. They ask a question: do you want to or

don't you? And they don't really give the public a chance of saying no. It *is* a sort of rape. I suppose that's what happened to me when I first discovered them.'[11] In Jonathon Green's oral history of the '60s underground, ex-Mod Dave Goodman recalled those Tuesday nights in Wardour Street. For him the experience was less carnal and more visceral: 'The set was so fucking violent and the music so heady, it hit you in the head as well as the guts . . . You'd never heard anything like it: "Maximum R&B" said the poster . . . and fuck me was it!'[12]

Lambert took great pride in how he promoted The Who: 'we'd cover London with posters; we'd stick them on Banks, anywhere. We would go round *every* night with a van. As the Banks tore them down we'd put them up again. We put the posters in the most outrageous places . . . Maybe the posters would only be up there for an hour. But that would do the job.'[13] Graphic designer Pearce Marchbank recalled the impact of Lambert's campaign: 'unlike all rock 'n' roll posters. They were much more like art posters or film posters . . . I gathered they were an art school band by the look of them.'[14] Adding to the carnal and visceral responses to The Who, Marchbank's reaction was aesthetic, and one which aligned well with the band's new promotional stance that took form towards the end of their Marquee residency: 'We stand for pop-art clothes, pop-art music, and pop-art behaviour,' said Townshend in 1965, 'We don't change offstage. We live pop-art.'[15] Explaining this alignment, Lambert and Stamp told journalists that after the band's Mod phase they 'wanted a whole new scene going. We knew pop art could swing it.'[16] Their association with Pop, the band suggested, was no more than an expedient act of exploitation intended to give them an edge in an overcrowded market.

There is some truth in this accusation of gleaning Pop's cultural capital, but The Who's aspirations were not limited to simply seizing

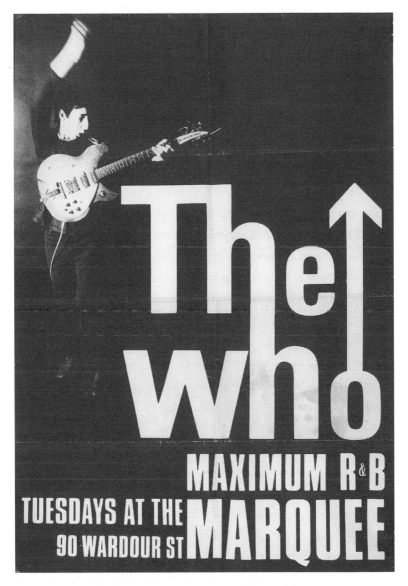

The Who's iconic poster. 'They were much more like art posters or film posters . . . I gathered they were an art school band by the look of them.'

its iconography and doctrines. There was more at stake than an art-less plundering of Pop concepts and images, whatever Lambert and Stamp said. The counter-argument is that The Who were involved in expanding a form, consciously or not, that had become limited in scope and moribund in ambition; and that in doing so they made a significant, if under-acknowledged, contribution to Pop art.

As an art form, movement, practice, concept and category, Pop art, as it was conceived of in England, had its initial public exposure via the projects, exhibitions, lectures, artworks and writings curated under the Independent Group's banner. In January 1957, following the collaborative exhibition *This Is Tomorrow* at the Whitechapel Gallery, Richard Hamilton suggested to fellow members that they mount another show, one that would comply with the characteristics of Pop art by being:

> Popular (designed for a mass audience)
> Transient (short-term solution)
> Expendable (easily forgotten)
> Low cost
> Mass produced
> Young (aimed at youth)
> Witty
> Sexy
> Gimmicky
> Glamorous
> Big business[17]

Capturing the key elements of Pop adroitly and economically, Hamilton's definition was prescient. Ten years later, the term had become widespread, describing a diverse range of contemporary art and design practices and products.

By the end of the 1960s, the term's very pervasiveness suggested to Lawrence Alloway that there was a pressing need to account for Pop art's history.[18] He argued that Pop art had gone through three overlapping but distinct phases by the mid-1960s. In the late 1950s he and his 'art-oriented' colleagues in the Independent Group were using the term interchangeably with pop culture in an effort to extend 'aesthetic attention to the mass media' and explain the absorption of commercial material 'within the context of fine art'.[19] At this juncture, Pop art was an expansionist aesthetic. Alloway was committed to an art criticism that was inclusive. He was not attempting to eradicate the differences between commercial and fine art, he simply held them to be of equal interest. In its original form, 'Phase 1' as he called it, Pop art 'was a polemic against elite views of art in which uniqueness is a metaphor of the aristocratic and contemplation the only proper response to art'.[20] Neither aspect – low art or high art – existed in isolation, as the second phase of Pop demonstrated.

Phase 2 took place in 1961–4 and referred to 'art that included a reference to mass-media sources'. This is the period in which Andy Warhol and Roy Lichtenstein played a defining role – and were themselves defined. It is in this phase that Pop art emerged as a movement alongside the figure of the 'Pop artist'. Pop art itself became compressed and maximized, which facilitated its rapid diffusion. More restrictive in its meaning than the previous iteration, the expansionist dimension is reduced to a set of formal properties. Pop art 'shrank to an iconography of signs and objects . . . a consolidation of formal procedures that are largely traditional'.[21] In other words, in Alloway's reckoning, Pop's radical agenda was cauterized by its popularity. Pop began to eat itself.

With its popularization, Pop art's status as a movement was diminished and further dissipated through its prolific application

to 'fashion, films, interior decoration, toys, parties, and town plan-
ning', which is the point at which The Who enter the picture.[22] Pop's
shift from fine art object to a marketing device can be seen in the
logo for Woolmark, designed by Franco Grignani and introduced
in 1964. The logo is an abstract ball of wool in the form of a Möbius
strip with a clear affinity to Bridget Riley's Op-art. The suggestion
was that natural fibres still had a decisive role to play in contempo-
rary fashion and textile design, an idea that was promoted in the
company's advertising campaigns throughout the mid-1960s. In the
September 1965 issue of *Queen* magazine, Woolmark ran an adver-
tisement for a John Laing-designed 'op-striped sweater'. The model
is shown standing face-on, wearing ear protectors and pointing a
revolver directly at the viewer. She is on a shooting range. To her
right a male model looks down a telescope in the direction of her
supposed line of fire. The accompanying text asks: 'Who says you
can't get a man with a gun? In a super-sexy sweater like this you can.'
Three small inserts surround the main image; a close-up of the wom-
an's right eye, the business end of the revolver, lensed with a short
focal length that blurs the shooter's face, and a target with a cluster
of holes around the bull's-eye. Suggestive of the *now*, the advertise-
ment is an amalgam of Pop clichés referencing Roy Lichtenstein's
Pistol (1964), Riley's Op-art, Jasper Johns's target paintings and the
close-up of a woman's eye, whose lashes are heavy with mascara, is
an image as ubiquitous as a Coca-Cola bottle in Pop art.

In defining 'Phase 3' Alloway used the figure of Batman to illus-
trate the crossovers and connections made between the commercial
and the fine arts.

It was originally a comic strip, and nothing else. In the early
1960s, Mel Ramos painted Batman subjects, in oil on canvas,
which were shown in galleries and in 1963 at the Los Angeles

In Lawrence Alloway's 'Phase 3' of Pop art, the signifier returns:
Woolmark's Op-art logo, sweater and Pop iconography.

County Museum. Bob Kane, creator of the strip, announced in 1966 that he had done a series of paintings in oils, but seems not to have known about Ramos . . . Then Batman hit TV and Bob Kane described the style of the series to me as 'Very Pop Art'. The comic continues, of course . . . The point is that experiences of art and entertainment are not necessarily antagonistic and unrelated, but can be linked into a ring of different tastes and purposes. And, to quote from a recent comic book: 'At the Gotham City Museum, Bruce Wayne, Millionaire Sportsman and Playboy [and Batman's alter-ego], and his young ward Dick Grayson [aka Robin], attend a sensational "Pop" Art Show.'[23]

Pop artists are as mobile as their subject, and Warhol, in particular, did not remain fixated on Pop's formal properties. The comic strip iconography of some of his early paintings – featuring Dick Tracy and Batman, among others – was left behind in his films and installations, the latter culminating in the multimedia experience the *Exploding Plastic Inevitable* (1966–7). Throughout Warhol remained adept at slumming with the vulgar arts. He knowingly appeared in a 1967 photo spread for *Esquire* magazine dressed as Batman's sidekick Robin, with the Velvet Underground collaborator Nico playing the Caped Crusader. This camp send-up of his status as Pop artist, and exploitation of the revived popularity of Batman, was a mirror image of a 1966 episode from the recently launched TV series, which presented a new villain. Described as 'the king of Pop Art and apostle of its culture', the master criminal Progress Pigment was a caricature of Warhol's public persona.[24]

The figure of Batman has proved to be extraordinarily adaptable to a range of media formats, including television, radio, film, digital gaming and music. The initial vehicle for this last was the

TV series' theme tune, composed by Neal Hefti and performed by Nelson Riddle. Numerous cover versions followed, from Jan and Dean, Link Wray, The Marketts, The Standells, The Ventures, moonlighting members of the Sun Ra Arkestra and The Who. These discs were all released in 1966, in line with pop culture's basis in immediacy, and were accompanied that year by scores of similarly themed tunes, such as 'The Ballad of Batman' by the perfectly named Camps, The Spotlights' 'Batman and Robin', Dickie Goodman's 'Batman and His Grandmother' and the marvellous 'Batarang' by the Memphis studio group The Avengers. While all are blatant, commercially motivated, exploitations of the TV series' success, The Who's involvement stands apart, not because their version is particularly distinct, or because money-making imperatives were of little regard, but because their cover of the tune embodied an element of self-reflection that made it an equivalent to a Mel Ramos painting. The Who's 'Batman' is indicative of their intent to slip in and out of categories – to be both pop *and* Pop art.

Looking back at The Who's Marquee residency, Marchbank recalled the slippage that was then happening between the popular and the fine arts, and how the band embodied the confusion and excitement that he, too, felt about such events and ideas:

> There were fantastic art exhibitions in London . . . In 1964 there was this great big show called the Gulbenkian and there was the 54–64 at the Tate, which had a whole room full of American pop art: Rauschenberg, Jasper Johns, targets and flags and what have you. Then you drift off to see The Who and you'd put two and two together. There seemed to be a direct line between what was on at the Tate and what was on at the Marquee. Listen to the first chords of 'I Can't Explain' by The Who. One of the best openings of any pop song

written and it's absolutely clean and concise, just like what
they wore on stage . . . tight and clean, like the look of the
catalogues at the Robert Fraser Gallery.[25]

Marchbank's connections perfectly illustrate Alloway's mass art–
fine art continuum; the pyramid of cultural capital is laid bare and
open to criticism.

The Who's second single, 'Anyway Anyhow Anywhere', released
in May 1965, was promoted with the tag line 'A Pop-Art group with
a Pop-Art sound . . . Pow! Don't walk run to your nearest record
player.' It represented, Lambert added, 'The sounds of war and
chaos and frustration expressed musically without the use of sound
effects.'[26] This marketing ploy associates The Who with both Pop
and social upheaval, and it was the first public move by the band and
its hip management towards dropping their identification with Mod
subculture and realigning themselves as avant-gardists in the field
of pop music. With every release by The Beatles, Stones, Yardbirds
and Kinks, the pop scene in 1965 was being actively remade and
remodelled. The Who were late arrivals to this party, just as they had
also come late to the table of Pop art. Like their immersion in Mod
subculture in 1964, Pop had a role to play in defining The Who as
distinctive in an overcrowded and highly contested field.

Having given a positive review of 'Anyway Anyhow Anywhere'
and its 'weird sound effects' in his 'Pop Scene' column in *Queen*,
Ready Steady Go!'s resident dance instructor, Patrick Kerr, followed
up with a longer piece on the band in the subsequent issue of the
magazine.[27] First came The Beatles, he reported, then came the
Rolling Stones, 'now the colourful world of commercial art influ-
ences the pop world and the first "Op-Art" group comes into being
with the intriguing name of The Who. Everything about The Who
spells the ideas of today's young ad-men.' He lists what each member

wears – Union Jack jacket, target T-shirt – noting the visual impact, but then quickly qualifying this, reporting that,

> Their 'sound' is really something quite different from anything anybody else has done. Pete almost plays two guitars at once: he has one guitar, electric, which he stands in front of his own amplifier and switches on and which immediately creates a continuous 'feedback' noise, and he plays the other guitar which is tuned to produce the maximum echo and howl effect. On stage, they are without doubt the wildest . . . I suppose one might almost liken the overall sound to that of *Musique Concrete*. Kit Lambert, who runs The Who, has promised that as soon as the public become accustomed to their special music, they will change to produce yet another noise.[28]

This is one of the earliest pieces of substantive media coverage of The Who and their Pop art stance, and what stands out is that Lambert is already scripting in change, looking towards the phase after Pop art has played out its purpose, and Kerr more than echoed Lambert's idea of The Who as a conflation of Pop and chaos, that is, namely noise.

During the spring and summer of 1965 the band's mouthpiece, Pete Townshend, re-enforced The Who's identification with Pop and the art of noise to the point of redundancy. One magazine article after another repeated his mantra on the topic to such a degree that they eventually absorbed his pitch wholesale, as in this clip from *Boyfriend*: 'The Who are everything that is 1965 to their wild, pushing audiences. You may think their music phony or gimmicky, but it is no more that way than the action painters who sling their materials violently on to the canvas instead of using neat perfect strokes and a pallet.'[29] Townshend put a theoretical spin on such

observations: 'From valueless objects – a guitar, a microphone, a hackneyed pop tune, we extract a new value,' he said in 1966. 'We take objects with one function and give them another.'[30] This was an idea that went back to the Dadaist Marcel Duchamp, who pioneered 'readymade' artworks when he submitted a urinal to the Society of Independent Artists in 1917, but not one spoken about in the context of pop before. The art historian Thomas Crow has called such a process the 'subcultural transformation of the commodity', characterizing these gestures as improvisational, activist and inventive.[31] The Who fit Crow's schema, but outside of pop they are also hopping a ride on an established trend. At this stage, their Pop art, like their 'Batman', is best defined as belonging within Alloway's expansionist 'Phase 3'. Townshend has little new to say about Pop art, but his rhetorical stance is utterly novel in the context of pop music culture. Lennon and McCartney, Jagger and Richards, and Ray Davis would recognize the moves The Who were making, but none of them presented their music in such an overtly theorized manner.

Never shy about offering explanations for The Who's actions and music, Townshend summarized their take on Pop art as about 're-presenting something the public is familiar with, in a different form . . . Like clothes. Union Jacks are supposed to be flown. We have a jacket made of one. Keith Moon, our drummer, has a jersey with the RAF insignia on it. I have a white jacket covered in medals.'[32] For Townshend, Pop art in this instance is about the presentation of self through appropriating the symbols of authority (flags, insignia, medals). This iconoclasm created a pose that was nonconformist, insolent and disrespectful, just like the single 'My Generation'. He defined that record as 'really pop-art. I wrote it with that intention. Not only is the number pop-art, the lyrics are "young and rebellious". It's anti-middle-age, anti-boss-class and anti-young

marrieds!'[33] This assumes that same rhetorical space as Lambert's conflation of Pop iconography with the iconoclastic intent of the band's noise-making – that is, it reconfigures Pop art within a pop music context, with The Who both using and being opposed to convention.

In the introduction to *Revolt into Style*, George Melly consciously follows the lines set down by Alloway and his Independent Group colleagues and argued for an account of pop culture that is neither obsequious to tradition nor meekly subservient in the face of aristocratic rituals of discrimination. By focusing on the commercial arts, Melly emphasized the 'non-literary' aspects of contemporary culture, which suggested a 'rejection of an educational structure in which social origin is revealed through the manner of verbal communication.'[34] The effect of this stance is to emphasize the importance of class politics as a defining principle in the British version of Pop art. It was the class-based and gendered aspect of popular culture that in 1964 the *New Statesman* columnist Paul Johnson called 'Beatlism' – something that he, like so many others, found distasteful. Johnson considered the vulgar arts to be 'anti-culture' and he despaired at how leaders in government and society were in thrall to the voices of the young. At the age of sixteen, Johnson recalled, he and his friends were reading Shakespeare, writing poems and listening to Beethoven.[35]

As befits The Beatles' standing, Melly gave them a central role in his narrative of revolt from convention; nonetheless, The Who also played a part. Melly proposed that the band had an intellectual coherence that conflicted with their mannered exploitation of Pop art. In his interview with Townshend, the writer posed a question about the band's use of the Pop art tag, asking whether it was anything more than pure exploitation. It was 'a bit of a gimmick,' Townshend admitted, 'but we felt it was necessary to bring

On 'Shit Street' with bon-vivant George Melly in the late 1970s.
Melly poses in regulation silk tie and, somewhat incongruously,
in denim – an homage to Peter Blake?

colour to [our] image, to stop us looking too sinister, too drab and over-intense. Actually though there was something in it, because pop art borrowed from real pop and we're taking it back again.'[36] Townshend positioned himself as both an imposter embracing Pop art for self-serving ends, and as a provocateur turning the world he is presented with back on itself. The Who's voguish adherence to Pop art principles are contained, in Townshend's terms, within an authentic engagement with its doctrines. This authenticity was achieved through a serious application of its tenets, or at least those that best served his purpose, namely his view of youth and its relationship to new cultures of consumption.

Band biographer Gary Herman contrasted the Rolling Stones' take on a culture of abundance, 'Satisfaction', with The Who's 'My Generation'. The former, he argued, is about an individual's unresolved frustration with incompleteness, unalleviated by acts of consumption despite the promises made, whereas the latter 'encapsulates . . . the entire Mod experience – the individual anger and frustration . . . misplaced nonchalance . . . and collective violence'. Unlike 'Satisfaction', The Who's single 'expresses no awareness of the deeper implications of its stance'.[37] Herman may have a point if only the lyrics are taken into account, but the autopoiesis that The Who practised adds levels of complexity to the equation. Singing about one's generation, its anger and frustration, is lent nuance when the band members who frame and deliver those lyrics are dressed in jackets made from national flags and shirts with rows of medals worn without entitlement. Together, song and presentation go further than the Stones' critique of consumer society, confronting the establishment that demands conformity and denies satisfaction.

Writing in 1969, the critic Dave Laing discussed London Mods as the advance guard of a post-war movement that gave youth a sense of self through their prioritization of consumption over production.

He argued that because Mods

no longer believed in the idea of work, but had to submit to the necessity of it, they were not passive consumers as their television and light ale elders were . . . Mods were consumers for whom the object of consumption was to produce active changes in themselves, to produce Mods. In this attempt, however distorted and confused, to live in leisure time whose official function is to provide distraction and relaxation between two working weeks, lay the essence of the Mod's subversive potential.[38]

The Mod hides in plain sight. With the bank holiday riots, that invisibility was lost and replaced with the more mundane desire on the part of youth to produce outrage in others for its own sake – to enact a rebellious stance; to become a social fact.[39]

IF THE WHO'S CONCEPT of Pop art was borrowed, there was nothing second hand in the sonic assault they practised. In the *Melody Maker*, six months before the release of the band's debut album, Townshend expounded on his ideas: 'We play pop-art with standard group equipment. I get jet plane sounds, Morse code signals, howling wind effects.'[40] The aural dissonance and the stuttered articulation of youthful dissatisfaction encapsulated by their first three 45s, 'I Can't Explain', 'Anyway Anyhow Anywhere' and 'My Generation', were the proof that Townshend was not just throwing hollow poses and making empty gestures. Their first album confirmed as much.

Framed top and bottom by the stencil-style block print of the band's name and the album's title, *My Generation*, and hemmed in

on the left side by oil drums, the band look up and into the lens of a camera that is being held high above their heads. Draped over his shoulders John Entwistle wears the now iconic Union Jack jacket; Townshend sports a striped college scarf; Moon has on white Lee denim jeans and jacket with contrasting red T-shirt, which corresponds to 'THE WHO' printed in the same shade of red. Daltrey is dressed in a pale blue Lee jacket matched by the colour of the 'MY GENERATION' type that runs across the bottom of the sleeve. The contrasting and corresponding use of colour stands out against the otherwise monochromatic elements in the image. The viewer's gaze loops from one band member to the next, each separate, yet linked, and equal in stature. Their faces are bleached white by the photographer's lights, the processing of the image or from the coldness of a winter's day. The band are dressed and posed in a casual manner, but they are also Mod sharp, with clean lines, drainpipe tight trousers and black pointed boots. The four oil drums and the grey concrete pavement suggest an industrial, urban environment that The Who appear comfortable within, even as their posture and clothes suggest cool consumption rather than fevered productivity. The labour–leisure continuum is subliminally reinforced by the denim worn by Daltrey and Moon, evoking American workwear even as the pale tone of the fabric denies any remnant of workaday functionality that might remain.

The photographic session took place on the Surrey Docks, southeast London, in November 1965, with Decca Records' in-house photographer David Wedgbury. In March 1965 Wedgbury had also shot the band in front of London landmarks, double-decker buses and vast advertising hoardings. Images from these shoots were used for the album's American release as well as on European EP sleeves.

Given the high-velocity publicity and image making that helped solidify their alignment with Pop art, the cover image of

My Generation is precise and direct, like the black-and-white poster designed for their Tuesday night residency at the Marquee club. The latter image showed Townshend in profile, arm raised, poised to descend on to his guitar, and promised 'Maximum R&B'. The band's iconoclastic *détournement* of the symbols of empire and nation – the flags into jackets and the medal-festooned tops; or Moon's appropriation of Pop art on his T-shirts sporting RAF roundels and exclamations of 'POW', 'Elvis Lives', 'Great Balls of Fire' and 'We're U.N.C.L.E.' – are all absent , with the exception of the Union Jack jacket, from the image chosen for the album's sleeve. Concision appears to be their new motif.

The *My Generation* album was seven months in the making, with sessions held in April and October. During their initial visits to the studio the band recorded the staples of their live set, including three James Brown covers ('Please, Please, Please', 'I Don't Mind' and 'Shout and Shimmy'), two songs first recorded by Martha and the Vandellas – '(Love Is Like a) Heatwave' and 'Motoring' – alongside Eddie Holland's 'Leaving Here', Garnet Mimms's 'Anytime You Want Me', Derek Martin's version of Otis Blackwell's 'Daddy Rollin' Stone' and Bo Diddley's 'I'm A Man'. Original Townshend songs were limited to 'Out in the Street' and 'Anyway Anyhow Anywhere'. Acetates were made that held nine of these recordings, but a proper release was put on hold following negative critical reaction to the paucity of original material. At the October sessions, new compositions included 'The Good's Gone', 'La-La-La Lies', 'My Generation', 'Much Too Much', 'The Kids Are Alright', 'It's Not True', 'A Legal Matter' and 'The Ox'. (Though credited to Townshend, Moon, Entwistle and session pianist Nicky Hopkins, the latter is a none-too-subtle rip-off of The Surfaris' 'Waikiki Run'. Nonetheless, it is a brilliant sonic car crash of a performance.) It was these eight tracks, accompanied by

'I'm A Man', 'Please, Please, Please' and 'I Don't Mind', that made up the released album.

The mix of covers and originals suggest that things were in transition. This is consistent with Townshend's desire for The Who to assume an urgency in leaving behind that which would pin them down and hold them to account. Even as the album was released, he was expressing his displeasure with all that they had just achieved. Giving a track-by-track run through in *Disc* magazine, Townshend expressed his dislike for what it had to offer – his own songs and the cover versions in equal measure.[41] As with the guitars and amplifiers he trashed on stage, Townshend was practising a form of autodestruction. He dismissed and belittled what The Who had achieved, if only to build up expectations of what was to follow.

The songs on the album documented Mod lifestyle ('The Kids Are Alright', 'My Generation', 'Out in the Street'), targeted staid conformity ('A Legal Matter', 'It's Not True') and mused on love turned sour ('The Good's Gone', 'La-La-La Lies' and 'Much Too Much'). The history of the album's germination might suggest that the original compositions represent the now against the yesterday of Bo Diddley and James Brown covers, documenting their movement from Mod purveyors of 'Maximum R&B' to Pop art expressions of love for (and disaffection with) the modern. But *My Generation* also expressed, albeit in an inchoate fashion, the contradictory position that in good part would define The Who over the next ten years. On this album, the band begin their critique of commodity culture, while simultaneously struggling with the paradox of their own commodification as pop stars. It was a struggle that eventually ensured they became active rather than passive agents in the mix of Pop art's third phase.

LIKE OTHERS IN BRITAIN who were invested in pop culture, The Who understood the modern to be American in alignment if not in actual location. From their perspective the United States, with its mass art and abundant products, represented a future that promised a maximized intensity of desire, strong enough to overwhelm the senses. This kind of imagery was prominently displayed in Mario Amaya's *Pop as Art: A Survey of the New Super Realism*. It was published in 1965 and was the first of many books on Pop art aimed at a general readership. The artworks Amaya reproduced are all mired in Alloway's 'Phase 2' where fine art referenced the commercial arts. Repeated images of pin-ups dominate the iconography; semi-clothed, recumbent and open mouthed, the female fantasy figures are aligned with consumer goods, most emphatically phallic objects – cars and soda bottles.[42] While distancing the aesthete from accusations of vulgar contamination, such Pop art also provided a context and a platform in which pleasure without guilt can be taken in consumerism. The Who worked on and within this dynamic but they would not be defined by it.

In publicity photographs shot throughout 1965, The Who positioned themselves alongside advertising billboards that echoed the iconography found in Amaya's book. They posed in front of posters depicting a woman in a white feathered hat, a bureaucrat in a bowler, and a giant eye which had a glass of gin for its iris. As with their version of 'Batman', juxtaposing The Who with such images placed them in the moment and saw them ticking off items from Hamilton's checklist of Pop art characteristics. Elsewhere – in their act, with their singles and the *My Generation* album – the Pop art exercised by the Who was neither static nor mere emulation; on the contrary, it was noisy, brash, angry, anarchic, violent and deeply disaffected with the inherited state of things.

When Lambert declared that The Who's rejection of a fixed and accepted heritage, their 'rootlessness', should be considered as a 'new

form of crime' it was an attempt to articulate the idea of the rock star as the personification of the rebel, the outlaw in our midst. But the band's mutinous stance was the start not the end of the story he and Townshend wanted to tell.[43]

> People come up to me and ask say, 'How could you break a guitar?' And some fool in the Bee Gees said, 'You wouldn't break a Stradivarius, would you?' The answer is 'Of course I wouldn't break a Stradivarius', but a Gibson guitar that came off a production line – Fuck it! I can get a better one.[44]

The Who's lack of respect for mass-produced objects, and their refusal to conform to pre-existing concepts of what constitutes a good performance, or a correctly balanced recording, is being shaped as a rejection of passive consumption, of the proper order of things. When identity can be bought in the high street, inheritance is devalued. Such activity is readily rendered as a revolt into style (as Melly defined it), but it is mostly an impotent action because, as with consumption, it is defined and contained by its own terms. The participant who thinks he or she can escape from one prison, convention, via another, consumption, has gone nowhere at all. By violently turning on the object of desire, Townshend avoided this trap:

> We don't allow our instruments to stop us doing what we want … We smash our instruments, tear our clothes, and wreck everything. The expense doesn't worry us because that would be something which would get between us and our music. If I stood on stage worrying about the price of a guitar then I'm not really playing music. I'm getting involved in material values. So I don't have a love affair with a guitar; I don't polish it after every performance; I *play* the fucking thing.[45]

On 9 September 1966, The Who's appearance at the Pier Pavilion, Felixstowe, was filmed by French television. The recorded songs are compressed into a montage of clips that concludes with a version of 'My Generation' featuring a long feedback coda. The end sequence focuses on Townshend, with brief cutaways to Daltrey and to Moon adding to the maelstrom. The noise is ferocious but given shape by Entwistle's throbbing bass line and Moon pounding on the one floor tom-tom left standing. Townshend places his back against his two amps and speakers, and with arms outstretched he uses his whole body to modulate the feedback. He flays the guitar, slashing out Bo-Diddley-esque runs before turning his back to the audience and spearing one of the cabinets – jabbing the guitar's head through the mesh and into the speakers. Facing front, he machine-guns the camera, he retreats once more into the backline and rams the guitar's body into the stack. The performance is thrilling. The Who produced an immersive, inescapable spectacle and sensation – an attraction that defied any alternative or substitute – which cannot be denied.

The Stooges' guitarist, Ron Asheton, recalled a 1965 visit to England he made with fellow band member Dave Alexander. Setting themselves up in Liverpool, they went regularly to the Cavern Club where they witnessed The Who's only performance at the home of Mersey Beat:

> It was wall to fucking wall of people. We muscled through to about ten feet from the stage, and Townshend started smashing his twelve-string Rickenbacker. It was my first experience of total pandemonium. It was like a dog pile of people, just trying to grab pieces of Townshend's guitar, and people were scrambling to dive up onstage and he's swinging the guitar at their heads. The audience weren't cheering; it was more

like animal noises, howling. The whole room turned really primitive – like a pack of starving animals that hadn't eaten for a week and somebody throws out a piece of meat. I was afraid. For me it wasn't fun, but it was mesmerizing. It was like, 'The plane's burning, the ship's sinking, so let's crush each other.' Never had I seen people driven so nuts – that music could drive people to such dangerous extremes. That's when I realized, *this* is definitely what I wanna do.[46]

The extremes described by Asheton were never an end in themselves. Reports of The Who's 1965 tour of Scandinavia underscore the serious intent of the band to do something other than simply entertain their audience. It became a commonplace in Denmark to describe their music as 'pigtråd': 'like having barbed-wire pulled through your ears'.[47] One critic likened the noise made by the band to a 'massacre' and, out of the turbulence, The Who 'create sounds we've never heard before', using an 'established music language' through which they channel 'their complex ideas into practice with an astonishing artistic straightforwardness that touches people . . . The act, exciting and passionate, is performed without losing control over the performance as a whole.'[48] The writer concluded with the thought that the show could only be bettered if the guitars and the building they were playing in would go up in smoke 'backed by the shout of joy from the audience. Indeed – The Who is anarchy!'[49]

In this view from Denmark, The Who appear to be dancing on the ruins of civilization, enacting an echo of F. T. Marinetti's Futurist summons to 'take up your pickaxes, your axes and hammers and wreck, wreck the venerable cities, pitilessly.'[50] Whatever the modernist reverberations The Who were responding to, they were consciously engaged in parsing elements of avant-garde practice through their live performances.

The glee to be found in destroying objects was something he did not deflect attention away from; Townshend's actions are never simply defined by him as joyful unfocused moments of vandalism. The film director Michelangelo Antonioni, unable to secure the services of the band, featured The Yardbirds in their stead and had them mimic The Who in a club scene in *Blowup* (1967). Jeff Beck destroys his guitar and throws part of it into the crowd. Fighting others in the audience, David Hemmings's character Thomas takes ownership of the guitar neck. In the moment of struggle, the desire for possession is everything, but thereafter the fragment of the instrument is emptied of meaning and value, and is tossed away. In his art and in his rhetorical utterances, Townshend recognized this state of affairs. He knows that desire cannot be satisfied, and so he sought *jouissance* – a transgression of the prohibitions on one's pleasure – in order to go beyond the base juvenile delight in smashing up things that others value.

Explaining why The Who had not appeared in *Blowup*, Antonioni said: 'What the Who do is too meaningful. I wanted something utterly meaningless, so I could use them.'[51] The wreckage and havoc in a performance by The Who was conceptual in its planning and enactment. It was not pointless, it was not simply an empty spectacle that Antonioni could exploit. The Who's aggression was being channelled through the practice of auto-destructive art as theorized by Gustav Metzger, whose ideas were given public shape in his 1959 manifesto and more intimately in the classes he taught at Ealing Art College, which Townshend had attended. Metzger described his art as anti-capitalist, anti-consumerist and anti-art-market.[52] In turn, Townshend's enactment of Metzger's theories was neither superficial – a marketing pose or a throwaway association – nor were they held by him without serious qualification.

When I was at art college Gustav Metzger did a couple of lectures and he was my big hero. He comes to see us occasionally and rubs his hands and says, 'How are you T?' He wanted us to go to his symposium and give lectures and perhaps play and smash all our equipment for lira. I got very deeply involved in auto-destruction but I wasn't too impressed by the practical side of it. When it actually came to being done it was always presented so badly: people would half-wittedly smash something and it would always turn around so the people who were against it would always be more powerful than the people that were doing it. Someone would come up and say, 'Well, WHY did you do it?' and the thing about auto-destruction is that it has no purpose, no reason at all. There is no reason why you allow these things to happen, why you set things off to happen or why you build a building that will fall down.[53]

With his embrace and criticism of theories around auto-destructive art, Townshend had shifted the terrain across which the band roamed. Pop iconography was now the least of their preoccupations. Furthermore, the direction of influence and theoretical borrowings was not simply one way, from art theory to Pete Townshend. In 1965, another of the tutors who had taught Townshend, Roy Ascott, brought a copy of 'My Generation' into his class, which left a lasting impression on one of his students: Brian Eno. David Sheppard, Eno's biographer, writes: 'This was pop music with its art school slip showing, as invigorating as it was emancipating. At a stroke, its three minutes of febrile, distinctly British musical energy convinced Eno that contemporary art and music could legitimately cohabit.'[54]

Alongside Metzger, Ascott was part of the organizing committee for the Destruction in Art Symposium held in London in September 1966 (this is no doubt the event Townshend said

Metzger had invited The Who to participate in). The symposium was widely publicized and Antonioni would surely have been aware of it when he shot The *Blowup* sequence with The Yardbirds the following month and, probably, equally sure he did not want his film to open up the debates being called for by Metzger (and practised by The Who). 'There will be burning of book towers in London this month,' wrote *The Guardian*'s art correspondent, 'there will be evisceration of type-writers and a dissonance of pianos going to their death. There will be floods of molten metal and a day-long event dedicated to throwing the end product away. All this and lectures too.' The sonic side of the event led by the American artist Raphael Ortiz, was dedicated to the destruction of pianos with microphones attached, 'so that everyone can hear what it sounds like. Music after all, is the result of arbitrary decisions on what sounds should string together. Mr Ortiz wants to return to the basic sound, and so he destroys pianos.'[55]

Throughout the 1950s and well into the 1960s, independent of any urbane, art-world sensibility, pianos were being routinely destroyed by the score at village fetes, town fairs and as part of an evening's pub entertainment. These heedless acts were conceived as a contest between teams to see who could most quickly obliterate the instrument so that all its parts could be passed through a small hoop. One bourgeois witness to such an event writes how horrified he was:

> to see two teams of grown men wantonly laying in to two defenceless uprights, to see felted hammers flying everywhere, tangles of springy piano wire, splintered wood and the black and white ivories lying slaughtered on the green grass. Now, years later, I think that it was possibly also a symbolic act, the ritual destruction of repressive Victorian values, embodied in the piano, which deserved to be taken out on to the village

green by right-thinking English yeomen and smashed. Decades
of primness, prudery and piety in the parlour, of hypocrisy and
violence, of empire, wars and colonialism. All this projected
on to the piano, around which families prayed and sang hymns
and parlour songs of fervent faith and patriotism. But the craft
that went into an upright piano! All gone in a twinkling. And a
tinkling. How very sad it was.[56]

The domestic piano had become redundant (and worthless) with
radio, phonographs and television dominating home entertain-
ment. Whatever the symbolism of such wanton acts of destruction,
the smashing of pianos was widely practised as a working-class pas-
time, not a middle-class art project. Elsewhere, in the world of
entertainment, when the need arose to upstage another performer,
Jerry Lee Lewis had shown he also held a similar disregard and lack
of respect for his instrument.[57] Townshend's wilful wrecking of his
guitars and amplifiers was taking place at the interstice between
Metzger's art, class resentment and rock 'n' roll's performance of
stylized violence.

In 1968 Townshend told the BBC's Tony Palmer he had written
a 'thesis for Gustav Metzger' on pop, art and violence, but by then
he hardly needed to make the point that The Who were about more
than being a pop group.[58] On the last day of 1966, the circuit between
Ealing Art College, auto-destructive art, Metzger and Townshend,
between pop and art, was closed when the artist provided a liquid-
crystal light show for the New Year's Eve Psychedelicamania event
at the Roundhouse in north London.[59] The Who, The Move and
The Pink Floyd shared the billing. The Move's set climaxed with
the smashing of TV sets and a car.[60] The Pink Floyd performed their
extensive jams hidden deep in the shadows. The Who suffered from
power failures, distracting strobe lights, and ended their set in a

full-on rage of destruction.[61] Not everyone was impressed by these displays of masculine aggression. Frances Gibson, a Royal College of Art student and guest reviewer of the pop scene for *Queen* magazine felt that, 'Such wasteful energy as The Who and The Move advertise seems very much like small boys' tantrums.'[62]

No doubt in thrall to masculine display, other guitarists paid homage to what Townshend was doing – Eddie Phillips of The Creation used a violin bow to turn the sounds his guitar emitted into something akin to the rumble of a diesel engine; Jimi Hendrix embraced pyrotechnics – but none found the violent seam that Townshend mined with such splendid, juvenile glee and insouciance. When Jeff Beck attacked his amplifier and smashed his guitar in *Blowup* it was in response to the instrument's malfunctioning; when Townshend rammed his guitar into his speaker stack it was done with the aim to create noise. He is not executing an intuitive action, but doing something that is intended to be provocative and that has the power to *attack* the listener: 'Pop music is ultimately a show, a circus. You've got to hit the audience with it. Punch them in the stomach, and kick them on the floor.'[63]

It is within the realm of sound that The Who are at their most radical; not copyists but innovators. The Who's dedication to immediacy, to the moment, to living in the present tense, produced an impatient pursuit of the new in the now. 'This is what art is; this is what our music is all about,' said Townshend in 1968,

> It *involves* people, completely. It does something to their whole way of existence, the way they dance, the way they express themselves sexually, the way they think – everything. But most importantly our music tells you about *now*. Ultimately there's nothing left but the present.[64]

Because he believed in the 'now' of pop music, Townshend showed complete disdain for all that The Who had achieved and for the others on the scene who were less fleet of foot in taking the initiative, less agile in grasping what moved before them. Dismissing the pursuit of quality as a worthwhile goal in and of itself, Townshend told a January 1966 television audience that he was 'more interested in keeping moving. I think quality leads to being static.'[65] His desire to live in the present was propelled by an intensity that gave the appearance of someone who was witness to, and a participant in, an accelerating, exaggerated and unpredictable world:

> My personal motivation on stage is simple. It consists of a hate of every kind of pop music and a hate of everything our group has done. You are getting higher and higher but chopping away at your own legs. I prefer to be in this position. It's very exciting. I don't see any career ahead. That's why I like it – it makes you feel young, feeding on insecurity. If you are insecure you are secure in your insecurity. I still don't know what I'm going to do.[66]

Through the language of negation, The Who amplified their non-conformist aesthetic and pushed it beyond that used by the posturing of their rivals. When Townshend said 'ours is a group with built-in hate,' he was defining The Who against both the pop mainstream *and* their immediate competitors; until the appearance of the Sex Pistols in 1976, The Who alone on the British scene spoke in such terms.[67]

Velvet Underground founder, the Welshman John Cale, recalled the formative effect that The Who's recordings, alongside those by the Kinks and the Small Faces, had on him and Lou Reed: 'They were sniffing around in the same musical grounds that we were . . .

their guitarists were using feedback on records. It made us feel . . . we were not alone.'[68] Cale conceived of the Velvet Underground in remarkably similar terms to those held in 1965 by Townshend: 'We were in it for the exaltation,' Cale wrote, 'and could not be swayed from our course to do it exactly as we wanted . . . We hated everybody and everything . . . We did not consider ourselves to be entertainers and would not relate to our audience the way pop groups like The Monkees were supposed to; we never smiled.'[69] In the lifeless urban landscape on the cover of the *My Generation* album no one in The Who is smiling either.

IN ITS SURLY ARTICULATION of hostility, *My Generation* struck a marked contrast with all the 'cool' images of a processed, fabricated, man-made world that appear in Amaya's book on Pop. There is one exception, however: Peter Blake's portrait of Bo Diddley (1964–5). Rendering the musician with conked hair, bow-tie, familiar tartan jacket and guitar erect, Blake further sexualizes Diddley by painting electric blue lines around his inner thighs. It is the only image of a non-white figure in all of the 51 Pop art works reproduced in Amaya's book (and none of the artists included were black). In contrast to this racial exclusivity, The Who acknowledged pop music's diversity and their debt to black American stars. What was provisional on the 'My Generation' single and the album became a statement of intent with 'Substitute', released in March 1966.

By 1965 innovative pop music that spoke to the moment, as exemplified by Detroit's Motown records, was urban, black and female.[70] This side of the popular arts was not being represented by artists practising Pop art. In an essay that considers the paucity of racial representations in American Pop art through examining a 1966 painting by James Rosenquist, *Big Bo*, art historian Melissa

Mednicov argues that there were 'so few Pop paintings with black subjects in part because, beyond music, white artists did not understand how to represent the black experience of consumer culture in this period.'[71] In a 2011 interview with Jon Savage, Townshend explained how more than one strand of black American music was refracted through The Who:

> The Mods particularly liked Tamla Motown because it was urban. It was city-based, community based . . . you could almost sense that the records were made in a street . . . It was such beautiful, well executed, well processed writing and recording with fabulous artists. It was an extraordinary phenomenon. But we also loved Howlin' Wolf, Buddy Guy . . . But The Who were never a blues band, in a strict sense.[72]

In their adoption of the idioms of black popular music, The Who acted out the play of racial mimicry endemic to British bands of the era. This process of love and theft, however, was done by The Who with a self-consciousness that was absent from the imitations of the Rolling Stones, The Yardbirds or The Animals. That self-awareness is evident in every aspect of The Who's fourth single 'Substitute'.

'Substitute' was Pop art attuned to precisely the present moment. Townshend turned the platitudes, flatteries and shibboleths of commercial culture inside out and showed his unbounded disdain for the prefabricated. Class mobility, sexual attraction, gender absolutes, product fetishism, authenticated emotions, eternal youth, all those things that help sell the promise of personal transformation through consumption, are revealed to be insincere, vacuous and phony, cynical ploys. Daltrey sings about substituting lies for truth; the dissembling of identity, where race, like class and gender, is both social fact and an illusion: the song's protagonist may look white but his dad was

black. The suggestion of miscegenation – racial and cultural – was too provocative in North America and South Africa, and the band removed that lyrical element and replaced it in these markets with a line about trying to go forward while walking backwards. The single was released in the States on Atco, a subsidiary of Atlantic records – the pre-eminent rhythm and blues label of the era. In this context the censoring of 'Substitute' is more than simply suggestive of the racial divisions in life and in music, it is the fact itself.

Townshend pilfered the musical refrain for 'Substitute' from a contemporary British single, 'Where Is My Girl' by Robb Storme and the Whispers. He had reviewed their disc in *Melody Maker* as 'Trying to do a Temptations, but that voice comes out so English . . . great arrangements very much like the new, solid Beach Boys sound', which might as well be a description of the direction The Who were headed in. On the influences that played a more profound role in Townshend's composition, 'The Only Ones' guitarist and Who fan John Perry writes, 'listening to "Substitute" when it came out, one never thought, "Oh, Motown!", but traces of its influence are all over the record – the tambourine, pushed right up front in the mix and the bass line in the verse.'[73] It is there too in the song's title that Townshend gleaned from Smokey Robinson's 'Tracks of My Tears', which he was listening to obsessively at the time. Perry also hears James Jamerson's bass line from The Four Tops' 'I Can't Help Myself' echoed in Entwistle's playing.[74] Without these correspondences with black American music, Townshend's critique of the contemporary would be little more than an act of bluster; his debt to Motown complicates things, not least, by adding race to the Pop art mix.

And it was complicated not just by race, but by class, gender and sexuality too. Michael Bracewell writes that the question 'who am I?', which featured so strongly in English pop, was, through Mod,

both a reaction against adolescent (even teenage) conformity, and a belief that pop could be a spiritual quest through the boredom and hostility of modern English life in search of self-knowledge. This was fundamental to the no-nonsense polemic of The Who, whose earliest period delivered pop punches to the kidneys as well as combining a bisexual mixture of extreme violence and extreme sensitivity – the bad boy so worn out with conformism of the tribe that he turns on his peers as well as his teachers and parents.[75]

The significance of ambiguity in The Who's work and persona which Bracewell celebrates, as does Jon Savage, helps explain the continued validity of The Who's 1960s recordings for these writers.[76] Sexual and gender dissembling is mirrored, magnified even, by The Who's appropriation of black pop culture on which their act was based – the feminine side echoed in their covers of tunes sung by Motown's girl groups, which were coupled with the male strut and machismo of their James Brown imitations.

In an interview in a January 1966 edition of *Disc*, The Who declared that they will 'jump out of '65 like we jumped out of the Mod scene to the Pop art scene . . . We intend dropping Pop art right away . . . We're sick of it.'[77] Townshend was astute enough to know that, like Mod, Pop art was not built to endure. Obsolescence was a given in his concept of the band, and his rhetorical stance presented this at face value, eagerly admitting to the band's novelty – though in his terms novelty was suggestive of not only evanescence but movement. Redundancy and succession are pre-scripted and etched into his declarations: 'I'm important now I'm young, but I won't be when I'm over 21,' as he was paraphrased in an article in the *Melody Maker*, or I hope I die before I get old, as Daltrey expressed it on 'My Generation'.[78] By March 1966 Townshend was done with this

phase of the band, or at least with Pop art as the means to explain things: 'It has no relevance to The Who except we used its ideas, although the way The Who used to talk about Pop art *was* Pop art: "Are you Pop art?" "Yes, we *are* Pop art".'[79]

THE POP ART IDENTITY The Who had fashioned throughout 1965 had gone by early 1966, at least in the publicity they stoked, but its influence was still at work in the run of singles they released over the next two years – 'I'm a Boy', 'Happy Jack', 'Pictures of Lily' and 'I Can See for Miles' – and it is readily present on the two albums they recorded prior to *Tommy* (1969): *A Quick One* and *The Who Sell Out*, released in December 1966 and 1967 respectively. The latter, with its cover a parody of advertising imagery and with its fake radio commercials segued between songs, is assuredly Pop art. The band's earlier exploitation of Pop art's tenets was a public play for attention and as such was a closed circuit, but their stage show was innovative and, in Alloway's terms, expansive. Ditching the rhetorical self-identification with Pop art kept The Who in the now of the moment, leaving a bandwagon of 'Pop art' bands to follow in their wake. The Who were now free, as Frith and Horne observed, to make 'records about mass communication, about the media disruption of common sense distinctions between the real and the false'; and, on their third album, *The Who Sell Out*, 'to both heighten the "realism" of [their] music and draw attention to its spuriousness'.[80]

In its expansionist expression, Pop art does more than reflect and appropriate commodity culture. Discussing Warhol's series of 'Disaster' silkscreens – with subjects including an electric chair, a falling suicide victim, car crashes and race riots – Thomas Crow writes that the works are

a stark, disabused, pessimistic vision of American life, produced from the knowing rearrangement of pulp materials by an artist who did not opt for the easier paths of irony or condescension. There was a threat in this art to create to true 'pop' art in the most positive sense of that term – a pulp-derived, bleakly monochromatic vision that held to a tradition of truth-telling all but buried in American commercial culture.[81]

With a stance that was London-centric and created from 'standard group equipment', rather than from American pulp materials, The Who in the years from 1965 to 1967 – like Warhol in 1963 – pursued an aesthetic that refused any easy turn to irony, blasé rejection of the blandishments of tradition, or empty fetishization of a depthless culture.

The Who dissembled Pop and made our understanding of the 1960's art scene more multifaceted. They returned to a petrified Pop art an element of surprise, creating work that was affectionately spiteful, eloquently confrontational and beautifully scuffed and soiled. The Who's intervention into Pop art put the focus on the process of art making, where high and low cultural forms are in flux; they did not fixate on the end product. Pop music exists in the present, and it is this fact that claims our attention – 'our music tells you about now', said Townshend.[82] Fine art objects only intimate this immediacy; The Who in the years 1965–7 produced their art in the moment of its performance. They were Pop art.

3 THE REAL POP ART
NITTY GRITTY AT LAST, IN FACT;
OR, WELL-PAID MURDER

Being a modern pop star is a sort of way of being intellectual
without being intellectual. Intelligence is useful but you can
easily get snowed under by the lava of publicity, and hysteria,
and screaming women. It's so easy, too, I've fulfilled my wildest
dreams already, and I'm sure I'm going to fulfil my even wilder
dreams in future, but it's a bit of a hollow triumph. I make a lot
of money, but I'm not all that happy, and I don't read anything
like as much as I would really like to. In fact, a pop singer's life
is murder, but it's well-paid murder.

PETE TOWNSHEND in conversation
with Jonathan Aitken, *c.* 1967

Reviewing Jan and Dean's 'I Found a Girl' for *Melody Maker* in
November 1965, Townshend called the surf duo 'more pop-art'
than The Who.[1] Taking a similar line of argument to Townshend,
Nik Cohn in his column in *Queen* magazine thought that The
Shangri-Las were 'the only genuine pop art group there has yet
been'.[2] The Shangri-Las were a 'musical blow-up of the True Love
& Romance teenage magazines', Cohn argued; they were 'young
and sweet and clean, as fresh and phoney as toothpaste. Pop is only
fantasy food, after all, and "Leader of the Pack" is where it all begins

and ends.'[3] Cohn liked them because they were an affront to solemn critics who 'get offended if anything frivolous comes along.'[4] They were an easy object of hate, he wrote, and for that reason alone he claimed them as his 'favourite girl group ever'. Jan and Dean and The Shangri-Las are championed by Townshend and Cohn as Pop art because they are unencumbered examples of commercial pop, unadorned by sophisticated ideas of their own importance. Others were not so guileless.

In his 'Pop Scene' column in *Queen*, Patrick Kerr discussed the number of pop stars with the name 'Jones' who were crowding out the contemporary scene: Tom Jones, Paul Jones, Ronnie Jones, Jack Jones, Brian Jones and the latest of the Joneses, Davie Jones, who should not be confused, he wrote, with 'Davey Jones', or indeed 'Davy Jones' – singers all. The Jones whom Kerr was interested in differentiating from the mass was backed by The Lower Third and had a new Shel Talmy record to promote, 'You've Got a Habit of Leaving': 'Davie is a very strange boy who spends most of his spare time alone writing songs . . . He says he is most influenced by Ray Davies of The Kinks, but he also digs The Who very much.'[5] Roughly two weeks after the publication of this story, Davie Jones had become David Bowie.

The Who and Bowie only played one gig together, at the Bournemouth Pavilion on 20 August 1965. After listening to The Lower Third's soundcheck, so the story goes, Townshend told the band that their stuff sounded like his.[6] He had not meant it as a compliment. 'You've Got a Habit of Leaving' was released in August, midway between 'Anyway Anyhow Anywhere' (May) and 'My Generation' (October). Bowie's recording is to the former what 'I Can't Explain' was to The Kinks' 'You Really Got Me'; a rather shameless piece of mimicry. This was Talmy's version of template pop, repetition with a colour coating of difference. Mimicking the

ennui of Ray Davies on 'Tired of Waiting for You', Bowie also cloned Daltrey on the scats across the guitar break, which is a virtual rerun of Townshend's solo from 'Anyway Anyhow Anywhere'.

When The Who unilaterally broke their contract with Talmy and released 'Substitute' backed with 'Circles' on Reaction, their agent Robert Stigwood's new label, Talmy countered by releasing a track off the *My Generation* album as a single, 'A Legal Matter', which had the same song as 'Substitute', retitled as 'Instant Party', on its flip. The Who then changed their B-side's title to 'Instant Party' before a legal injunction had them switch it to an instrumental track, the Graham Bond Organisation's 'Waltz for a Pig'. The bizarre exchange between the two warring parties was further complicated when, in that same month, the Immediate label released The Fleur de Lys's cover version of Townshend's 'Circles', marketed with the promise it would supply 'An instant smash for your party!'

Originally, Talmy and The Who had scheduled 'Circles' backed with 'Instant Party Mixture' as the follow-up to 'My Generation', but the band's desertion to Reaction put paid to that release; that, or Talmy got cold feet with regard to the B-side's prankish celebration of the joys of 'new cigarettes'. The Who nicked the tune from Dion's 'Runaround Sue' and appropriated the title 'Instant Party' from an Everly Brothers album of 1962, which, despite promising a fun-filled diversion by offering tips on how to throw an instant party on its sleeve's reverse, is a glum affair.

'Circles' is a song about obsession and the impossibility of leaving a relationship. The Fleur de Lys's version drives the tune home behind a volley of electric guitar, evoking but hardly matching Townshend; it runs, it does not walk to the exit. Featuring Entwistle's French horn, which throws everything into the red, Talmy's version is a swirling, vertiginous set of twists and turns. A little after two minutes a guitar crescendo is filtered into the mix,

but it is not the incendiary eruption of old. It is a more controlled affair, an anti-climax that aptly captures in its sonic eddies the psychodrama of the song's protagonist. The Reaction release sounds conservative by comparison.

In late 1965, Talmy had cut Townshend's 'It's Not True' with The Untamed for release on his Planet label; meanwhile his engineer, Glyn Johns, who had worked on The Fleur de Lys's recording of 'Circles' for Andrew Oldham's label, produced A Wild Uncertainty's cover of The Everly Brothers' 'Man With Money'.[7] This slavishly followed The Who's own version, which had become something of a live favourite during this period, along with other covers of the Everlys' recent repertoire culled from the 1965 albums *Beat 'n Soul* and *Rock 'n Soul* – 'Love Hurts', 'Love Is Strange' and their arrangement of 'Dancing in the Street'. The Who recorded 'Man With Money' for the BBC in March 1966 and again in August for possible inclusion on *A Quick One*. A Wild Uncertainty had their disc released in October 1966; it rose no further than the outer regions of the charts, but nonetheless outperformed the version from The Eyes, which had seen no chart action whatsoever when it was released four months earlier.

The Everlys' song begins as a formulaic Tin Pan Alley story of a poor boy and his unrequited love for a girl who wants what only a rich man can give her. It then takes a turn for the weird and plays out as a sexual revenge fantasy. At night, while the girl and her wealthy lover are sleeping, the boy will cover his face, break the lock, open the door, slip inside and rob the store. Then *he'll* be the man with lots of money, and *he'll* buy her things and she'll call *him* honey. Whether or not the song's slip from cute to creepy appealed to Townshend, it undoubtedly chimed with his emerging penchant for character studies and storytelling following 'Substitute'.

The first two singles released by The Eyes, 'When the Night Falls' (backed with 'I'm Rowed Out') and 'The Immediate Pleasure'

(backed with 'My Degeneration') also failed to pull money out of many pockets. A pity, because they are terrific discs in their own right and splendid homages to The Who. (If The Eyes were responsible for the cover of 'It's All Over Now' that played over The Who in *Carousella* then there is some small irony in the idea of these slavish followers of Townshend and Co. acting as their substitutes.) Unlike The Who's peers, such as The Small Faces, The Birds and The Action, who drew upon the same pool of American soul and R&B releases, and had been similarly spurred on by the success of The Beatles and the Stones, bands like Davie Jones and the Lower Third, The Untamed, A Wild Uncertainty, The Eyes and John's Children all had The Who as their model and correspondingly stuttered on their way from Mod to Pop art. The Eyes promoted their debut with the gimmick that it featured 'E.S.P.', 'Expressive Sounds Production, an extension of pop-art, but with meaning. E.S.P. portrays the natural sounds of a city at night, a guitar representing a clock and a gong striking out three o'clock in the morning.'[8]

'Smashed Blocked!' was the American title of John's Children's debut single released in October 1966, a marvellous celebration of being pilled up on amphetamines. The flipside of the follow-up single was 'But She's Mine', a thin take on 'I Can't Explain'. In the spring of 1967, the band was joined on guitar and backing vocals by one-time Mod Marc Bolan and were subsequently booked as support to The Who on a tour of Germany. Dressed all in white, they built their eight-song set to a climax that attempted to out-do The Who in acts of self-destruction. One appalled observer wrote to the *Melody Maker*: 'the lead guitarist kicked his equipment, beat the stage with a silver chain, and sat in a trance between his speakers producing deafening sounds on his guitar. It was sickening.'[9] Meanwhile, singer Andy Ellison leapt into the audience, letting loose a storm of feathers.

Whatever the band's merits, John's Children were first and foremost the creation of their manager, Simon Napier-Bell, who described them as 'The Who plus blues!'[10] Discussing the group with Nik Cohn, Napier-Bell said:

> They are very intelligent, which is the main thing, because it is very boring to deal with people less perceptive than yourself, and they look good, which is also nice, because I hate ugly people. All the very big groups project in some way the personality of the manager, and I feel that I could project myself through John's Children. Therefore, they will emerge as cold and calculating, which they are basically anyhow, so all I'm doing is to bring this coldness out. I think they can be very big.

After Napier-Bell had made his point, Cohn concluded:

> All of this is no doubt monstrously inhuman, but that's almost beside the point, because pop is strictly a monstrous business and always has been. The real point is that Napier-Bell's open ruthlessness has to be better than the sliminess of the old-style managers. I would rather that pop was high-powered and inhuman than squalid and two-faced as it is now and, for this reason, I think Napier-Bell is going to be very important indeed in the development of British pop.[11]

Forcing the cynical, selfish motivation of the pop dynamic to the front of his marketing of John's Children put Napier-Bell in the same philosophical space as Lambert, who had Townshend as his agent provocateur. Cohn simply revelled in it all.

Tony Secunda managed his protégés, The Move, with a cynicism equal to Napier-Bell, and he also looked to The Who for inspiration.

Like John's Children, The Move aped the more spectacular parts of The Who's stage act. Rob Chapman writes, 'they stomped their way through an art-prole variant on Pete Townshend's auto-destruction show that was not so much Metzger-inspired, more a gleeful smashing of stuff without a hint of intellectual pretension.'[12] Watching them at the Marquee, Nik Cohn was unconvinced by their 'fashionable preoccupation with sounds, tinkering about with various mock-Indian, mock-Chinese and mock-electronic effects. I'm not much impressed by the pseudo-intellectual attitude they adopt towards these gambits, but they do come out quite entertainingly on stage.'[13] The Action's singer Reg King thought Secunda had also instructed The Move to mimic his band. Ian Hebditch describes the Birmingham band as 'reassuringly nondescript' in their early days (with the exception of bassist 'Ace' Kefford 'who looked as if he'd been fed amphetamines intravenously since birth'), but Secunda changed that by having them wear 1930s gangster costumes – an act of 'appalling taste'.[14]

In the early 1980s, graphic designer and archivist Phil Smee called the music practised by Who acolytes 'freakbeat', which like another name invented by record collectors – doo-wop – perfectly evokes the aesthetic it is intended to describe. The Creation are the band that best exemplifies Smee's term. Produced by Shel Talmy, they were his most emphatic and long-nurtured attempt to find a replacement for The Who. The press release for their second single, 'Painter Man' (backed with 'Biff Bang Pow', October 1966) reported that 'Electronic music, feedback, imaginative identification with colours and art and unique sounds is our art-form. We feel we are contributing to the new "total sound culture". This culture will take its place in the world just as the Renaissance and Picasso's Blue Period has.' No doubt scripted by their manager Tony Stratton-Smith, who went on to build a leading progressive rock label, Charisma, it is a woefully

pretentious statement with none of the imagination, creativity and arrogance found in the pronouncements Townshend was liable to make. It was also made eighteen months after Lambert had declared 'Anyway Anyhow Anywhere' to be the first Pop-art disc; and a year and a half is several lifetimes in the fickle world of pop fashion.

The Creation's 'Biff Bang Pow' was pure Talmy-period Who, essentially a rewrite of 'My Generation' and another exploitative bit of *Batman*-related merchandise. The Creation's guitarist, Eddie Phillips, could easily pass muster as a stylist in his own right, but the solo on 'Biff Bang Pow' is Townshend through and through. On other recordings, Phillips's use of a much lower register, enhanced by bowing the guitar (later filched wholesale by Jimmy Page in his time with The Yardbirds and Led Zeppelin), took the band in an original direction. Talmy boosted the bottom end of Creation recordings, not least on 'How Does It Feel to Feel', by giving the drum sound extraordinary depth and a resonance that made discs by their contemporaries, including The Who, sound thin.[15]

At their best, as on 'How Does It Feel to Feel', 'Nightmares' or 'Through My Eyes', The Creation are peerless, but in their marketing slogans ('Our music is red with purple flashes'), stage gear (matching purple shirts with epaulettes, black hipster pants with white belts) or the part of the stage show where they knock out some kind of action painting during an extended instrumental break, they were hardly likely to impress as anything more than second-rate attempts to launch themselves on a Mod/Pop art bandwagon that was already overcrowded.[16] Nik Cohn thought 'Painter Man' a minor classic and rated highly their third single, 'If I Stay Too Long': 'it has a nice deep sound and a certain sense of style. I like it very much.'[17]

The Creation's sophomore single was released between 'I'm a Boy' and 'Happy Jack' and around the same time as The Who's *Ready Steady Who!* EP in November 1966. The Who's disc featured

'Batman' and two surfing covers – Jan and Dean's 'Bucket "T"' and 'Barbara Ann', originally a 1961 hit for The Regents that had recently been revived by The Beach Boys for their *Party!* album (a more fun affair than The Everly Brothers' effort and, with its between-tracks faux sound effects of merrymaking it was, perhaps, more of an inspiration for 'Instant Party Mixture'). *Ready Steady Who!* also included the shimmering Townshend original 'Disguises', alongside another outing for 'Circles'. The concept was the nascent sound of psychedelia on side one and a short set of now out-of-date Pop art throwaways on the flip side.

'Disguises' is a tale of a girl a boy once thought he knew, but whom he can no longer find in a crowd. The use of phasing in the recording's mix underscores the themes of allusiveness and dissembling; of acting out one's identity. 'Join My Gang', a song Townshend gave away to fellow Reaction label mate Oscar, similarly plays with unstable identities through the all-male gang unsettled by an invitation from a boy to a girl to shake his world, to join him and his mates, even though she's a girl – a gender revolt to match the gender bewilderment of 'I'm a Boy'. With such songs Townshend moved The Who onto new ground and left behind his imitators, at least those reluctant to leave behind the security of the all-boys club.

The Who's vaunted reputation is apparent in the early critical reception of The Pink Floyd, who were seen to be mining a similar sonic and thematic landscape.[18] At the beginning of 1967, Cohn reviewed the Floyd's show at the Marquee with mixed feelings. Despite considering them the most committed psychedelic group on the scene – the lights and projections making a 'reasonable logical connection with the music', with an overall effect 'like an endless series of action paintings' – he found the actual music to be little more than 'a lot of thumping and crashing and guitar-screeching, all of which was presumably meant to signify intensity and musical

explosion', but which, ultimately, all went on too long and 'adopted the same relentless mood'.[19] For Cohn, 'Pop is first and last a business and all the best groups have accepted this and have made their work commercial. The Pink Floyd at this stage are too cerebral by half. I would like to see them produce a better balanced, more varied act and I would like to see them project a bit more sex.'[20] Which amounted to saying they are good but they are not The Who. Some of the challenges Cohn set for the band were met with their first single, though not the sex bit. He liked 'Arnold Layne', because it took chances.[21] The Pink Floyd avoided the pitfall made by most 'self-styled *avant-garde* groups' who became 'cringingly commercial as soon as they get in the studio'; Syd and his confederates had 'kept all their guts and imagination'. Despite his avowed preference for The Beach Boys and The Shangri-Las, pop unfettered by any kind of sophisticated enquiry into the teen dream, Cohn also rather liked groups whose intellectual vanities he perceived as having been fed through a pop sensibility, such as The Pink Floyd and The Who.[22]

In an interview with *Rave* magazine from February 1966, The Who discussed the problem of staying ahead of fads and meeting the challenge of a changing audience:

> Everything we do is in the context of pop music, even the LP we made. We're getting pop audiences and we're just not the same. Now I think we're up against it. You see, you've got to admit it. Sooner or later, you know you can't go any farther. You've got to admit you can't communicate to other people something you're not sure of yourself.[23]

In the following month's issue The Who expounded on living for kicks and their antipathy to working. 'What would they advise people to do, if they couldn't find artistic work?' asked *Rave*'s Dawn

James. 'Do nothing,' Roger said. 'Just loaf about.' 'Yes, you should roam about, looking . . .' added Pete the *flâneur*.[24]

In 1966 The Who moved in attitude and style away from a reciprocal and equal relationship with their audience. The band were no longer being given leave to play by West London Mods; Townshend had stopped returning his audience's gaze, The Who had become entertainers. They were pop stars, a status confirmed by their being named in magazines as part of the nouveau-elite, always seen in the latest night spots. In *Queen*, Patrick Kerr listed Townshend – alongside Brian Jones, Eric Burdon, Denny Laine and George Harrison – as one of those holding court at The Scotch of St James.[25] In a subsequent column, Kerr noted that Keith Moon had been jamming with members of The Animals and The Kinks behind P. J. Proby at The Scotch.[26] The Who were now performing the role of pop stars. From being members of the Mod meritocracy, the group shifted and claimed a place among London's glitterati, even if they had not yet earned a place at the top table with The Beatles and the Stones. Kerr's listing and ranking of pop stars took place in a magazine that still had the function of recording the activities of the rich and entitled, a social register for debutantes that testified both to the continuation of the class system and, through the 'Pop Scene' column, its vulnerability from those moving up from below.

In *Queen*, the writer and son of a peer of the realm Anthony Haden-Guest characterized The Scotch of St James as the kind of club 'where the chart-watching minor groups were wont to clock in almost compulsorily, and glower at other Popsters in that ambience'.[27] Haden-Guest was documenting the latest fad in discotheques, of which the soon-to-be-opened Sibylla's in Mayfair was to be among the hippest. With financial input from George Harrison, the club had pulled together an impressive guest list of swinging London's celebrities for the opening night; The Who did not make the grade.

Across the Atlantic, New York's Cheetah club was causing an equal fuss with the cultural commentators; both *Time* and *Life* magazines covered the season's big event and both highlighted the presence of Andy Warhol and his entourage.[28] Haden-Guest also gave Warhol, Nico and The Velvet Underground a role in his story, noting the imminent London arrival of the 'Erupting Plastic Inevitable'.[29] Needless to say, the Exploding Plastic Inevitable never travelled to Britain, but the possibility of a visit did allow him to muse (in a somewhat off-hand manner) on the idea that the discotheque was a new art-form, indeed 'the *only* new art-form'. Haden-Guest invited the reader to

> examine the mutated forest of the new forms – action-painting, poetry and jazz, Pop concerts, improvised movies, *cine-verite*, the 'smellies', three-D, Pop painting, with Robert Rauschenberg studding his canvasses with radio-sets, and 'Happenings' lumbering on their dreary Dadaist way.[30]

All these diverse practices, he argued, were seizing on Marshall McLuhan's concept of contemporary media which 'announced that *the medium is the message*.' 'And the discotheque', wrote Haden-Guest, is really It:

> 'Instant total awareness', a non-stop, utterly spontaneous Happening, coming at you through every sense at once – heat, light, taste, sound, smell, and touch, plus that super-sense, the heightened awareness – chic-to-chic glamour! And you, the spectator, are the focal point. The discotheque exists only through you, a glutinous environment, enfolding artists, spectators, and even the financial backers in one embracing experience.

The discotheque may never express the sublimity of epic poetry, he wrote, nor even, so as to make sure his reader was in on the joke, epic television, but 'it can also avoid those depths.'[31] In two short years, the West End discotheque had evolved from the unlicensed Scene club in Ham Yard (with Guy Stevens spinning the discs and giving lectures on their provenance while amphetamine-assisted Mods danced through the night) and the lunchtime dances at The Lyceum and at Tiles in Oxford Street, to become an art-form – albeit one that, as Haden-Guest put it, had all the cultural authority of a surrealist-hairdresser.[32]

For The Who, the issue was how to maintain the line into the authentic that had fed and nurtured them thus far, while still having their collective ego flattered by the insincere embrace of socialites. In the BBC television programme *A Whole Scene Going*, Townshend provided a summary of their new reality as pop stars. He was no longer in the thrall of his audience, as was evident in the way in which he turned his ire on the contract between the band and their followers. He bemoaned the kids who turned up at Who shows with pre-scripted expectations – the boys to see him smash his guitars, the girls to study their Pop art show togs. 'A large part of the audience is thick,' he said. They don't appreciate quality: 'You do something big and a thousand geezers go "Arh!" It's just basic Shepherd's Bush enjoyment.' The audience and the band deserved and served each other well, he cynically suggested.[33] The position the band found themselves within would be negotiated, Townshend suggested, by continuing to ride the contradictions of their new reality: we are pop stars, he was saying, and pop stars are fatuous frauds. *Rave* magazine regularly asked Pete Townshend to give advice on dating, living together, drugs and the band's preferred holiday destinations: he chose Torremolinos; Moon was going to Cannes.[34] The Who could play the game of stardom as easily as not.

FOR RICHARD WILLIAMS, IF The Who had only released their first three singles and then packed it all in by Christmas 1965, 'they'd have been regarded for all time as the greatest rock group ever, no contest'.[35] He was looking for 'a kind of rock and roll that took the freedom, energy, technique and authenticity' of free jazz trailblazers, but that came dressed in a 'leather jacket and Cuban-heel boots and teenage attitude'.[36] The Who's discs that followed 'I Can't Explain', 'Anyway Anyhow Anywhere' and 'My Generation', Williams argued, took them away from extemporization and back into the land of song:

> I was hoping for something more. I wanted music with the revolutionary spirit of Ayler's *Bells*, the blues cry of Elmore James's 'Dust My Broom' and the rumbling punch of Bo Diddley's 'Mama Keep Your Big Mouth Shut', something that blended the sophisticated beauty of Coltrane's *A Love Supreme* and Coleman's *Free Jazz* with the ecstatic funk of James Brown's 'Out of Sight' or the soulful warmth of Solomon Burke's 'Everybody Needs Somebody to Love', performed by someone who looked like he did his shopping on the King's Road.[37]

That person was Jimi Hendrix. He had arrived in London in September 1966 and released his first single in the third week of December, two weeks after 'Happy Jack' hit the shops and in the same month as *A Quick One* was released. Competition between The Who and The Jimi Hendrix Experience would in some ways define their respective activities through much of 1967, exemplified in their shared billing at the Monterey pop festival in June. But as Hendrix pushed the boundaries of the blues in directions unexplored by The Who, essentially towards a black sensibility embodied in funk, soul and jazz, Townshend and company moved deeper into the pop arts.

In March 1966, having succeeded Patrick Kerr as the author of the 'Pop Scene' column in *Queen*, Nik Cohn worried about the loss of P. J. Proby from British pop culture as the star had to return to the United States for six months due to visa restrictions. The Beatles, the Stones and The Who had all benefited from Proby's example, Cohn wrote, and his 'capacity for bonanza showmanship has showed up native pop for the dowdy business it is.'[38] Over the following editions of *Queen*, Cohn worked out what he understood to be the good and the bad in pop music. 'Bad' for him was the quotidian and the everyday; interviewing The Small Faces, who had just delivered three back-to-back hits, he was disappointed to discover their 'total ordinariness':

> Pop, to me, means glamour and extravagance, a certain magnificence. Almost all the major pop figures I have met had something, if only their ability to be nasty, to distinguish them from the general league. The Faces have nothing of this and I am very much afraid that they are a signpost to the whole future of pop. Everything is becoming more life size, less interesting; the day of the showman may have been and gone.[39]

Nostalgia for a lost pop paradise clearly marked his response, especially the pleasure evoked by listening to Chuck Berry, The Shangri-Las, but mostly to The Beach Boys. He is able to suspend disbelief in any of their fantasy worlds, but even if he lost faith it would not matter because their vision would still be attractive: 'It is a tightly limited world, very compact, very safe, and there are people who think it's a vision of hell, but I'm not one of them.'[40] In the publicist, and sometimes sidekick of Andrew Loog Oldham, Andy Wickham, Cohn finds his surrogate: a man he defined as five and a half feet of solid hate. Wickham disliked mediocrity and phoniness, but most of all he hated England:

He would sit alone in his room at four in the morning with all the lights off and listen to West Coast surfing records, and he would long for the promised land of Mustangs and sidewalks, surfboards and endless sun. He nicknamed himself 'Wipeout', which is when a surfer falls off his board. I've never known anyone who longed so much for things to be different.[41]

Remarkably for a pop columnist, Cohn was as likely to turn against the latest sensation as to join the chorus of approval, such as he did with the Mothers of Invention. They depressed him, because he wanted pop to be 'genuinely progressive and alive, and I hate a supposedly new sound to come out as tired and old-hat as the Mothers.'[42] Perhaps he was allowed a critical honesty because *Queen* did not carry advertising from record companies, or its editors had yet to figure out whether its readers were much attracted to the topic. Outside of female fashion, there is little to suggest they were interested in actively catering for pop taste. Regardless, even when singing a record or band's praises, Cohn did not do so without also pointing out any perceived shortcomings. When he stopped writing 'Pop Scene' *Queen* renamed it 'Sound' and employed Benny Green, who covered jazz and easy listening, only occasionally turning to rock, when he showed just how unique Cohn's view had been. Green liked John Mayall's *Bare Wires* because he used 'real musicians'. With an elitist's sneer, he wrote: 'It is perfectly true that authentic jazz musicians sometimes find themselves involved in pop performances, but those who take this as a sign of merger ought to hear what the musicians in question say about the work in private.'[43] This was not something you feel Cohn would have been concerned about; his idea of good music was based on flash and outrage not authenticity.

When Cohn gave The Who's *A Quick One* album some solid praise, he noted that they could be 'wildly erratic, brilliant one night

and dull the next.'[44] What pleased him most about the album was that they had 'thrown off the pomposity and Disneyland intellectuality that has always been so tedious in the past. They are so much more than the conventional rebellion group that *My Generation* and that tired old auto-destruction routine made them out to be'; instead of 'surface exhibitionism there is oddness and withdrawal and originality.'[45] Entwistle's two songs, 'Whiskey Man' and 'Boris the Spider', came in for particularly high praise, and are, he wrote, unlike any pop songs he has ever heard before. Townshend's 'mini-opera, involving a girl, her absent boy and a snake-in-the-grass comforter called Ivor the Engine Driver' he found a little tedious, but funny nonetheless, and a 'nicely unpretentious idea.'[46] 'A Quick One While He's Away' sums up the group's achievement, which is that they have created something that is 'glossy and brittle and off-hand and melancholy at the same time.'[47] Like the post-punk commentary of critics Michael Bracewell and Jon Savage, Cohn finds a masquerade of contradiction and ambivalence to be at the heart of The Who's appeal: oddness and withdrawal, an unpretentious mini-opera – a pop song with arias, no less – the songs and their presentation at once shiny, disposable, humorous and mournful.

A Quick One's title was a ribald jest and a Pop art reference to its own ephemerality and disposability. The album followed The Beatles' *Revolver*, released that summer of 1966, by dropping the standard group portrait for the front of the sleeve; but the comparison between the two albums ends here. Klaus Voorman's monochrome mixed-media work of photomontage and Beardsley-esque drawing for *Revolver* contrasts sharply with Alan Aldridge's colour caricature of The Who, complete with song titles hyperactively snaking out from each musician and escaping the image's frame. Townshend and Entwistle's guitars similarly puncture the picture's border, exaggerated and erect and further heightening the

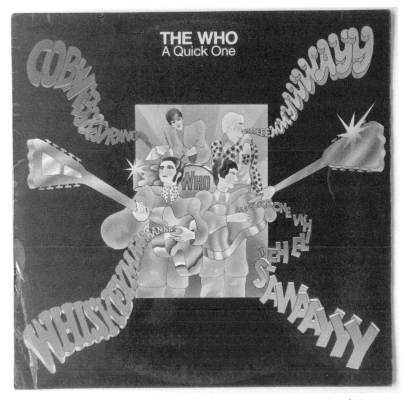

Dispensing with the usual group photograph for the LP *A Quick One* (1966), the illustrator Alan Aldridge rendered the band as cartoon pop figures and, for compositional balance, Entwistle as left-handed.

double-entendre of the album's title. Against a radiating sunburst backdrop, Aldridge's figures are all billowy curves within inked outlines, skinny angular bodies inside oversized clothing. The illustration celebrates its own airbrushed two-dimensionality: The Who as cartoon characters. On the sleeve's reverse, the four disembodied faces of the band float in a sea of black with 'The Who' projected across them – Entwistle tight-lipped, Daltrey smiling, Moon dumbstruck and Townshend open-mouthed as if speaking. There is nothing po-faced, pretentious or obscure about this sleeve. It is glossy, colourful, superficial, humorous, self-deprecating,

commercial and fun. It is Pop! Aldridge's illustrations anticipated
the caricatures used two years later in *Yellow Submarine* (1968), the
animated Beatles feature film. A television series featuring a cartoon
version of The Who was long discussed, but never came to anything.

The Who's choice of Aldridge was inspired. Born in 1938, he had
begun to make a name for himself during the first half of the 1960s
with his cover designs for *New Society* magazine (including the issue
that reported on the Mods and Rockers), his illustrations for the
Sunday Times Magazine and his trend-setting work on paperback
covers.[48] Aldridge's illustrations and designs for a series of Penguin
crime novels in 1964 drew upon the same Pop art iconography The
Who were also poaching and re-animating: a running man with a
pistol has a target for a body and a series of arrows where his head
should be (Michael Innes, *Operation Pax*); in a hotel corridor, ren-
dered in abstracted geometric lines, two lovers embrace – they are a
mix of Fernand Léger's tube-like limbs and Peter Blake-style portrai-
ture, a composite overlaid with a target and a True Romance heart
(James Byrom, *Or Be He Dead*); cluttered around a corpse are various
objects, clues perhaps, and on the sole of his shoe a Coca-Cola logo,
a red dot radiating out of its monotone setting (George Bellairs,
Corpse at the Carnival).[49] Aldridge's work sits within Alloway's
'Phase 3' of Pop art, the expansive phase in which the commercial
and the fine arts fuse together, sometimes with the functional results
of a Woolmark advertisement and sometimes, as with the series of
Penguin covers, with a spirited creativity. Subsequently, Aldridge
worked closely with The Beatles, most notably on an illustrated
songbook. Paradoxically, since they had publicly eschewed Pop art
as hackneyed, The Who had now gone further and deeper into this
'Phase 3' fusion of high and low. The sleeve illustration for *A Quick
One* provided the contextual frame for the recording; a pop perfect
setting. In a 1968 interview Aldridge commented that

Covers shift books. Same with pop record sleeves. They've changed so much in the past year. We did this sleeve for The Who and at the same time there was the sleeve for The Beatles' record, *Revolver*, but before that, can you remember one single record sleeve that you would want to own? I think people do want objects to be beautiful in themselves, possessable.[50]

In fairness, The Kinks had also dispensed with the group shot in late 1966 with *Face to Face*, but that unattributed illustration, with butterflies taking flight from a Carnabetian's head, was unloved by the band and looks landlocked in its time and place; and 1967 would see an explosion in imaginative sleeve design, notably Martin Sharp's work on Cream's *Disraeli Gears* and David King and Roger Law's art for Jimi Hendrix's *Axis: Bold as Love*.

In a united show of industry conservatism, European and Antipodean releases of *A Quick One* rejected all that was new and vital about the album, producing the standard pop group cash-in to exploit and milk the band's success in the singles charts. Polydor dropped the title, calling it simply 'The Who', replaced 'So Sad About Us' and the mini-opera with 'I'm a Boy' and its B-side 'In the City', and shuffled in a further re-run of 'Circles' and second outing for 'Disguises'. This mishmash of tracks was housed within a cover sporting a monochrome portrait of The Who that had earlier been used as a picture sleeve for the German and Swedish issues of 'I'm a Boy'. Townshend, dressed in a white roll-neck pullover, looked particularly morose, as if he were refusing to participate in the marketing of his own band. The reverse of the album sleeve used photographs of The Who in target shirts and Union Jack jackets from 1965, accompanied by a band biography from *Melody Maker* scribe Nick Jones. Only the Italian sleeve differed from this basic design. It sported a Ralph Steadman illustration

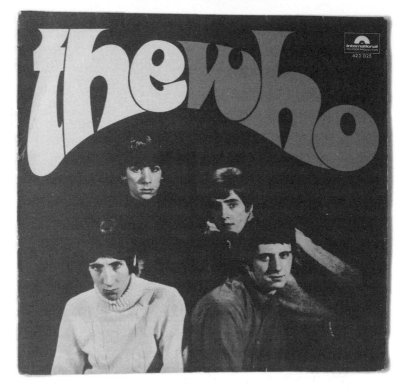

The German edition of *A Quick One*. Townshend was unamused.

of the band on the front, an image which had also been used in adverts for 'Happy Jack' in Britain and as the picture sleeve for the single in the USA and Europe. Unlike Aldridge's soft, colourful and vibrant portrait, Steadman's frenetic ink work puts each band member's head on a snake's body. Moon is shown doe-eyed, Entwistle's orbs are rolling back into his head, Townshend looks askance and Daltrey appears to be possessed by demons with his rictus smile and half-lidded eyes or maybe just stoned.[51] In combination, the Aldridge and Steadman caricatures capture the light and dark side of the band as endearing Pop art avatars and malign pop star puppets.

In order to make good on a publishing deal, each band member was expected to deliver two original compositions. The result was that the album had to carry what would otherwise, at best, have been B-side fodder from Daltrey, Moon and Entwistle. Daltrey's 'See My Way' and Moon's 'I Need You' are pleasant enough diversions, and Entwistle's 'Boris the Spider' makes a well-matched pair with 'Whiskey Man' – a suitably macabre melodrama about alcoholism and insanity. The gothic, comic-book horror of Entwistle's contribution is echoed in the title of Moon's 'Cobwebs and Strange', which, like *My Generation*'s 'The Ox', was another spot

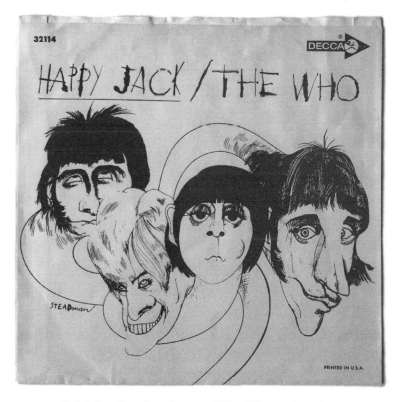

Ralph Steadman's caricature of The Who used on the
U.S. picture sleeve for 'Happy Jack' (1966).

of high-plagiarism, this time ripping off 'Eastern Journey' by the
Tony Crombie Orchestra, which had formed part of the *Man from
Interpol* soundtrack (1960). As with 'Waikiki Run', The Who's ren-
dering is transformative; a great clattering of percussion and brass
that sounds like a marching band in an underpass.

The one undisguised tribute was a version of Martha and the
Vandellas's 'Heatwave' – included no doubt as sop to fans for whom
it was a stage favourite, but an anachronism nonetheless. The only
Motown cover to survive past this point in live performance was
Marvin Gaye's 'Baby Don't You Do It'. The Townshend original 'Run
Run Run', which opens all versions of the album, was firmly in the
vein of the more pounding choice cuts from Detroit that had been
part of The Who's repertoire, songs such as 'Motoring' and 'Leaving
Here'. The August 1966 recording of The Everly Brothers' 'Man With
Money' would have made a better selection than 'Heatwave' and been
more in keeping with the direction Townshend was taking the group.

One of Townshend's songs that made the cut, 'So Sad About Us',
had been previously recorded by The Merseys. Released in July 1966,
it had barely bothered the charts. Produced by Kit Lambert (though
Townshend is often said to have been involved), The Merseys' ver-
sion was a heavily over-orchestrated effort that swamps Tony Crane
and Bill Kingsley's vocals, two singers who had a real affinity with the
Everlys. The Who's less-adorned version reveals that this was a song
Townshend could have written for the Brothers. 'So Sad About Us'
filters The Who's admiration of The Beach Boys' harmonies, but the
opening and reprised la-la-las are as London accented as The Beatles'
singing was Liverpudlian. The band mimic neither Kentucky nor
California, any more than the James Burton-like guitar turn in
'Don't Look Away' or the Tex Ritter-isms of the clip-clop coda on 'I
Need You' (reprised in the 'Soon Be Home' segment of the album's
title track) suggested the band had switched Shepherd's Bush for

Nashville. The London accent is part of Townshend putting into practice his ideas about the process of Atlantic translation that takes place when American and English pop culture meet and then divide to create something unique: something like 'Happy Jack' (a very English take on the world of the Beach Boys and surf music) or *The Who Sell Out* outtake, 'Jaguar', which combined period advertising slogans for the car manufacturer – 'grace, space, pace' – over the top of an accelerating turbo-charged instrumental that took off from (and left standing) hot-rod music.

A Quick One established The Who as one of England's great vocal groups, a fact usually lost in the hullabaloo about smashed guitars and feedback. In the studio, the Beach Boys were always a more important influence than Metzger. Once Daltrey had moved

The Jaguar advertisement that inspired Townshend's Pop art take on the Hot Rod song.

on from the posturing machismo of his James Brown imitation, he showed himself to be one of the finest vocalists of his generation – no histrionics, no whiskey-laced gravel 'n' grits, no fake soul. At its best, his voice is self-effacing; he sings the song. The band's three-part harmonies pretty much define the album and, though Daltrey leads, he never overshadows his partners, never soloing across their parts. His singing is a joy pure and true, never more so than on the album's title track.

FOR ONE OF TOWNSHEND'S more expansive concepts, the story told in 'A Quick One' is notably coherent. A young woman pines for her lover, who has been away for nearly a year. She cries and is comforted by a randy old man. When the young couple are re-united, she confesses about the liaison with Ivor, the Engine Driver, and her man forgives her for this and other acts of infidelity. It is a story that can be realized in two minutes , never mind nearly ten.

Bob Dylan's 'Desolation Row' from *Highway 61 Revisited* (1965) and the Rolling Stones' 'Goin' Home' from *Aftermath*, released in the spring of 1966, both stretched to just over eleven minutes long. The short-form album track, the long-player as a collection of actual and potential sides of a 7-inch disc, was under attack. Dylan and the Stones were the precedents in pop for the long-form song, although jazz had already explored the possibilities of expansive compositions that could stretch across a full side of an LP. But if these were examples Townshend might cite to defend the length of 'A Quick One While He's Away' to the band or interviewers (should he have been called upon to do so), they are also poor points of comparison. Dylan and the Stones' marathons are single-themed and mono-directional; Townshend's song is constructed by linking six distinct tunes. The concept of it being a pop opera, mini or otherwise, is at

once provocative and pretentious, but it is certainly neither serious in intent nor practice. The song is a gimmick, one that is aware of its own status. It is the equivalent of Warhol stacking Brillo boxes in an art gallery, raising questions about value and meaning of the art object. 'A Quick One While He's Away' asks what form a pop song could take; but its shape and structure, and the question it poses, does not make it an opera, whatever anyone or its composer called it.

'A Quick One' is to opera what Phil Spector's 'pop symphonies' were to orchestral music – a rhetorical point of comparison. Cohn rated Phil Spector highly; he sat in his pantheon alongside Proby, The Shangri-Las and The Beach Boys. His records, he wrote, 'were dirty great explosions, guerrilla grenades. They were the loudest pop records ever made.'[52] And the loudest of the loud was Ike and Tina Turner's 'River Deep – Mountain High' released in the early summer of 1966. In his review of the single, Cohn imagined Spector in a vast studio surrounded by an army of musicians ready to do his bidding, and make 'a whole world of unlimited noise'. Spector, Cohn argues, 'took every small boy's dream of growing up to be a conductor, made it come true and made millions of dollars out of it at the same time.'[53] 'A Quick One' hits the listener in the same way as a sequence of Spector tracks, like a chain reaction of pop explosions, but here too the comparison ends.

Spector always had a propensity for self-aggrandizement and pomposity. Richard Williams asked him about his 'little symphonies for kids' and the cataclysmic controlled noise of 'Be My Baby'. 'I always went in for that Wagnerian approach to rock 'n' roll,' he replied. 'Had he any formal grounding in classical music?' Williams asked. 'Just self-grounding,' said Spector. 'If you listen to the immensity of one Wagner record, and then you put on one old "Then He Kissed Me" or something, you can hear that there's a student of the school there, just playing different chords and stuff.'[54] Townshend

may have borrowed from Purcell, but he would never claim you could hear *Pagliacci* in 'A Quick One'; an English music-hall parody of the opera he might admit to, however.[55] Grandiosity was not The Who's style; self-deprecating humour was.

Both Cohn and Williams used the idea of 'noise' to describe an important aspect of Spector's productions – 'unlimited', 'cataclysmic' and 'controlled' noise, a formulation that sounded a lot like The Who's live aesthetic. Noise belongs to the lower forms, music to the higher reaches. Noise within music functions as irritant, provocation *and* pleasure. Chuck Jones and his Looney Tunes collaborators well understood the role noise plays in our culture. In the 1949 animated short *Long-haired Hare*, a banjo-plucking Bugs Bunny disturbs the rehearsals of an opera star. Incensed, the overweight pompous singer alights on Bugs and breaks the neck on his banjo – 'music hater' is Bugs's retort. The battle between the characters and the music they represent escalates until Bugs exacts his revenge by literally bringing down the house on the singer. The final image has Bugs sitting on top of the ruins plucking out another unruly twang on his banjo. A small, noisy victory for the popular over the elite.[56] Outtakes from the *Ready Steady Who!* EP and *The Who Sell Out* – 'My Generation' collapsing into 'Land of Hope and Glory' and Grieg's 'Hall of the Mountain King', respectively – tell a similar story of the pleasure in messing with the classics, but this is not what 'A Quick One' does.

There is little instrumentally that evokes anything other than the song's roots in pop; it is modest in its arrangement. The Who make a virtue out of limited resources, vocally mimicking the elements they do not have at their disposal, with the onomatopoeia of 'clang' and 'cello' used to good effect, while avoiding the kind of juvenile glee expressed in their destruction of Elgar and Grieg. The six-parts are suggestive of arias – self-contained pieces that are part

of a larger work – but it is unquestionably the 'Fa-la-la-la-la-las' that most vividly express the idea that the song is a pastiche of a higher form. But whatever the mode, The Who never sound like anything other than pop vocalists.

'A Quick One, While He's Away' is at once pastiche, gimmick, Pop-art conceit, provocation and communion. It is a compendium, a summation of The Who in full flight. What you get in those ten minutes is The Who's act in condensed form, a neatly packaged and organized anthology of the band. The song is a pre-assembled consumable, an effervescent pop confection that is mindlessly joyful and darkly humorous. The Who's longest studio recording up to this point in time is also, paradoxically, their most concise.

AS THE SUMMER OF 1967 began, *Queen* had Nik Cohn report on the 'Love Generation'. He interviewed sixteen contemporary scene-makers and asked them what they believed in, what they thought of the young generation and of love and flower power. Simon Napier-Bell opened proceedings with a nihilist's *bon mot*: 'I believe in nothing. I just exist,' he said.[57] Brian Epstein supplied the contrasting closing remarks: 'I believe in my friends.' He also advocated the use of hallucinatory drugs. In between Napier-Bell and Epstein, Chris Stamp professed to believing in very little, Paul McCartney believed in love (and LSD), Eric Clapton did not believe in authority or organizations and said that people should reject education and live by instinct. Donovan believed in belief.

In the same issue, Cohn had his personal say on 'hippiedom'. First, it made him feel old, as it was addressed to an 'audience appreciably younger than myself and, at twenty-one, it really hurts to find out I've had it'.[58] He intended to blacken the eye of the next kid to hand him a flower:

Still, hanging miserably round the fringes of the hippy scene these last weeks, I have to admit that the beautiful people aren't quite as sick as they might be. It's true they are arrogant, naive and ridiculous but all these faults are more than cancelled out by their peacefulness. For the first time that I can remember punch-ups have stopped being an essential part of teenage lore. Instead hippies have played to their strength and introduced the black arts of the snicker, the sneer and the snide aside . . . Calm behind their granny glasses, safe in wild but financially secure anarchy, they can afford to be cool and they are. And the only sad thing is that this same smugness which makes them civilised also makes them boring.[59]

The roots of the love generation were found in America, according to *Queen*'s editorial, 'Its philosophy is entirely new. Its members have never seen poverty or known insecurity. They challenge without guilt the established attitudes towards work and financial security.'[60] The Pink Floyd's Syd Barrett summed things up for his generation: 'I'm part of a movement, a really big international movement towards love. I think people will learn from it and be changed by it. I hope this will happen within the next ten years.'[61] Violence, real or imagined, as Cohn explained, was not part of the hippie's wisdom, which as with their presumed financial security, meant that class-conflict was not a part of this youth culture's agenda. 'The message is', said Donovan, 'relax, cool it, and don't be frightened; rejoice and seek the sun.'[62]

Where did this leave The Who? The band had taken part in the Monterey International Festival of Pop held in June 1967, an event that has subsequently been seen to have ushered in the Summer of Love. Writing from London, Cohn thought the whole event was weighted down with inflated notions of grandiosity, 'the most gargantuan pop promotion ever staged'. For him it marked not the

coming of age of hippiedom, but pop changing 'from a business into a self-conscious art form':

> The whole excitement of pop has always been in the balance between quality and strict business. A record is not good unless it sells, an artist is not important unless he gets screamed at, a manager is not interesting unless he can afford a Rolls – these are the basic laws that make pop the hard, nasty, uncertain and enthralling business that it is. Make it respectable, degut it, and you immediately take away all the things that make it interesting.[63]

The movie of the Festival released in 1968 fixed the idea of the event as pivotal in the development of rock, with Janis, Otis and Jimi all transcendent. The Who's performance is abridged to a visual conflagration and sonic barrage, an explosive riot of noise, smoke and light that leaves the stage looking like a wasteland. The Mamas and Papas' 'California Dreaming' set the groove, with inserts of wistful and blissed-out young people and aimless stoned pop celebrities interspersed between and within the performance sections. Among all of this harmony and togetherness, The Who are like the static on an unwatched television set relaying fragmented images from the war in Vietnam into a domestic suburban setting.

Townshend gave his thoughts on the Festival to the *Melody Maker*'s Nick Jones. He was impressed by the size of the event, by its organization, by the quality of the groups and performers (not the Grateful Dead whom he deemed 'terrible! Ugh! One of the original ropeys!') and the good vibrations, which were incredible.[64] In Haight-Ashbury, he buys hippie gewgaws and again is arrested by the positive vibrations: 'the kids are just fantastic. None of them want to fight . . . Oh yeah, that new guy Scott McKenzie is beautiful.

He has the most beautiful vibrations.'[65] Did he really think this or
had Nick Jones misread his sarcasm as sincerity? Cohn was non-
plussed either way. In the context of Townshend's apparent delight
in McKenzie, he thought the single 'San Francisco' came across as
a shock, as he wrote in his review. The record is a back-dated ballad
from the Lawrence Welk school, and its vibrations are strictly *Mickey
Mouse*. 'Still, draggy as it is, it opens up some nice possibilities for
a British counter-attack – Kathy Kirby freaking out on the *Black
and White Minstrel Show* and Kenneth McKellar, chained to the
railing at Westminster, handing out plastic roses to Quintin Hogg.'[66]

IN HIS FIRST 'POP SCENE' column of 1968, Cohn reviewed the big
end-of-year releases of 1967, The Beatles' *Magical Mystery Tour* is a
'let down' and the accompanying comic book has a 'terrible forced
zaniness about it, something like a poor man's Monkees'.[67] The
Rolling Stones' *Their Satanic Majesties Request* which – contrary
to the negative reviews it had generally received, and the fact that
there is something 'determinably second-rate' about them these
days – Cohn liked because, beneath the 'surface far-outness,' it was
'exactly the same Jagger/Richards rave-up that we've been getting
for years'.[68] Procol Harum's debut is a 'worthy achievement' but, on
the whole, it means little to him. Jimi Hendrix's *Axis: Bold As Love*
is the most interesting of the releases. The artwork is 'brilliant' – 'By
any academic standards, it is crude and gaudy, besides being an insult
to the entire Indian nation but, in pop terms, it's just sensational.'[69]
After the sleeve design, the music is a bit of a let-down, it is too much
like Hendrix's debut. The Small Faces single 'Tin Soldier' is 'rowdy
and impatient and full of energy' but they have become 'nostalgic
of an era, the prehistoric post-Mod age of maybe two years ago and,
almost in retrospect, one of my favourite groups'.[70] The 'best buy

of the lot' is *The Who Sell Out*, but it arrived too late for a detailed critique in that round-up.[71]

Cohn's review of the album came two weeks later. He began by noting that his regular readers will be tired of hearing that The Who are his favourite group and Townshend his favourite writer; predictably, then, *The Who Sell Out* got his vote as the best album of 1967. He summarized the album's concept (pirate radio, jingles and commercials) and described its sleeve – Daltrey in a bathtub of beans, Townshend's deodorizing regime. 'The whole production is roughly a pop parallel to, say, Oldenburg's hamburgers or Andy

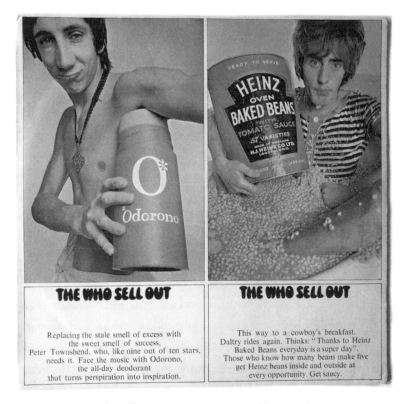

The Who Sell Out: Pop art as arranged by David King,
Roger Law and David Montgomery.

Warhol's Campbell soup cans. The real Pop Art nitty gritty at last, in fact.'[72] Cohn is wholly sympathetic to the concept, because it is an

> obvious reaction against the fashionable psychedelphic [sic] solemnity, against the idea of pop as capital-letter Art, against everything I most detest. It is all mainline pop, bright and funny and blatantly commercial. Not wanting to labour the point, I also think that it's relevant to the way that people really live in this time, much more so than Sgt Pepper, for example.[73]

Indeed, he thought 'Mary Anne with the Shaky Hand', 'Tattoo' and 'I Can See for Miles' were among the 'very best rock songs ever written.' He explains, 'At a time when everyone else is frantically trying to get away from pop's basics, its speed and glamour and essential expendability, Townshend's just about the only writer who still has his head screwed on, who sees clearly what is interesting and what is just pretension.'[74]

But he also berated The Who for not fully following through on the concept. He wanted the album to be a 'total ad-explosion, incredibly fast, loud, brash, and vulgar, stuffed full of the wildest jingles, insane commercials, snippets from your man Rosko, plus anything else that came to hand – a holocaust, an utter wipe-out, a monster rotor whirl of everything that pop and advertising really are'.[75] The basic idea is there, he felt, but the execution is weak. The failure is not the band's fault, but a lack of studio time and their hectic touring schedule that hasn't given them the necessary breathing space. Ultimately, for Cohn, 'The Who Sell Out irritates me more than any album I can remember, just because it could have been pop's first ever masterpiece and it simply isn't.'[76]

Cohn celebrated the album's use of the most basic of Pop art elements – speed, glamour and expendability – but The Who Sell Out

does more than that. Thomas Crow argues that 'Townshend and the Who had come realistically to reckon with the powers of commercial machinery to outflank their best efforts at creative independence, yet had found a way to figure that state of ambivalence and contradiction within a vividly convincing musical and visual statement.'[77] They were aided in making this manoeuvre by working with graphic designers David King (art editor at the *Sunday Times Magazine*), Roger Law (a cartoonist whose work appeared in *The Observer* and the *Sunday Times*, and the photographer David Montgomery. This team's shared background in the commercial arts was complemented by an interest in radical and revolutionary politics. King would gather together one of the largest collections of Soviet-era graphics, art and photographs – an archive now held by the Tate. Law was one of the finest satirists of his generation and a key figure in the production of the 1980s and '90s television series *Spitting Image*. American born and trained, Montgomery would go on to have an illustrious career as a portrait photographer.

Together with The Who, Crow argues, 'the team produced a fresh addition to the repertoire of visual Pop beyond what any recognised fine artist was then capable of producing.'[78] Crow is intrigued by what happens to the referent in Pop art – the pin-up, the Coca-Cola bottle, the Hollywood star – when it is returned to its originator, whether that is in the layout of a magazine cover, or moments in film, such as in Schlesinger's *Billy Liar* or Godard's *Le Mépris* (both 1963). In pondering the referent's mobility, Crow gives long-overdue attention to The Who's appropriation (and return) of Pop art motifs and, most emphatically, the carnivalesque sonic and graphic concepts wrapped up in The Beatles's album *Sgt Pepper*. After The Beatles, Pop art as fine art flounders.[79]

The Who Sell Out arrived at the very moment that Pop's radicalism was appropriated and sold back to its audience as merely hip

consumption. Thomas Frank's study of this oxymoron, *The Conquest of Cool*, begins with a wry reflection on the culture wars of the 1990s and he argues that the contested history of the 1960s, in particular the birth of hipness, has 'somehow determined the world in which we are condemned to live'.[80] Whether a critic is on the progressive or conservative side of the debate on the legacy of the 1960s,

> rebel youth culture remains the cultural mode of the corporate moment, used to promote not only specific products but the general idea of life in the cyber-revolution. Commercial fantasies of rebellion, liberation, and outright 'revolution' against the stultifying demands of mass society are commonplace almost to the point of invisibility in advertising, movies, and television programming.[81]

This process which allows youth culture to be seized by commercial interests – selling the youth images of its own acts of rebellion – was there from the very beginning, Frank argues:

> The 1967 'summer of love' was as much a product of lascivious television specials and *Life* magazine stories as it was an expression of youthful disaffection; Hearst launched a psychedelic magazine in 1968; and even hostility to co-option had a desperately 'authentic' shadow, documented by a famous ad for Columbia Records titled 'But The Man Can't Bust Our Music'.[82]

Frank's project is a study of how business seized images of dissent and non-conformity in order to market and sell its products. He excludes the simple binaries that most histories of the counterculture present, exemplified in Norman Mailer's formulation that

'one is Hip or one is Square . . . one is a rebel or one conforms . . .
doomed willy-nilly to conform if one is to succeed.'[83] Frank argues
that a fuller picture of the decade emerges if we acknowledge that
commercial interests often shared a vision of contemporary life sim-
ilar to that of the counterculture. If his ideas are put through a Pop
art filter then issues of what is authentic and what is fake, what is
radical and what is reactionary, what constitutes individuality and
what constitutes conformity, can be seen as points along a contin-
uum that is an equivalent to the line drawn between the fine and
commercial arts. As Frank notes, The Monkees and MC5 occupy
different points on the spectrum of authenticity and commodifica-
tion.[84] In this scenario, *The Who Sell Out*, at the very least, unsettles
any simple binary alignment.

In their film of 1968, *Head*, The Monkees would satirically reflect
upon their own manufactured condition in a manner wholly in keep-
ing with The Who's album; with *Back in the USA* (1970), MC5 shifted
from the commitment outlined in their ten-point manifesto to gen-
erate a total assault on American culture to embrace their origins in
the commercial music of their youth, such as the records of Chuck
Berry and Little Richard. Relative to each other, The Monkees and
MC5 were still, respectively, fake and radical, but their positions were
never entirely discrete and unconnected; both exist somewhere along
the pop continuum. From their involvement in Mod cultures of con-
sumption through their emergence as consumable pop stars, The
Who showed themselves to be ever more fluent and practised in the
lingua franca of pop, ever more familiar with its lines of compression
and expansion, its limits and its possibilities. As 1967 turned into
1968, if you wanted to join in the best conversation being held about
pop, *The Who Sell Out* was where it was happening.

4 ROCK 'N' ROLL WILL STAND

The Who *are* the spirit of rock and roll.

GREIL MARCUS, *Rolling Stone* (1968)

Over eight months in 1967, The Who made four trips to the United States, with bookings including their New York debut as part of Murray Kaufman's 'Murray the K' revue, a package tour with Herman's Hermits, the Monterey festival and finally eleven gigs throughout November covering both coasts with stops in between. Around their transatlantic jaunts the band toured Europe and Scandinavia with the result that, in all, they travelled to more countries that year than in any single year before or since. They also played widely throughout the UK, seeing out the hectic year with a New Year's Eve performance at the end of Hastings Pier.[1]

January 1968 saw the band flying to Australia and New Zealand for a set of disastrous dates supported by The Small Faces; jet-lag, foul language, inadequate sound systems, boredom, drink and Keith Moon were held responsible for the poor reception from the authorities and press alike. With a handful of UK gigs in between, by late February they were once again playing on the west coast of America, travelling from there into Canada, back to America's Midwest and on to New York in April. In May, they played a round of university halls in Britain before returning for another set of North American gigs in June, July and August. More UK university and theatre concerts followed in October through to the year's end when they played their final gig of 1968 at the Marquee; their last ever at the venue.

The stages provided on Hastings Pier and in the Marquee must have seemed both reassuringly familiar and hopelessly small and backdated after the American tours. Gigs at dedicated rock venues like the Grande Ballroom in Detroit (capacity 1,800) or the Bill Graham-run Winterland Ballroom in San Francisco (5,400 capacity) and the Fillmore East in New York (capacity of nearly 3,000) had brought them to relatively large audiences. Those venues also provided them with a house PA system and amplification sizable enough to communicate in new ways with those crowds.

While a few single releases and rag-bag collections of old material kept some new Who product in the stores, lack of anything like a proper album release in 1968 led Lambert and Stamp to explore the possibility of releasing a live recording. To that end, gigs at the Fillmore East theatre in Manhattan in April and at the Fillmore and Winterland auditoriums in San Francisco in May 1968 were recorded. Tapes from the two New York dates were edited down to fill up two sides of a potential long-player, and acetates were made, from which countless bootlegs were sourced. The official release, however, was held back for fifty years.

Technical issues meant the first two songs, 'Substitute' and 'Pictures of Lily', did not make the cut on the 2018 album; the rest of the show is an all-out sonic attack that rises and falls over ninety minutes and fourteen songs. 'Summertime Blues' is the first of three Eddie Cochran compositions they played, with 'My Way' and 'C'mon Everybody' later ploughing headlong into 'Shakin' All Over'. 'Fortune Teller' follows the first of the old rockers, before the band drops the tempo to deliver 'Tattoo', a standout track from *The Who Sell Out*. Placed in the mix, following the singles 'I Can't Explain' and 'Happy Jack', is another *Sell Out* highlight, 'Relax', which is here pushed to an eleven-minute marathon, with quotes from Cream's 'Sunshine of Your Love' woven into a free-form psychedelic hike

that is eventually brought back down to earth with a precise 'I'm a Boy'. After the obligatory 'Boris the Spider', the gig concludes with a version of 'My Generation' lasting more than thirty minutes.

Extemporizing, drawing out elements, extending a number well beyond its recorded original – these were all techniques and strategies that British groups took up during tours of the States, in part to cover up for a shortage of songs to fill out the contracted playing time, with venues often demanding two sets a night of unique material. Cream became masters of this, with 'Toad', 'Spoonful' and 'Crossroads' all pushing towards epic lengths; the two sides of the live half of their *Wheels on Fire* LP were taken up with only four songs and the live flip of *Goodbye* boasted just two tracks. The recording of *Live at the Grande Ballroom* in October 1967, at the end of their first American tour, documents the band feeling their way into the mode of improvisation that would come to define their live shows, catching them at a point in their development before inventiveness became formula. The Seth Man, a regular contributor to Julian Cope's Head Heritage web pages, writes:

The recording was taken off the house mix featuring Clapton's guitar clearly defined with sustain, indicating a performance at top volume. His amplification was comprised of four Marshall 4×12 cabinets with two 100 watt amplifiers which possessed a capacity to retain sustain and distortion effects at varying volumes simply because it was so loud. This extreme use of volume in turn helped to mutate Clapton's stock blues riffs into something else entirely. It also allowed for a finer control of volume, tone and dynamics as well as the ability to rattle the rafters and pummel the punters.[2]

The Yardbirds had been rehearsing something similar even back in the days when Clapton was in their ranks, with rave-ups built into 'Smokestack Lightning' and later, when Jeff Beck was on board, 'I'm A Man'. By the time Jimmy Page had taken Beck's place, 'Smokestack Lightning' was fluid and expansive enough to incorporate The Velvet Underground's 'I'm Waiting for the Man'; and 'I'm A Man', alongside the new 'Dazed and Confused', was rebuilt to exceed the ten-minute mark. The Who at the Fillmore East are following what these two bands laid down, but as they don't play the blues the extemporization goes somewhere else. That somewhere is not the space occupied by The Pink Floyd with the pulsing ebb and flow in, say, 'Interstellar Overdrive', The Who pile in full-on, pull back for a breather and then launch another attack. It is an approach that lacks subtlety. 'My Generation' is insolent and delivered with a sneer unimaginable on the face of Syd and his band. The Velvets' 'Sister Ray', which often hit the half-hour mark in live performance, might be a better point of comparison, but its metronomic intensity is not the stuff of The Who's live performances either. For a band who epitomized concision in their studio recordings and a focused sonic attack in their club performances, such bludgeoning improvisations seem the very antipode of what they stood for. With the exceptions of 'Magic Bus' and 'My Generation', The Who forsook jamming once they had *Tommy* to perform. But at this moment in time, the increased scale and volume of their shows was indicative of the package rock now offered – a shift in the firmament of pop just as seismic as that signalled by the new earnestness of *Sgt Pepper*.

In counterpoint to all this extemporization, throughout 1967 and into 1968, Cohn documented a re-emergence of interest in classic rock 'n' roll, re-issues of old discs, reviews of gigs by The Everly Brothers, Fats Domino and Chuck Berry, and the shift by some contemporary bands away from psychedelia: The Beatles with

'Lady Madonna', 'I Can See for Miles' by The Who, 'Fire Brigade' by
The Move and 'Jumping Jack Flash' by the Stones. 'It was renewed
aggression,' Cohn argued, 'an intelligent mixing of basics and pro-
gression.'[3] The best augury of a return to good times was the three
recent UK Elvis singles, 'Big Boss Man'(November 1967), 'Guitar
Man' and 'U.S. Male' (February and May 1968, respectively). Cohn
celebrated them all, stating that 'the slush has been swept away
and hound dog Tupelo Elvis Presley stands revealed once again in
gold-leaf suit, sideboards, duck-ass plume and guaranteed genuine
rocking shoes. It adds up to quite a second coming.'[4] In the same
column Cohn reviewed Donovan's 'Jennifer Juniper', a song that
'holds no surprises . . . an object lesson in "how to be angelic and
still make money."' Donovan is a child poet, seer and holy fool,
according to Cohn, which is 'to say the least, oppressive'.[5] Both Elvis
and Donovan peddle fantasies, but one singer closes down options,
while the other opens things up. 'Guitar Man' 'gives you a flash of
mean poolhall Elvis, small-time Memphis hustler, punk and palooka
of 1955. And it doesn't matter at all that neither of these figures is
remotely real, that they're both stock Hollywood myths, personal-
ities mass-produced like polythene bags. Phoney or not, Elvis '56
was something beautiful.'[6]

The Who recorded little of consequence in 1968. Even if released
at the time, tracks like 'Faith in Something Bigger', 'Melancholia'
and 'Glow Girl' were not much better than filler. All three drift
aimlessly without the shaping context of an album, and the last two
would be more effectively reworked into the fabric of *Tommy*. Of
the other Townshend originals left on the shelf, only a song about
a bullied fat boy who doesn't smoke and outlives his tormentors,
'Little Billy', holds its own against 'Happy Jack' and 'Pictures of
Lily'. 'Faith' is closer to 'Jennifer Juniper' than to 'Guitar Man',
oppressive rather than open to the possibility of excitement and

renewal. As if plotting a similar line to that being laid down by Cohn in his column, The Who recorded two versions of Cochran's 'Summertime Blues' and also covered the rocker's 'My Way', along with Johnny Kidd's 'Shakin' All Over', Scene club favourite Benny Spellman's 'Fortune Teller' and Mose Allison's 'Young Man Blues'. None of these recordings were given a release that year. 'Summertime Blues' was considered as a potential stop-gap single, though Blue Cheer got the leap on them by releasing their version in January 1968 (March in the UK). Lambert also played with the possibility of pulling various unreleased tracks together as a holding operation while the band incessantly toured and Townshend laid plans for *Tommy*. In its stead, he cobbled together an uninspiring collection of tracks released post-Talmy, *Direct Hits*, and their U.S. Decca label scrabbled together *Magic Bus: The Who on Tour*, which was even less imaginative in its track selection. In Europe, *Direct Hits* was retitled *Best of . . .* and had a cartoon cover that looked like it had been clipped from *Fabulous* magazine, which only helped to emphasize how effective the Aldridge and Steadman caricatures had been.

The Diddley-esque call and response of 'Magic Bus' aside, released in the States in July and the UK in September, The Who's conundrum of what next after *Sell Out* was summed up in the release of 'Call Me Lightning', a full-on rock revival piece of braggadocio. It was the topside of a single in every market except Britain, where it was relegated to the B-side of 'Dogs'. Townshend thought 'Lightning' was unrepresentative of the band's current sound.[7] 'Dogs', on the other hand, was not released in the States, no doubt due to its insular English subject matter. The song, a whimsical homage to the west London White City dog-track stadium and its habitués, is an observational piece on London's working-class culture of the kind that The Kinks had being purveying in ever more microscopic detail and that The Small Faces had also made a play for

The Who, minus an absent Daltrey, pose with Yellow Painter,
star of their non-hit single 'Dogs' (1968).

with *Ogdens' Nut Gone Flake* and their final single as a gigging band,
'The Universal' (with 'Donkey Rides, a Penny a Glass' on its B-side),
both released in the same summer month as 'Dogs'. This was a small
run of like-minded releases, enlarged a little by adding Cream's 'A
Mother's Lament', The Yardbirds' 'Goodnight Sweet Josephine' and
Oscar's rendition of Bowie's 'Over the Wall We Go', which features
the immortal refrain 'all coppers are 'nanas' – but even then these
examples probably exaggerate the fad's scope.

Whatever its merits, 'Dogs' was not about being a teenager, and
it was as far removed from the Summer of Love as was 'Summertime
Blues'. The latter, 'Shakin' All Over' and 'Young Man Blues' were
each in their own way teenage manifestos; the recordings of these
songs may have stayed in the studio vaults, but live in 1968 The Who
used them to re-set what they and pop was all about in the aftermath
of Monterey and the new West Coast sound of The Doors, Jefferson
Airplane, the Grateful Dead and the nouvelle authenticity that The
Band highlighted on their debut album. The Who were the most

urban-fixated of their contemporaries, and had little in common with the beatnik-infatuated communitarian ideals of the leading Californian bands, or with a return to country roots advocated by Dylan, The Byrds and The Band. What might work for Clapton with Delaney and Bonnie, or Steve Winwood with Traffic, would have been an impossible fit for such arch-London modernists as The Who. Even The Kinks' village green was unavailable to them. 'Dogs', at least for the moment, was The Who's answer; it said something about their west London background, as much as The Band's arcadian vision seemed to say something about their North American origins. Both images were equally mythical, aimed at making a scene in the pop market by reaching behind for inspiration.

In March 1968 Cohn was in the process of composing a history of pop that would be published in 1969 as *Pop from the Beginning*. His last few columns for *Queen* were dispatches sent from a cottage on the west coast of Ireland where he had taken himself to write without distraction. In his penultimate column, he recorded the chance appearance of The Everly Brothers playing live in a local dance hall. They featured their hits, everyone got drunk and fell about, and in a half-hour the set was finished. Was it a dream? What was a star turn of the size of the Everlys doing playing way out in the middle of nowhere? Cohn is caught in a fatal web of nostalgia, the revival of rock 'n' roll brings that which he loves back into focus – at the very least, for him it curtails the threat of boredom – but it is not the thing itself, it cannot be one bright violent explosion after another, a relentless spectacle of the new. Flip the new Elvis single over and the B-side of 'U.S. Male' is 'Stay Away', which, Cohn wrote, is 'grotesque. At one throw, it sums up everything that has been wrong about Elvis in these last years.'[8] The purity of '56 Elvis is despoiled by twelve years of Hollywood garbage. Not even the mighty weight of nostalgia can repress that history.

Whenever he championed The Who, Arthur Brown or Hendrix, which he did often and volubly, Cohn would occasionally joke that he had been accused of taking backhanders from Lambert, Stamp and Track Records, the company the pair formed in 1966. Whatever the truth of this, or his claim that he owned 10 per cent of Track artists John's Children, the link between Cohn and The Who's management was right out there in the open.[9] His choice of book jacket designers was likewise self-explanatory. He had used Aldridge to illustrate his sophomore novel, *I Am Still the Greatest Says Johnny Angelo*, and *Pop from the Beginning* used David King, who had worked on *The Who Sell Out* and the best part of a dozen other Track releases. *Pop*'s dust jacket features a flight of genital-less female nudes who crowd out colourized, airbrushed images of The Beatles, the Stones, Jimi Hendrix and Frank Zappa. Inside, the illustrated plates are laid out like one of King's *Sunday Times* supplement designs. Image-wise the book appeared to be very much of its time. Lay it on top of King's sleeve for Hendrix's *Electric Ladyland*, or alongside the label sampler *The House That Track Built*, and Cohn's book looks right at home. Cohn was, though, coming to feel that he was an anachronism. In an interview in the *Observer* used to publicize his pop history, he declared: 'I don't really belong to these times . . . In a lot of ways I'm a reactionary. Like I care about style, elegance, grace. Scott Fitzgerald, not Hemingway. That's why I like rock 'n' roll. It's violent, but it has a clean edge to it. Music today is just brutal, like stamping on a chicken.' He was giving it all up, he said, to be a pig farmer in Hertfordshire.[10]

Kit Lambert, in his introduction to *Pop from the Beginning*, wrote that 'Nik is no obituarist: anyway, if he did write your obituary you'd be better off dead.'[11] But that is exactly what Cohn had become, a chronicler of the dead; a mortician. At the end of the

Nik Cohn's second novel, *I Am Still the Greatest Says Johnny Angelo* (1967), used *A Quick One* illustrator Alan Aldridge.

book he doesn't show any faith whatsoever in the present or the future: 'it's finished now, the first mindless explosion, and the second stage has begun . . . Pop has gotten complicated. That was inevitable, everything ends, nothing remains simple.'[12] Superpop, he concluded, 'has to be intelligent and simple both, it has to carry its implications lightly and it has to be fast, funny, sexy, obsessive, a bit epic.'[13] An idea best encapsulated by 'I Can See for Miles'. That single was the final shockwave of The Who's initial explosion and the first reverberations of what was to come.

Until it gets to The Beatles, Cohn's pop history is built on a series of flashcard jogged memories, vignettes mostly that revisit the already known: Haley's advanced years, Buddy Holly's acne problems, Presley as wannabe trucker, Jerry Lee Lewis's child bride.

Nik Cohn's *Pop from the Beginning* (1969) – here sitting on top of the Track Records compilation *The House That Track Built* (1969) – used the graphic designer David King, who was partly responsible for half a dozen album covers for Lambert and Stamp's label.

Fats Domino, Screamin' Jay Hawkins, Larry Williams, The Everly Brothers, Chuck Berry – poet of rock 'n' roll – and Lieber and Stoller all pass by at a rate of knots, all quickly left behind, mimicking pop's effervescence and speed: 'Rock 'n' roll was very simple music. All that mattered was the noise it made, its drive, its aggression, its newness. All that was taboo was boredom.'[14] Little Richard's 'Tutti Frutti' was its summation.

The Beatles absorbed and exploited that summation. Where they led, others followed. And for a while they were truly marvellous. For

Cohn, the group went down a dead end when they started to believe in their own hype, when they concurred with 'the posh Sundays' that they made Art. In making that turn, pop lost out. Cohn rated *Sgt Pepper* highly, but he had real issues with what it represented. 'In itself,' he wrote, 'it was cool and clever and controlled. Only, it wasn't much like pop. It wasn't fast, flash, sexual, loud, vulgar, monstrous or violent. It made no myths.'[15]

When The Beatles lived out their lives in a mythical 'Liverpool USA', they spoke to their teenage audience in the language of pop; 'these boys were coke drinkers from way back,' wrote Cohn. But with Dylan joining them in their Rolls-Royce, The Beatles lost that audience; and they lost a truth that can be found in trash: 'originally, in the 1950s, the whole point about rock was its honesty, the way it talked so straight after all those years of showbiz blag, and now it's just become as fake as Tin Pan Alley ever was.'[16] Cohn could barely listen to Dylan, he disliked his voice as much as he hated 'the changeless wail of his mouth-harp'. He thought he was a monotonous 'mouthpiece of teen discontent . . . peddling politics and philosophies and social profundities by the pound . . . just the same, [he] moved pop forward into its second phase,' namely, shutting down rock and roll as 'the golden age of pulp'.[17]

The Rolling Stones, on the other hand, 'were like creatures from another planet, impossible to reach or understand but most exotic, most beautiful in their ugliness'.[18] The band was made in the likeness of their manager, Andrew Loog Oldham, who 'without doubt, was the most flash personality that British pop has ever had, the most anarchic and obsessive and imaginative hustler of all. Whenever he was good, he was quite magnificent.'[19] The long description he provides of the Stones is Cohn at his best: Watts, 'moronic beyond belief'; Wyman, 'impossibly bored'; Keith Richards 'kept winding and unwinding his legs, moving uglily like a crab, and was shut-in,

shuffling, the classic fourth-form drop-out. Simply, he spelled Borstal.' Jones was 'flouting and flitting like a gym-slip schoolgirl' and Jagger, 'he was all sex.'[20]

After a Liverpool gig by the Stones, pegged by Cohn as the best show he has ever seen, he wanders around the empty auditorium. A dank smell of urine hangs heavy in the air, 'the small girls had screamed too hard and wet themselves.'[21] The Stones did things to their audience, they were evil, independent and utterly uncompromising. Every group before them had played the game, wrote Cohn, but they 'threatened the structure, because they threatened the way in which pop was controlled by old men, by men over thirty.'[22] The sound they made was the thing, it was the sound of 'chaos, beautiful anarchy. You drowned in noise.'[23] But by the autumn of 1966, they had become too familiar, new groups emerged – Hendrix and The Who – and the Stones now looked tired and dated. 'That's how fast pop is: the anarchists of one year are the boring old farts of the next.'[24] Cohn enjoys the Stone's renaissance with *Beggar's Banquet* and 'Jumping Jack Flash', but he is not optimistic they can sustain such quality; old age and hair loss beckons. 'And if they have any sense of neatness they'll get themselves killed in an air crash, three days before their thirtieth birthdays.'[25]

Cohn thought The Who in 1968 were the 'last great fling of Superpop'.[26] The band are a contradiction in terms, he wrote: 'They're intelligent, musical, they keep moving forward, but they're also flash and they come on with all the noise and nonsense of some backdated rock 'n' roll group. They make good music and they're still pop.'[27] They were all image, but they also had Townshend's song craft: 'Often the songs would carry quite heavy implications but they never got flabby, their surface always gleamed. No sermonizing, no crap – Townshend kept everything tight and firm, very real, and he chronicled teen lives better than anyone since Eddie Cochran.'[28]

Eddie Cochran was 'pure rock'; others played other kinds of rock, country or high-school, hard, soft, good or bad or indifferent. 'Eddie Cochran was just rock. Nothing else. That's it and that's all.' Cohn wrote that Cochran was a 'composite of a generation . . . a generalized 50s blur.' But in his maximization of 1950s teendom he transcended that identity:

It's not as easy as it sounds. Anyone who can compress the atmosphere of a whole period into six songs, who can crystallize the way any generation worked, must have something very unusual going for him. Pete Townshend of the Who is the only person who has caught the 60s in the same way and he has had to work his ass off to do it. Cochran did it almost instinctively. For that alone, I'd rate him very high indeed.[29]

When Cohn reviewed 'Debora', the debut single by Tyrannosaurus Rex, in *Queen* he began by summarizing Marc Bolan's career to date, having it follow the vapour trails left by The Who. He wrote that Bolan was a 'walking teenage history of the Sixties'.[30] He recalled that the singer was once called Mark Feld, 'a self-styled Supermod', who switched his clothes four times a day. 'He was very image then [*sic*], arrogant and cold, and he wouldn't even nod at anyone who wasn't hip.' He then changed his name, became a singer and released a 'good record called "Hippy Gumbo"', which had Cohn hooked. Before joining John's Children, Bolan had moved from classic Mod to being a 'hard-eyed Donovan'. John's Children were 'hilarious', wrote Cohn, 'entirely impossible, and they cut the worst singles ever released, but they also fluked one true classic, a Bolan number called "Desdemona". This was pure rock, way before any revival, and it went like a bomb.' Today, Bolan is clothed in robes, sits cross-legged and comes across like 'Stamford Hill's reply to the giggling guru'.

Cohn can hardly recognize him, but he loves the new single's rhythmic vitality, 'which is vast'. He didn't think 'Debora' would be a hit, alas, as 'good songs usually aren't these days.' Anyway, it also lacked a hook, but more significantly, 'Bolan has been around a long time. Too long, and I can't quite see him clinching things.'[31]

A little less than three years later, following a shortening of the band's name and another costume change, Bolan rode a white swan to number one. The single had 'Summertime Blues' on the B-side. The success of T. Rex had proved Cohn to be wrong in his assessment of Bolan's chances. Except he was not mistaken, at least not on his terms. Things *had* stalled in 1968. Bolan was just a few months younger than Cohn, who at 22 considered the pop jig to be over and done with even though he would run with it for a few more years. Central to his deliberations in *Pop from the Beginning*, and in his review of Tyrannosaurus Rex, was a deep uncertainty about the direction that pop was about to take.

The Who's answer to that conundrum was to adopt a Janus-like approach to pop, looking back while looking ahead was an option that had worked well for the Everlys on their two albums from 1965, *Rock 'n Soul* and *Beat 'n Soul*. The Brothers' covers of songs by Ray Charles, Buddy Holly, Chuck Berry, Elvis, Charlie Rich, Rufus Thomas, Little Walter and Little Richard are set alongside contemporary covers culled from the songbooks of Curtis Mayfield and Holland-Dozier-Holland, and a handful of their own tunes. Since their hit-making days the Everlys had been unerringly drifting towards banality and irrelevance, but this direction of travel had stalled with *Beat 'n Soul*, the first album the duo made away from Nashville.

They had picked up with Hollywood's best: James Burton, Glen Campbell, Sonny Curtis on guitars, Billy Preston on keys, Jim Gordon on drums. The tracks made at United Recorders Studio in Hollywood were cut clean and sharp; no polished surfaces or

rounded corners. The guitars are overdriven and the vocals sweet and raw. Where once was only drift and uncertainty, in Hollywood they found direction and conviction – and they had fun doing it. The Who took this frame and dropped in their own portrait. Just as significantly, the lesson the band learnt from the Everlys was how tension, the torque in a performance, has to be used in the service of a song's inherent drama.

THE DIVIDE IN POP'S ongoing progression, which Cohn was so unwilling to cross, was readily spanned by young American critics, chief among them Greil Marcus, who in the same year as the publication of *Pop from the Beginning*, 1969, edited the collection of essays *Rock and Roll Will Stand*.[32] The change in the location of the critics, from England to the United States, from London to San Francisco, echoed the shift in pop's centre of operations. Marcus's book opens not with pop's first acts of creation, but with Richard Nixon's acceptance speech as the Republican party's Presidential candidate. The only politics in Cohn's work is a politics of style; in Marcus's book the politics of the day is stamped into every page. Activist Marvin Garson wrote the introductory chapter and called upon his hoodlum friends outside, rock 'n' rollers, to help tear down the gates and take the metaphorical hill Nixon spoke from. Marcus followed Garson with a history of rock 'n' roll that explained how contemporary music was owned by the young – his generation, who came of age listening to Elvis, Fats, Chuck and Little Richard. That listener is today's 'student' – 'in school or out of it, graduate or dropout – the person who reads, thinks about what he hears, who likes to talk to his friends about it.'[33] Someone who might ask the question, as Marcus does, of whether or not rock should be taught at university?

Rock 'n' roll's myths are central to his generation's sense of self, Marcus argued. In his history, he tracked the music from the 'non-verbal incantations' of The Cellos' 'Rang Tang Ding Dong (I Am the Japanese Sandman)' released in 1957 and The Crystals' 'Da Doo Ron Ron!' (1963) to the metaphors waiting to be unpacked from the treasure chest of Bob Dylan's 'Memphis Blues Again', a track on *Blonde on Blonde* from 1966. Marcus was interested in the intensity and immediacy of the relationship between a given song and the listener. A good part of that interaction depended on the generational exclusiveness of rock 'n' roll, which spoke in tongues to its initiates – rang tang ding dong. His peers understood as others did not that the bird is the word. On the passing of arcane knowledge, he wrote 'That is what The Beatles did when they sang "I'm Down", the toughest rock 'n' roll since Little Richard – they returned to the beginnings, even as they stayed far ahead of everyone else.'[34] In the exchange of codes from one listener to another, from one musician to another, rock became the metaphor, the means, through which one negotiated and interpreted the world, even the fact of Nixon's presidency.

> What rock 'n' roll has done to us won't leave us. Faced with the bleakness of social and political life in America, we will return again and again to rock 'n' roll, as a place of creativity and renewal, to return from it with a strange, media-enforced consciousness increasingly a part of our thinking and our emotions, two elements of life that we will less and less trouble to separate.[35]

Marcus's view represented the solemnity, the earnestness, that Cohn was taking flight from. Twenty years later, in a different context, but having stayed true to his 1969 manifesto, Marcus said of

Pop from the Beginning that it was 'the first good book on the subject'.[36] Cohn, he wrote, had 'disavowed all claims on meaning the form might make, affirming instead a pure sensual anarchy, summed up in the watchword of Little Richard: "A Wop Bop A Loo Bop, A Lop Bam Boom".'[37] Unlike Cohn, who just gave it all up, but like Townshend who never did, Marcus has tirelessly worked on the divide between instinct and intellect.

Appropriately, Pete Townshend is the cover star of *Rock and Roll Will Stand*. Legs apart, arm upraised in that familiar pose, he is doubled by his own shadow cast on the stage's backdrop. In a round table discussion, documented in the book, one of the participants claimed his first impression of The Who was that they were an 'asexual Hendrix'.[38] That is, they sing sexy, move sexy, but we know and they know that they are not sexy. The discussion runs with the idea until someone suggests The Who are like Victorian pornographers:

> All this stuff they were singing, about wet dreams, about mothers dressing up boys in girls' clothes, Jesus, all this really *perverted* stuff, and I thought, if somebody wrote, in the London *Times* where it would all come out very respectable: 'Pete Townshend of The Who, London rake, was dressed as a girl until he was seventeen years old, and that is why he can only make it with boys dressed as girls.' All kinds of stuff like that . . . I mean, Sandy, you know Peter, I don't know what Peter Townshend's like, but it all seemed very pornographic in an incredibly delightful way, and that's not asexual – it's not like Hendrix's 'Fuck me!', it's not that kind of thing, it's not 'look at my guitar, my super-cock exploding in fire-and-flames' – but it's sexual in the way we dream about things rather than the way we 'uunnhh!' to something. That's power too.[39]

The Who perform sex; they know they are not Hendrix, yet they are humanly sexual in a way that Hendrix's 'uunnhh!' can never be. Like the band itself, their subject, their object of desire, is always wearing disguises, endlessly dissembling. They are perfect in their imperfections and perfectly lucid in articulating their inarticulacy. Elsewhere in the book, The Who are likened to an exploding practical joke that can make you throw up *and* laugh. 'Don't ask which is The Serious and which is But a Jest. It's all real and it's all unreal. Some of us run off to India to join the circus; The Who stayed right where they always were and built their own circus out of themselves and the whole carny world.'[40] Like the image of Townshend on the book's cover, the meaning attributed to The Who is doubled, the binaries blurred into a marvellous set of contradictions in which listeners can always find themselves if they so choose. The Who are masters of indirection.

While Marcus and co began the conversation with their generation in earnest, *Life* magazine spoke to those who were left out from that discussion. The June 1968 edition featured 'top rock group' Jefferson Airplane on the front cover and an editorial on 'The New Rock'. Once again pop's primitive, lewd and vulgar start is alluded to, followed by its progression from that fertile soil to becoming, with *Sgt Pepper*, 'thoughtful and adventurous': 'If the world found rock rude and offensive, that was exactly the way the young generation found the world. It wasn't willing to accept that world and rock became a way of protest.'[41] Everywhere, pop's journey to become Rock was covered as history. Over half the issue was dedicated to picking through the 'music with the beat of slang'.[42]

The article is illustrated by Art Kane's photographic studies of Rock's West Coast luminaries: Janis Joplin and Big Brother and the Holding Company, Jefferson Airplane, Mothers of Invention, Jim Morrison and The Doors, Country Joe and the Fish and two

English groups: Cream, straddling a single railroad track that met-
aphorically leads 'back to the country of the Mississippi Delta,
the heartland of the blues', and The Who, sleeping beneath two
large Union Jacks against the base of the Carl Schurz monument
in Morningside Park, New York.[43] 'The Who are doing what?' the
article asks, 'They are living out a chronicle of costume.'[44] From
leather rocker jackets, to Mod stylists, to Pop Art mannequins, to
today, 'Edwardian dandies in velvet and brocade, shirts of silk and
lace.'[45] Their 'sound is happily aggressive ... They play three-minute
morality plays, mini-operas and spot commercials', and as a 'mel-
odramatic finale ... they are compelled to destroy', before, finally,
under the drapes of the majesty of empire, 'they take a moment for
a nap after tea.'[46]

Unused in the *Life* issue was a series of individual studio shots
of Daltrey and Townshend, posed and lit by Art Kane as if they
were for a high-end fashion spread. Against an indigo backdrop,
bare-chested Daltrey, wearing a girl's pink cardigan, a heavy silver
cross necklace and cameo pendant, looks down into the camera's
lens while holding his chin up. He appears bored. In three shots
of Townshend, he also looks bored (and weary to boot). He too is
wearing pink – an open-necked shirt. In another image, Townshend
is framed standing square on, shot from above the ankles, tuning
a guitar, the instrument's head just out of focus. A third shot has
him turn around with his guitar facing away from the camera, his
blurred windmilling right arm held aloft.

These are not playful images, like the ones of The Who sleeping
under the flags; rather they are mannered, the sitters striking poses
they have done many times over that all gesture towards a sexual
offer but simultaneously freeze out any erotic charge, whatever the
viewer's predilection might be. The too-small girl's cardigan should
feminize Daltrey, but at best it only entertains the idea. There is

no follow-through like Jagger so often staged. The Who might flirt with camp personas but they are hopeless in their execution. It was not a code The Who spoke with any confidence. They certainly lacked the kind of eloquence in the presentation of camp that Ray Davies displayed. The Who might costume themselves as 'Edwardian dandies', as *Life* magazine suggested, but like William Brown, the mischievous schoolboy in Richmal Crompton's *Just William* series of books, once dressed in his sister's satin petticoat and silk stockings, you always have the sense that such fine clothes will not survive untorn and unsoiled through whatever adventure is pursued. As posed in the Morningside pictures, The Who were good boys when sleeping.

The high quality of Kane's Daltrey and Townshend photographs saved the images from being just more teen magazine filler, but that's exactly what the poses signify. In a letter of February 1966 to *Rave*, Diane Houlton of 23 Starfield Street, Liverpool 6 wrote:

> After recently seeing The Who at the Cavern, may I say on behalf of hundreds of Who fans who went to see them, that they are the most talented group to have ever performed on Merseyside. Their stage act left us spellbound for hours, and the dancing of Roger Daltrey and Pete Townshend alone, placed them in a class of their own. Please print this letter as every word is true.[47]

This was the same gig that Ron Asheton, future Stooges guitarist, witnessed and remembered as having turned into a riot. Diane, however, recalled Pete and Roger's dancing, not chaos and cacophony, nor, more perplexingly, given the usual style of letters to the magazine, how drop-dead gorgeous the band were. Townshend always talked of the band's fans as male, though letters such as Diane's

and images of Who audiences with teenage girls in abundance at the front of the stage suggest this is a misrepresentation, at least for their pop-age era of 1965–8.

Richard Goldstein concluded the article in *Life* which accompanied Art Kane's photographs by asking if Rock is Art? Is Dylan akin to Whitman? Is Donovan Wordsworth? 'In a sense', he wrote, 'assertions like these are the worst enemy of liberated rock. They enslave it within an artificial heritage. The great vitality of the pop revolution has been its liberation from such encumbrances of form.'[48] Yet the question of pop's status was asked so frequently, and with such serious intent in 1968, that inappropriate canonical history is exactly what it had to contend with; all paths away from it were blocked. Pop was now being given a seat alongside poetry and opera. Cohn knew this, resisted it, and that is why he bailed out (though not quite yet), while Marcus signed-up for the (long) duration. Meanwhile, Pete Townshend had a rock opera to write, and dance moves, pink shirts and fan letters in *Rave* were left behind.

IN HIS FIFTY-SEVENTH and final 'Pop Scene' column for *Queen*, Nik Cohn signed off by giving a 'fat plug' for 'Still the Boss' by Amazing Johnny A: 'This is nothing but a monster. Apparently, Johnny was killed in a recent Chicago shooting accident. In that case, this stands as a fitting epitaph, a memorial to a major talent.'[49] The review was a suitably mythical finale to mark Cohn's 27 months at the magazine. 'Still the Boss' made not the slightest impression on the record charts, nor on anyone's turntable. That is because the disc did not exist. Cohn finished his stint at *Queen* by referencing his own creation, *I Am Still The Greatest Says Johnny Angelo*, which was published a year earlier in August 1967.

The Guardian's book reviewer Norman Shrapnel, blessed with the perfect critic's surname, wrote that Cohn's writing was 'violently sick'.[50] He had produced 'an ugly little book, downright nasty and deliberately so. It is a pop-tragedy about a pop-star's rocketing ascent and blazing fall.'[51] The novel opens with a prologue, 'Johnny Angelo was a hero. From the moment he was born until the time of his death, he lived the life of a hero, and that was all he really cared about.'[52] To be a hero in his day and age he had to be a pop singer; in another time he might have been a soldier, a politician or a prize-fighter. Becoming a pop singer was the only way Johnny could achieve his ambition quickly and with flair. Cohn's story is about a hot life lived in pursuit of style. 'This is not a realistic story about the pop business,' he wrote, 'and it is not an exposé. It is legend.'[53]

Johnny Angelo is a modern myth about a working-class boy who rises from a wretched background to claim fame and wealth beyond imagining, before his hubris and paranoia destroy him. His name reverberates with echoes from pulp-tales of Italian American mobsters, of urban punk hoodlums who murder their way out of the big city slums of New York and Chicago. Dressed to kill, the gangster and the pop star are versions of the same myth, a tale of aspiration and ambition sold on the promise of personal transformation and reinvention through acts of conspicuous consumption.

He is narcissistic, sadistic and an extrovert. At age eight Johnny Angelo reinvented himself as a gunslinger. Costumed all in black and with matching cap pistols he rehearsed the pose of style as violence, anticipating the idea of pop as a violation of the everyday, a crime against the quotidian. At school, the girls loved him and the boys hated him. As a teenager he discovered Elvis, coffee bars and Teddy Boys, and became 'Hipster Johnny Angelo'. At age sixteen he fed the neighbourhood cats meat laced with paraffin and then set them alight – the street lit up with blazing moggies. By seventeen

he is playing guitar and singing in a cellar club. He is the new king, the leader of the pack, and rides in front of a motorcycle gang. By the age of 24 he is a pop star to rival Elvis.

The star's fall is precipitated by a fan, and a Mod to boot: 'He was sixteen years of age, Arthur, a pretty boy who rode a motor scooter, liked Otis Redding and Wilson Pickett, and swallowed purple hearts by the hundredweight.'[54] The skinny little Mod is invited into Johnny's inner sanctum. Arthur inadvertently gives release to Angelo's long-suppressed homosexual desires, and then has the temerity to call it by its name. In self-disgust, Johnny lashes out and has him murdered: 'Kill Arthur. Kill him. Kill it.'[55] The police come to arrest Johnny but he refuses to go quietly. Like Jimmy Cagney's character in *White Heat* he chooses to go down under a hail of bullets: 'No more: his body twitched twice and then lay still. No more fun for Johnny Angelo. In death, the greatest. Johnny Angelo was the greatest.'[56]

Dying before the age of thirty meant that the pop star did not have to face the 'big stumbling-block . . . when you've made your million, when you've cut your monsters, when your peak has just been passed, what happens next? What about the fifty years before you die?'[57] Cohn traded in myth, not social commentary. In his novel, he created a world where style was god. A couple of months after his last column for *Queen*, he made a final appearance in the magazine as a menswear model. Showcasing the season's new topcoats, 'the military look in furry fabrics', the 'author, journalist, pop authority' posed for Helmut Newton's camera in Soho's streets in front of its strip-clubs. A dapper young man about town; a man of style.[58]

The novel didn't make it into paperback until a 1970 Penguin edition.[59] Inside, Cohn had completely overhauled and re-edited his story, Arthur was nowhere to be found. In the new edition, Johnny talks about his youth, of going to an amusement arcade and putting

Nik Cohn in Soho, 1968.

a nickel in the slot of a Scopitone. He watches Little Richard pound-
ing on his piano, and discovers the truth:

> 'What was the truth?'
> 'Awopbopaloobop Alopbamboom.'
> 'Awopbopaloobop?'
> 'Alopbamboom.'[60]

By the end of the 1960s pop had a history long enough for the
truth born in 'Tutti Frutti' to get lost. Bands either now spent their
time trying to excavate it from some hidden tomb – a rave from
the grave; a blast from the past – or tried to put even more dis-
tance between it and them by burying it deeper beneath a veneer
of refinement and sophistication. The Who looked to be a bridge
to both the past and the future. In so much as pop was for the first
time feasting on its own history, this Janus approach was, at least for

the moment, a novel space for The Who to inhabit. The relentless series of shocks of the new documented by Cohn was seemingly at an end. Pop referred only to itself, it was now a Möbius strip of self-examination not dissimilar to the Woolmark logo. In 1968 its revelling in its own importance had only just begun, and on stage, with new and better forms of amplification, in ever larger auditoriums (and, later, stadiums) that show got bigger and louder; if *Tommy* was about anything it was about the circus that pop had become.

5 *TOMMY*:
THE POPERATIC

Pop music will cease to be of any interest if it gets too interested in musical or lyrical obscurity, because when it comes down to it, its purpose and its value is in the creation of an immediate and overwhelming excitement.

PETE TOWNSHEND to Tony Palmer in 1968

In an afterword to the section on The Who in *Pop from the Beginning*, Cohn noted the band had done another album, unnamed, and that it justified a lot of the things he had hoped for. Townshend had finally 'written a full-scale pop opera . . . and it's brilliant. In particular, two of the songs in it – "Pinball Wizard" and "We're Not Gonna Take It" – are as good as anything he's done, meaning that they're as good as anything anyone has done.'[1]

Following his stint with *Queen*, Cohn delivered irregular pieces for the *New York Times* between November 1968 and October 1971. In all, he wrote twelve dispatches from London. Predictably, his first was about British rock being at its lowest ebb since before The Beatles happened. The Beatles and the Stones had excused themselves from touring, their 'successors, Cream and The Who and Jimi Hendrix' spend all their time in the United States, record buyers play it safe and, consequently, the monthly pop explosion that was a mark of how much London swung had come to an end. 'All that's been left behind has been the dregs, the real third-raters.'[2]

Of new recordings by the established groups, sneak previews of *The Beatles* suggest a return to pre-*Sgt Pepper's* 'good hard rock' and that it is 'brilliant'. After a fallow-period, the Stones have dug down to 'bedrock and they're big all over again' with their last two singles 'Jumping Jack Flash' and 'Street Fighting Man', which have been 'fierce, crude and sexual, and their forthcoming album *Beggars Banquet* is shaping up to be their heaviest yet'.[3] With albums from The Beatles and the Stones on the cusp of release, Cohn turned to The Who, arguing that, of all the bands, they have 'been coming on strongest'.[4] He raves about their live shows, their stamina, Townshend's songwriting, and their yet unreleased songs 'Pinball Wizard' and 'I'm a Gypsy, I'm an Acid Queen', which he ranks among The Who's 'best yet'.[5] These records may turn the tide but, in the end, it is the live shows that count: 'without the basis of pretty boys singing and ugly girls screaming, without all the hype and bonanza that goes with it, everything else works in a vacuum'.[6] He waits for The Beatles to hit the road again and set the world alight with rock's 'beat and sexuality and insanity'.[7]

In December, with The Beatles and the Stones albums finally released, Cohn set the *New York Times'* letter pages alight when he championed the latter over the former. Without question, *Beggars Banquet* was the Stones' best album, he wrote, *The Beatles* was 'nothing'.[8] Unlike the concentrated focus of *Beggars Banquet*, *The Beatles* ranges wide, 'put together with endless care and tenderness and, finally, it's boring beyond belief'.[9] Remaining true to his pop manifesto, The Beatles may be more profound, sharper and inventive than the Stones, but the latter were excitement, wildness and sex, and 'that's what rock lives off'.[10] His next dispatch followed five months later, still bemoaning the shocking state of pop, or as it was now called, rock. Fortunately, *Tommy* was in the stores on both sides of the Atlantic.

It had become The Who's trademark, Cohn argued, to be always threatening but never quite delivering, allowing lesser talents to sneak up and steal the credit that should have been theirs. But now, the band had finally produced the 'most important work that anyone has yet done in rock'.[11] Given that he previously dismissed The Beatles for their aspirational profundity, how could Cohn justify his admiration for The Who's 'full-length opera'? Surely this was a pretension above all others previously held by rock? After introducing the idea of the work's importance, he then begins to tacitly deal with the contradiction by dismissing the storyline as 'unimpressive'. The 'plot doesn't work', he argued, 'all those religious-political-mystic overtones come straight off some intellectual conveyor belt, 100 stock rock parables for our time.'[12] On the other hand, he wrote, 'when was plot important in an opera?' What counts is the music:

> Almost two hours without a let-up, 25 tracks altogether, it
> hardly ever flags [he exaggerates; it runs one hour and 15
> minutes and has 24 tracks]. In turns, it is fierce and funny,
> schmaltzy and sour. Always imaginative. Well, it also has
> its moments of pomposity and some of the instrumental
> interludes are too long, but the good things swamp the bad.[13]

He rates five tracks among Townshend's best, the three previously mentioned in dispatches along with 'Christmas' and 'Go to the Mirror, Boy'. But the individual tracks are not the point, it is the sum effect that matters. This is 'the first pop masterpiece. And that is it.'[14]

Cohn thought that the 'use of the pinball machine as the central symbol [was] a good original touch', which is not surprising given that he was in part responsible for the idea.[15] The game had become part of Tommy's narrative when Townshend had talked through the

album's storyline with Cohn and played him some of the songs. As Townshend recalled, he had become friends with the writer, who was part of Lambert and Stamp's social circle, and they had taken to hanging out and playing pinball together in the arcades in Old Compton Street, near Track's offices. Cohn was then writing his novel *Arfur: Teenage Pinball Queen*. Townshend recalled:

One day Nik brought Arfur – the real girl who was his inspiration – to meet me. She was short, with short dark hair, pretty and rough-cut in a tight-fitting denim jacket. We would play pinball furiously and competitively and she slayed me on a machine with six sets of flippers. After our games Nik and I usually popped over to Wheeler's oyster bar for lunch. We were terribly Sixties pop about this – pinball, oysters and house Chablis.[16]

According to Townshend, Cohn thought *Tommy* in draft form was 'pretty good. But the story was a bit po-faced and humourless.'[17] In order to garner a positive review from him, Townshend played to the critic's vanity and interest and wrote 'Pinball Wizard', which incorporated terms used by Cohn to describe the game. Whether or not Townshend would give The Who 'an operatic masterpiece that would change people's lives, with "Pinball Wizard" I was giving them something almost as good: a hit.'[18]

And hits still mattered to Townshend. When telling *Rolling Stone* about how the album was influenced by the teachings of Meher Baba and how the band indulged his ideas, he also insisted that it was just as important to him that the album was a commercial success: 'I've only ever had hits with the Who. And hit records are very near and dear to me.'[19] Cohn's novel was published in Britain in March 1970, ten months after *Tommy* was released; it was not a

hit. The *Sunday Times* reviewed it relatively positively, 'a jolly little piece of inventive nostalgia, full of rich B-feature nomenclature, Runyonesque detail and sheer high spirits'.[20] The novel, the critic noted, was about 'the pursuit of style'.[21] The *Financial Times* critic thought the whole tale highly colourful and asked whether a book could be psychedelic? And the message? 'Perhaps the medium is for once the message. What is Arfur's future, all passion spent, at 16?'[22] None of the broadsheet reviews mentioned either *Tommy* or The Who. In the underground publication *Friends*, Jonathon Green readily picked up on the connection and called it 'Tommy in drag'.[23] But most reviewers were either unaware of the association or made little of it. *Arfur* was not published in the United States until May 1971. Sales there and elsewhere could not have been great as *Arfur* did not make it into paperback until September 1973.

Regardless of the novel's commercial and critical invisibility in the shadow of *Tommy*, the character of Arfur had achieved a public profile eight months before the album's release. She had featured as the cover star of an October 1968 edition of *Queen* and was promoted as a real life pinball celebrity. The magazine almost always featured an upcoming female film star or model of some renown on its cover, usually just a head and shoulders shot. The October edition was an anomaly, with Arfur posed sitting cross-legged dressed in black trousers and lace-up shoes, a blue and yellow striped knit top, red braces and a fedora. Inside she briefly expounds on her career and philosophy: 'Live clean. Think clean. Shoot clean pinball'.[24] Ray Rathborne's photograph was used on the dust jacket of the novel with another, on the back of the cover, of Arfur playing pinball alongside a punkish-looking Cohn in dark shades and a leather biker jacket.

Arfur is an Alice for the pop age. Her story proper begins when she falls through a funfair mirror and ends up in Moriarty

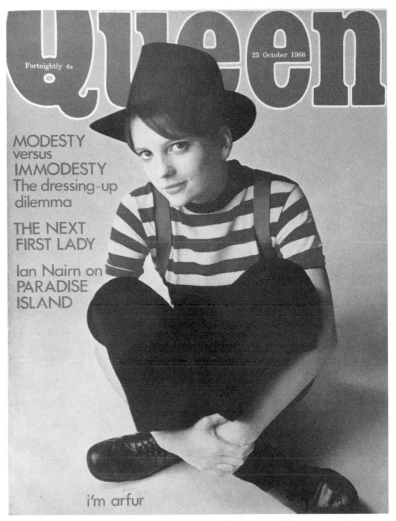

Eight months before the release of *Tommy*, Arfur appeared
on the cover of *Queen* (23 October 1968).

– a kaleidoscopic amalgam of Sax Rohmer's Chinatown, Conan
Doyle's Limehouse, Jelly Roll Morton's Storyville and Sergio
Leone's Wild West. A world of bar rooms, opium dens, brothels
and gambling parlours, peopled by characters drawn from literary
history who include Bram Stoker's Dracula, Jack Kerouac's Dr Sax,

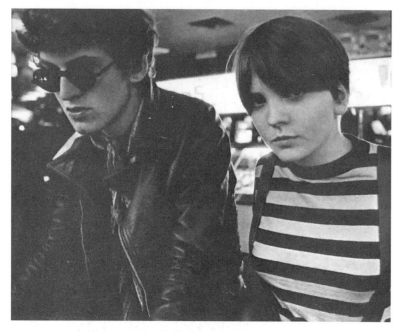

Live clean. Think clean. Shoot clean pinball: Nik Cohn
and Arfur playing pinball, as displayed on the back of
Arfur: Teenage Pinball Queen (1970).

Lewis Carroll's Alice (here gin-addled and consumptive), and fig-
ures celebrated in old-time songs and stomps; honky-tonk bullies
who take after Stagger Lee.

It is a picaresque tale in which Arfur wanders aimlessly through
Moriarty's tenderloin and its subterranean labyrinths. She is helped
on her way by kindly gentlemen such as the Chinaman Lim Fan and
the operator Otto Schultz – a professional tear-jerker – while min-
gling with the underworld's denizen's: Sun Ra, the process preacher;
Skinny Head Pete, Chicken Dick and the Pensacola Kid; Chinee
Morris, who left two hundred suits at his death; Jack the Bear, a
heavy so tough he could chew pig-iron and spit out razor blades;
and Willie the Pleaser, a card sharp whose only purpose in life was
to live with style.

The story follows Arfur from eleven to sixteen years of age. As her name suggests, and in keeping with the porous boundaries of the world she inhabits and the blurring of first and third person narrators, she is of uncertain gender. Midway through the novel she discovers pinball. During an intermission in her story, Cohn describes the game, something of its history, and its attraction:

> Pinball offers pure sensation: it looks perfect and sounds perfect and feels perfect, it has lights that flash and bumpers that buzz and numbers that unspool endlessly, it is speed and it is stillness, it is turmoil and calm, it is anything that the player cares to make of it. And always there is this, a certain secret connection, him and it, the player and his machine, and a time arrives when it isn't possible for the player to miss, when he is one with the table and he understands everything.[25]

The attraction is as rock 'n' roll. The game is to become the complete stylist – immaculate, clean and sharp. To morph, if you like, into The Who.

Was Arfur real, or a figment of Townshend's and Cohn's imaginations? If she was real was that her in the photographs in *Queen* or a stand-in model? Townshend once described her as a prostitute, or at least thought she might be.[26] If she was a living person then was Cohn using her to become the world's first pinball impresario, an Oldham or a Lambert of the electronic table? Whatever the difference between the two pinball wizards, Arfur was all myth and style, and Tommy all metaphor and spirituality. Arfur has yet to escape her fictional status; Tommy, on the other hand, became a pop legend – eclipsing even The Who and Townshend, his creators.

THE BRITISH MUSIC PRESS dealt with *Tommy* as if it was business as usual, which is to say not much more than the latest pop gimmick.[27] Part of the album's novelty was whether or not a story about a sexually abused deaf, dumb and blind boy might be 'obscene' or 'sick'.[28] In other forums *Tommy* was appraised more thoughtfully. Tony Palmer reviewed the album for *The Observer* and he believed that even if Townshend had written 'the greatest music of the twentieth century', musical snobs would not give him any credit or a fair hearing because he writes in the pop idiom.[29] He was using the establishment as a straw dog, presuming an opposition to his own view, which he could then attack. In actuality, it was remarkable just how widely and seriously the album was taken, even by musical snobs.

Billboard announced *Tommy* 'a hot item' in its thumbnail review, sandwiched between Bobby Vinton and James Brown. Elsewhere in the States, *Tommy* was being given a more respectful and expansive reception.[30] As was rock more generally. When Cohn was first employed to write about pop for *The Observer* in 1964, coverage of the topic in the broadsheets – the papers with cultural capital – was a novelty. By the time of *Tommy*'s release in the spring of 1969, it was expected.

Tommy was both a cause and symptom of the new pop serious-ness, summed up by *The Guardian*'s resident rock critic, Geoffrey Cannon – the first in Britain working for a daily broadsheet – in an article of May 1970 called 'Unpop Pop'. Pop, he noted, had split into two categories: pop as in popular and pop as in progressive or underground. That is, pop as either commerce or art.[31]

Being taken seriously did not mean that the conceit itself, a rock opera, was seen to have merit. For all those who celebrated Townshend's vaunted ambition, others found fault in it. George Melly did not pull his punches when it came to pointing out *Tommy*'s shortcomings, doing so in a manner you imagine Cohn

would have done if he had not been first and foremost a fan of The Who. Melly felt the album was 'in line with pop's new-found belief in its cultural role', but he also thought the music was a 'straight throwback . . . It's as though the heroes of pop's golden age had turned back towards the old certainties. It's as though they were beginning to feel that pop – as pop – had begun to lose its way.'[32] The Janus approach, The Who looking back as they moved forward, had not won over Melly. In sum, he considered *Tommy* to be 'pretentious in content and not worth a single chorus of "My Generation" in emotional or sociological insight'.[33]

In his *Record Mirror* column, Charlie Gillett discussed the significance of *Tommy*. He clearly held a soft spot for The Who and thought that their assimilation of a diverse range of American styles had made them unique among their peers. The Who incorporated 'the chunky, resentful guitar of Eddie Cochran, the harmonies of the Beach Boys, the tripping beat of Sandy Nelson, the rich guitar surge of the Ventures and a non-committal, unspecific West Coast vocal style', out of which they produced, incongruously, 'the most distinctly "British" music of the last five years. And some of the best music period.'[34]

The idea of a rock opera appeared to Gillett as a contradiction in musical terms:

the qualities of rock and roll have seemed to be its spontaneity, its impact on us through our physical and emotional senses, its unpredictability, and its compactness. Opera has seemed to be planned or contrived, to be directed at our intellect, and be long-winded. So what made the Who do opera?[35]

Other groups like The Jimi Hendrix Experience or Cream got lost, he wrote, in the freedom they found in rhythm and blues, but

The Who 'usually remembered that popular music has to have a regular beat', which made the idea of *Tommy* all the more puzzling. He credits The Who with being *artistes* and needing, therefore, to express themselves, but: 'If the singer becomes self-conscious about his effect, and the audience worries about its reaction, most of what rock and roll should be is gone.'[36] Opera demands discipline and self-control on the part of the listener and that is not what rock 'n' roll is all about, Gillett argued.

Gillett was the first to have written a Master's thesis on rock 'n' roll, in 1965, and was quite capable of giving a scholarly gloss to his ideas, but Barry Miles at *International Times*, with all the right Beatles connections and Oxbridge bona fides, was even better placed to spin British pop into a highbrow orbit. He had first interviewed Townshend for the journal in 1967. They had discussed, among other things, auto-destructive art and Gustav Metzger. With the release of *Tommy*, The Who gained even more comprehensive and extensive coverage in *IT*. Miles reviewed the album, track by track, in early May 1969, and then in the late May and mid-June issues he published another lengthy Townshend interview, this one fully focused on the album. Unlike Gillett, Miles was supportive of 'progressive pop music'.[37] He believed that in the forward rush from pop to rock, The Who had taken 'the final step . . . with a full scale pop opera.'[38]

Much of the interview dealt with issues of plausibility and *Tommy*'s storyline. Its complexity, Townshend thought, left behind the simplicities of characterization in Italian opera. He also explained that he had no intention of adding to whatever The Who, as four musicians, could bring to the table. No strings, no symphony orchestrations, no Albert Hall pipe organ. That was all fine if you were Frank Zappa, who he rated highly, but not for The Who. The concept had undergone significant alterations across the eighteen months it was

in gestation, but Townshend now thought it jettisoned the opaque and a good many of his pretensions. The finished article, he said, left behind some of the profundities and was now more in keeping with The Who's identity: 'pop and cosmic cartoony'.[39]

The discussion inevitably pulled in spirituality, and the influence of figures like the evangelist Billy Graham and gurus like the Maharishi. The messianic dimension is debated and Townshend recalled watching 'God Jim Morrison' at a Doors gig when a girl was injured trying to touch the singer on stage. She became the inspiration behind the 'Sally Simpson' track. He also spoke about the growing importance in his life of the avatar Meher Baba:

> The general theme of the album is a direct result of me getting involved with Baba, getting involved in a powerful spiritual move forward. I think the thing is more powerful because of that very reason, because the project has got a very high ideal to it. And also there's been a lot of Baba's basic teaching which had kept me from getting spiritually proud, you know what I mean? Sticking to the basic formulas of Rock and the basic formulas of lyricism and not to be religiously snobbish about the whole thing.[40]

In *Oz*, Britain's other leading underground rag, Graham Charnock thought the album's message was suitably ambiguous: 'answers aren't important,' he wrote.[41] Like The Beatles with *Sgt Pepper*, The Who had made an album that was recognizably them, but also something unique, 'a triumphal progression'.[42] Townshend had produced an opera 'using the language, music and values of his own generation': 'It's amazing, in fact, that the Who could have produced songs of such rawness and violence, with such momentum and with such emotional impact as the ones we find here.'[43]

In the same issue as its review of *Tommy*, *Oz* ran a Tony Palmer interview with Townshend that would later appear in his book, *Born Under a Bad Sign*. In it Townshend said, 'I'm today's powerful young man. I'm today's successful young man . . . It's crucial that pop should be considered as art. It's crucial that it should progress as art.'[44] *Tommy*, as it was received in such organs as *IT* and *Oz*, confirmed that pop was indeed Art.

If the British underground press had taken *Tommy* as a rallying point for the belief that their generation could scale the giddiest of cultural heights, this was no less the case in the States. In January 1968, The Who had their first, highly positive, exposure in *Rolling Stone*: 'The music of The Who can only be called rock and roll; it is neither derivative of folk music nor the blues; the primary influence is rock and roll itself.'[45] In February, *The Who Sell Out* was given a celebratory review – and they were granted the accolade of the paper's 'Rock and Roll Group of the Year Award' for 'their totally original sound, their refreshing attitude, their fine instrumental work, and excellent song writing.'[46] In September 1968 they were the paper's cover stars. Jann Wenner's interview with Townshend, conducted after one of the August Fillmore West gigs, ran over two issues, totalling around 15,000 words. Illustrated with Baron Wolman's sequence of photographs of Townshend on stage caught in a spotlight, the interview ranged across all the usual topics: smashing guitars, Mods, hippies and youth culture, the process of writing and recording, spirituality and rock's inner meaning, the current rock 'n' roll revival, performing, audiences and fans, jazz and Townshend's nose. The Who's 'opera', as Townshend called it, was also discussed. Not yet called 'Tommy', it was talked about under the title 'The Deaf, Dumb and Blind Boy' – 'a pretty far out thing actually,' said Townshend, who clearly already had a strong grasp of the storyline and theme.

Following the album's release, in July 1969 *Rolling Stone* again gave extensive coverage to The Who with another Townshend interview. 'For the first time', wrote Rick Sanders and David Dalton, 'a rock group has come up with a full-length cohesive work that could be compared with the classics.'[47] Tommy's progression from intuitive pinball player to a savant with followers is one of the areas the interview focused on. 'Life's games' is partly what it is about, explained Townshend, 'playing the machine – the boy and his machine, the disciples with theirs, the scores, results, colours, vibrations and action.'[48] Townshend's interviewers asked him if it is all a metaphor for pop music, 'which at one time was an unconscious thing and now has taken on a serious religious level?' Townshend avoids a direct answer, but suggests that the pop star and pinball champion are both absurd figures. He does concede, however, that there is a wider link between Tommy and pinball and human interaction with machines, like cars.

American newspapers, often using rock journalists who supplied copy to *Rolling Stone*, were also giving considerable exposure to The Who and *Tommy*. The *Chicago Tribune* covered the first of three nights The Who played at the city's Kinetic Playground. Dropping the overture from *Tommy* for this gig, The Who otherwise showcased the album in its entirety. The reviewer thought it came off 'even better on stage than on record'.[49] The band's performance was 'remarkable' and showed extraordinary command.[50] On the West Coast, the *Los Angeles Times* documented the premiere of *Tommy* at the Magic Circus, where Townshend announced they would do 'three-quarters or five-eighths' of the 'rock opera'. The reviewer raved that they capped 'brilliance with brilliance'.[51] When The Who played the Fillmore East in June, the *New York Times* was there to report that the group 'is still one the most exciting rock bands' and after describing each member's contribution, it noted they had

played selections from their 'rock opera'.[52] By mid-July, *Billboard* reported the 'Rock Opera' had gone gold, a $1 million seller certified by Recording Industry Association of America (RIAA), and their U.S. tour was winding up at San Francisco's Fillmore on Thursday the 19th.[53]

Having favourably reviewed the album and interviewed the band in July, in September the *Los Angeles Times* gave The Who further and greater coverage, beginning with a summary of their history, Mods, splintered instruments, the pre-figuring of *Tommy* (and even *Sgt Pepper*) with the 'mini-opera' 'A Quick One While He's Away' and acknowledging the full opera as 'one of rock's most brilliant accomplishments'.[54] The journalist John Mendelssohn then gave selected highlights from a series of interviews he had conducted with Townshend around the Magic Circus shows, in which the guitarist expounded on his theory of 'rock as an emotional catalyst':

You've got to come across so vulgar, so heavy, so glamorous, so flippant and so sure of yourself that you create equality just by your presence. This is what rock has always been about and always will be about – creating a feeling of being together in people. Even when we go on with very good vibrations there are moments when we feel that the audience should be challenged with violence, that they should see something violent and sudden right after being taken through something very poignant.[55]

Taking the audience on an 'amazing journey' that stretched across the duration of the show, encountering the emotional and the physical side of the band's music, became part of the new contract Townshend imagined between The Who and their fans. For him, playing live was an 'assertion of masculinity on an animal instinct

'level', which was akin to a Universal monster movie.[56] He said it was like watching an ape thumping his chest. He spoke too about why he was motivated to stir up stoned audiences. Discussing *Tommy* after the fact, he said, meant that much of its meaning has been reached for post-conception, and that its religious, philosophical and spiritual ideas shift within the new contexts the band encounter. In America 'everyone is far more concerned with problems of the flesh . . . there isn't time for person-to-person poetic communication' as there is in the land of Shakespeare and Milton, where you are 'permitted the selfishness of building a fiction around your own feelings'.[57] That kind of intellectualizing of *Tommy* was qualified by Townshend explaining that the music can also work at a more instinctual level, the chest beating part: 'Despite all of the flaws of *Tommy*, I'm still happy that it's also achieving something on a non-intellectual level, that it works as a musical piece. Which was really our aim, to come across on a rock level', to continue to entertain.[58]

When The Who returned to the Fillmore East for a six-night stand in October 1969, Albert Goldman turned up to cover the gigs for the *New York Times*. That paper's review of the concert in June had taken up no more than four column inches; Goldman's extravaganza ran for over a yard in length, nearly ten times the coverage. He loved the band and he loved *Tommy*:

> The score was a powerful steel blade blowing away the rancid
> incense of the hippies, the bells and baubles of the love
> children . . . What *Tommy* proclaims with the first blast of
> its Beethovenish horn is the red dawn of revolution . . . A
> prophecy as well as a passion, *Tommy* prefigures in its score (if
> not in its text) the final confrontation when blood will flow in
> the streets and the seats of power will be dynamited.[59]

Goldman is entranced by the idea of what the contradiction in terms of a rock opera might mean. At the age of 42, born on the wrong side of the war, he was losing himself in a contemporary culture that Greil Marcus and others thought he had no right to (and Marcus would hate with a righteous passion Goldman's 1981 *Elvis* biography).

Having parsed Beethoven, Bach, Mozart and Wagner in his unflinching admiration for *Tommy*, dealt with Judeo-Christian tradition and Oriental religion as 'familiar prescriptions' to which Townshend has added 'a new practice symbolic of the modern marriage of man and machine – the cultivation of perfection of *pinball playing*' – Goldman noted the similarities between the youth cult rendered in *Tommy* and the career of the rock 'n' roll star: 'In any case, the alternative of submission to the guru or revolt against the master brackets rather neatly the spiritual dilemma of the present generation, who would gladly learn but not willingly be taught.'[60]

Dismissing The Beatles's *Sgt Pepper* and Dylan's *Nashville Skyline* as respectively 'pipsqeak' and Nixon-esque, he claimed *Tommy* had

restored to popular music its traditional ideal of art. Following the great tradition of Scott Joplin's ragtime opera, *Treemonisha*, and George Gershwin's jazz opera, *Porgy and Bess*, the first rock opera has no truck with those camp-town cuties who insist that pop music must be made with built-in obsolescence.[61]

Was Nik Cohn the camp-town cutie? Regardless, Goldman concluded by noting the new rage for the 'poperatic' (including Lloyd Webber's *Jesus Christ, Superstar* and The Kinks' *Arthur*) and by imagining The Who playing at the Metropolitan Opera House, an act that would be heavily symbolic of the changing of the cultural guards, he suggested:

As a final touch, the evening's proceeds would be donated
to purchase bombs for needy high school students. After all,
Verdi's *Ernani* sparked a revolution in Italy – why shouldn't
Tommy trigger the first gun of the American revolution from
the citadel of uptightness, the Met?[62]

Writing about his ennui and despair with official culture and his
discovery of rock as something 'monstrous and fascinating, bizarre
and theatrical, stirring and ridiculous – as, in a word, a freakshow,'
Albert Goldman, before seeing Jim Morrison in 1967, had thought
rock was beneath serious discussion; and he still thought it was
'preposterous to go on solemnly about the Penguins and the Platters
as if they were something more than jukebox artefacts.'[63] The appeal
of the jukebox was precisely why Cohn was drawn to pop, but the
pleasure of pop as pop was beyond the crusading Goldman, who still
hung on to the remnants of a cultural hierarchy even as he embraced
the new as only a convert can. He was evangelical in his espousal of
the rock revolution, yet unwilling to give himself fully to the cause.
Contemporary pop, he wrote, is 'decisively inferior' music to the
jazz and show tunes of the 1930s, the sounds of his youth; but rock,
nevertheless, is their superior as a 'social phenomenon and much
richer as a social mix. Jazz is Beethoven and rock is Wagner.'[64]

In June 1970, The Who fulfilled at least part of Goldman's fan-
tasy and played at the Metropolitan Opera House. According to
Variety it was an entertainment and box office success, taking $55,000
for the two performances – close to $400,000 when adjusted for
inflation.[65] The *New York Times* also covered the shows. Their music
critic, Donal Henahan, six years older than Goldman, began his
review by asking, 'Why, do you suppose, have its admirers thought
it necessary and useful to label *Tommy*, an extended ballad in con-
cert form, as a "rock opera"?'[66] Little, he wrote, qualifies it as such.

Poster for The Who at the Metropolitan Opera House, 1970.

'Unstaged, unacted and uncostumed and minimally sung, *Tommy* actually represents one of the most successful attempts by aging pop performers to move past the standard rock concert or even transfigure it.'[67] Here he echoes Cohn's sense that maturity was overtaking the rock generation. Still, he thinks The Who should condescend to no one because they deliver a visceral punch unmatched by any other

group, and while the plot of *Tommy* may be 'poignantly sentimental' there is enough 'overt and covert symbolism to keep it from seeming as feeble as most things you can find in the Victor Book of Opera'.[68]

When Mike Jahn for the *New York Times* reported on the October 1969 gigs at the Fillmore East (he had also covered The Who's June performances at the venue) he now qualified the idea of *Tommy* as a 'rock opera'. 'It is a rock opera for rock lovers, in the same way *Hair* is rock theatre for theatre lovers.'[69] It is, he thought, a 'kind of ballad opera' and thereby made a bridge between the way *Tommy* was generally being thought of and the concerns that Henahan would raise the following year.[70] The fact that such terminology was being debated is what is important, not whether *Tommy* is best described as 'pop-opera', 'rock opera', 'ballad opera' or anything else. The confusion over 'pop' and 'rock' was also there in Nik Cohn's book; had he written a history of 'pop from the beginning', as the title of his British edition had it, or was it 'rock from the beginning' as with the American edition? In his 1971 biography of The Who, Gary Herman wrote that 'rock is progressive, pop reactionary.'[71] That value-laden distinction became the norm post-*Tommy*.

Henahan considered the link between the story of Tommy and The Who's young audience to be that many

> firmly believe they have been traumatized into something figuratively akin to autism, and it has left them functionally blind, deaf and dumb to the values of the gerontocracy that rules them and us all. So they are evolving what they hope are their own 'miracle cures', among which pop music is one of the more potent.[72]

That hybrid term 'rock opera' bothers him still, as it automatically invites a snicker – soap opera and horse opera come to mind. *Tommy*

deserves better, because once you get past its pretensions it is a 'tribal scream of togetherness'; and it is a lot of fun.[73] That final aspect is what Goldman overlooks in his race to celebrate the work's serious intent and, of course, it is what Cohn would have taken to; indeed, the showmanship of The Who might even have surpassed the spectacle of P. J. Proby. *Tommy* and The Who, Henahan wrote, proved that 'vaudeville is not dead.'[74]

The two Met shows were billed as the 'final performance' of *Tommy*. Henahan thought this a wise decision, because he saw the work as essentially short-lived, while Goldman spoke of it as if it was for the ages. '*Tommy* itself is musically thin,' wrote Henahan, 'and otherwise rather ephemeral at times, so for the performers it could only be a dead end.'[75] He confirmed Cohn's sentiments, here, as did his final line: 'The best rock depends on the surge of the moment; when it takes itself too seriously it dies. What could be less exciting than petrified rock?'[76]

IN THE SPRING OF 1970, a year after the release of *Tommy*, critic William Feaver wrote a lengthy article for the *London Magazine* on the art of the album sleeve, its history from a functional means of keeping the dirt out of a record's grooves to today's gimmicky covers that have 'embraced classicism, humanism, rococo, mannerism, romanticism and expressionism and thrown up not so much masterpieces (although these have appeared) as archetypes. Designers now look to these for ideas. Pop imagery has come of age.'[77] George Melly concurred, 'the record sleeve is at present the natural home of a visual pop style.'[78]

Feaver began his piece by recalling Karel Reisz and Tony Richardson's *Momma Don't Allow*, 'the muffled little documentary made in 1955' that featured 'boys with exclamation mark haircuts

and Dylan Thomas pullovers' and 'girls with crimped waists and perms', and dancers oblivious to the 'deluge of commercial art and music looming off stage'.[79] In the short span of time since that film of jiving north London teenagers, the design of album sleeves had developed 'by dint of relentless plagiarism or popularization of fine art concepts':

> Carried in the Beatles double LP package, the collage and typography of Richard Hamilton and Gordon House was bought by over two million people throughout the world. The cultural effects of this can remain beside the point, but there can be no denying that this form of art/design is being disseminated and accepted on a scale beyond the wildest dreams of, say, Centre 42.[80]

Centre 42 was an initiative by playwright Arnold Wesker to spread the best of culture beyond the elite.[81] The Centre's most visible outcome was the Roundhouse, an old engine shed in Chalk Farm reimagined in the mid-1960s as an arts and performance space. Discussing the process by which an art motif can be carried from performer to artist and sometimes back again, in part enacting Wesker's aim to more widely disseminate art, but at a level often lost on artists, Feaver wrote:

> So that Presley to Warhol, Jagger to Hamilton, become a spectrum of impressions: their real selves in concert, their photographic selves, their selves as gallery art, their selves picked out of the gallery and replaced by sleeve designers in market setting. The end product of this process is best seen in the orgy photograph inside the Rolling Stones' *Beggars Banquet* which adopts the garish phototint conventions used

by Warhol and Hamilton and thus turns Mick Jagger into one of the most complicated bits of motif in existence.[82]

On the other side of things, this process can end up in hopeless pretension: 'The Moody Blues, who specialize in being classy and poetical, provide the sort of music to eat After Eights by. Their packaging blends perfectly with their sound – each record illustrated with softened-up versions of the already second-hand vision.'[83] The Who's two most recent albums, *Sell Out* and *Tommy*, clearly sat within the category represented by *Beggars Banquet*'s use of fine art motifs that were then relayed back to the gallery and beyond; as such, *The Who Sell Out* was 'a clear homage' to Pop artist Claes Oldenburg and *Tommy* parsed a subtle blend of 'Magritte and M. C. Escher, a complicated play on space illusions'.[84] It was a scant ten years since Colin MacInnes had written about the teenagers in Soho gawking into the 'disc shops with those lovely sleeves set in their windows, the most original thing to come out in our life time'.[85]

Even as some establishment critics found value and worth in aspects of rock, others refused to be seduced. Often running alongside Cohn's columns for *Queen* was novelist Anthony Burgess's reviews of classical music performances and recordings. In a 1968 interview with Tony Palmer, the writer told him he liked pop as he liked Coca-Cola, wrapped bread or fish fingers. It was instant and gave the illusion of nourishment. What he didn't like, and what frightened him, was intellectuals 'elevating pop to the level of art'.[86] To compare even the best of pop with Beethoven, Mahler, Brahms or Wagner is absurd, because pop, he stated, cannot possibly contain the same 'emotional satisfaction and intellectual complexity'.[87] The Beatles' songs, he thought, had only simple lyrics and were 'written by young men of no great education and great knowledge of our literary past; they do a very simple job very adequately.' They dealt,

he said, with 'simple little emotions, suburban little emotions'. They wrote about adolescent love and desire, which existed without genuine knowledge of the world, and their music was sentimental with just a 'touch of fashionable toughness'. He excoriates the songs on *Sgt Pepper* as vapid sentiments treated vapidly. Pop is by and for the young, and all that youth has going for it is its youth.[88]

Palmer followed up Burgess's lament with an interview in which Kit Lambert talked about his father's mistrust of musical snobbery of any kind. Lambert was particularly proud of how Constant's compositions were full of jazz idioms, 'which were considered unthinkable by the musical élite'.[89] His father preferred to hang around with Louis Armstrong rather than classical musicians. Now, Kit is glad to see culture travelling in the reverse direction and that 'classical influences are being absorbed by pop'.[90] Nothing new is coming from the establishment, and he thinks 'that the impetus has passed to the younger generation and to the excitement that is generated in pop'.[91]

Geoffrey Cannon noted in his column in *The Guardian* that 'Pete Townshend said recently that because *Tommy*, The Who's double album, was classified as art the band was now losing all its old raver fans and had to play in Britain to university audiences all the time. He was outraged.'[92] Despite outrage, real or rehearsed, Townshend was as much to blame as anyone if he had lost the type of fan that once might have belonged to the Goldhawk Road contingent. His own ambition and the presentation and marketing of his music was just as responsible as any of the more progressively orientated bands for the gentrification of the pop/rock audience.

Townshend was acutely aware of *Tommy's* cultural status when he wrote in the introduction to Richard Barnes's *The Story of Tommy* (1977) that his opera had become rock's *Pirates of Penzance*. Following the album's initial reception, its extraordinary sales,

The Who's live performances, a Lou Reizner orchestration with guest superstar singers (including Rod Stewart and Ringo Starr), Ken Russell's film version of *Tommy*, a performance by the Royal Canadian Ballet and 'minor exploitations such as *Electric Tommy*, the music played on synthesizer, and *Marching Tommy*, the music scored for college brass bands', Townshend jokingly suggested *Tommy* had turned into 'light entertainment'.[93] But joke or not, the fear being expressed here is that his Mod group was losing its status as a people's band that thought of itself 'a little like the Punk Rock/New Wave bands of today do, though less politically inclined I think'. But like punk, The Who had 'complained about society, education, unemployment, diffident parents, capitalist exploitation of the young'. With the material success *Tommy* had brought, they had lost that need to complain. *Tommy* 'liberated us financially', wrote Townshend, 'but it also smashed us down in some senses. It challenged our legitimacy as true Rock chroniclers, and refused to age gracefully!'[94]

The jazz and pop columnist for the *Sunday Times*, Derek Jewell, had not much cared for the album on its release. He wrote that its makers had calculated to shock so that it comes on like a 'movie begging for an X certificate, or a paperback jockeying for prime space on the counter. Pete Townshend, the composer, is the Harold Robbins of rock.'[95] This was a more pointed and damaging critique than those which argued that *Tommy* was too pretentious for pop, or that its lyrical and thematic concerns jarred with its retrogressive musical posturing. Jewell was dismissing the work as middle-brow – where cheap sensation co-habits with a desire for cultural capital. When Townshend compared *Tommy* with a Gilbert and Sullivan operetta and other light entertainment he was similarly placing it into cultural purgatory – The Who played as background music at Abigail's party.

The idea that *Tommy* or The Who could be cast aside as 'music for pleasure' inevitably followed on from the commonly held belief that with this album the band had become part of the establishment it had once sought to confront and unsettle. It did not matter whether this was Townshend's intention because The Who lost control over *Tommy* as soon as it was released. Moreover, the critics at *IT* and *Rolling Stone* – Albert Goldman and even Kit Lambert among them – had said that this *was* Townshend's intention. Such excessive critical claims did not by themselves secure a place for *Tommy* within the canon of great works; rather, they had the – perhaps unintended – effect of condemning it to an indeterminate space, one neither high nor low, but widely mocked and reviled: easy listening.[96] Townshend surely saw this threat to *Tommy*'s authority and, when the dust had settled a little around his creation, gets in his own hits about its failed pretensions (and simultaneously contesting an over-valuation of The Who by aligning them with the attitude, if not the style, of punk). As he surveyed The Who from the standpoint of the late 1970s, Townshend had sought, in his contrary fashion, to bring *Tommy* back under control by reassigning it to a place where it would no longer compete with or challenge *his* authority. But six or seven years earlier, the more immediate issue was what to do after the deaf, dumb and blind boy had changed everything for The Who.

6 SEEKING THE DEFINITIVE
HARD-ROCK HOLOCAUST;
OR, THE NEW GOLDEN OLDIES

It's difficult to talk about rock and roll. It's difficult
because it is essentially a category and a category which
embodies something which transcends the category.
The category itself becomes meaningless. The words
'rock and roll' don't begin to conjure up any form of
conversation in my mind because they are so puny
compared to what they are applied to. But 'rock and roll'
is by far the better expression than 'pop'. It means nothing.

PETE TOWNSHEND to Jan Wenner, 1968

Whatever else he was, when it came to helping promote
The Who, Nik Cohn was a loyalist and their keenest critic.
In March 1970, he filed a *New York Times* report on the band's
forthcoming single, 'The Seeker', and their scheduled live album.
Always the contrarian, he began the piece by dismissing the new
single as a 're-hash of the traditional Who tear-up, loud, strong and
brutal, another "Call Me Lightning" or "Magic Bus", except that
it's not as good'. The single sounded tired and stale, he wrote, or at
least the music did. The lyrics were that 'odd mixture of arrogance
and fright, half-way between a boast and a confession' of the sort
Townshend specialized in and did better than anyone else. There

were no such qualms about the new LP: 'Quite simply, it is the best live rock album ever made.'[1]

Recorded at Leeds University Refectory in February 1970, *Live at Leeds* was essentially a document of the shows given on the last American tour, except for the songs from *Tommy* that were edited out. There are the old hits, a couple of songs from past albums and, Cohn wrote, 'three revived rock classics from the fifties ("Fortune Teller", "Summertime Blues" and "Shakin' All Over"). Without exception, they are shatteringly loud, crude and vicious, entirely excessive. Without exception, they're marvellous.'[2] The album brings to the fore all the 'ferocity and power' that had otherwise been held back on studio recordings, as if 'Townshend had suddenly been ashamed of all the obsessions and neuroses that produced his music and had tried to cover them up.' All such 'defensiveness' is put to one side on the album, which is alive with 'bum notes and missed cues, screwed-up harmonies and moments of general shambles'. None of which matters; the energy and speed of their performance sets aside any normal standards. The 'rage' of the early Who that had become a bore and hokum 'sounds real again'. Ignoring, because they run counter to his argument, the extended jams on side two ('My Generation' and 'Magic Bus'), Cohn wrote:

> The point about The Who's violence, the reason why it doesn't feel squalid, is that it carries such surprise and precision. Unlike the hard-rock groups that have followed them, Blue Cheer or Led Zeppelin, say, they don't go in for slow mutilation, wrestling a song to the ground and then bludgeoning it and tearing it until it has been mashed beyond all recognition. Instead, their brutality is fast and total, like a one-punch knockout or a clean kill in a bullfight. On its own terms, it carries elegance, range, humour and, yes, beauty.[3]

Townshend, he reported, likes the album because post-*Tommy* it recovers the visceral and the primitive that was threatened by becoming the 'pet poodle of the intellectual critics'. Townshend had a choice, wrote Cohn: become more cerebral or go back to 'straightforward rock 'n' roll singles'. The 'failure', at least in Cohn's terms, of the 'The Seeker' suggested the latter was a dead-end just as much as trying for another *Tommy* appeared to be. This problem, Cohn wrote, had been present from the beginning: 'Townshend is intelligent, creative, highly complex and much given to mystic ponderings, but the things that he values most in rock are its basic explosions, its noise and flash and image.' Which is to say, Townshend shared Cohn's pop view of things:

> So he writes stuff like *Tommy*, sophisticated as it is, and he can see that it's good but, at the same time, he feels that it's a cop-out from all the things that rock lives off, almost a betrayal. And he goes out on stage and he smashes his guitar, simple, mindless release. But then he gets his breath back and he knows that's not it either, to deny his own brain. And so it goes on, round and round with no end.[4]

Noise and image, theory and idea; the two sides of the equation that is The Who could once be contained within a two and half minute single but now needed a double and a single album to find expression. That change of scale eluded Cohn, who signed off with a suitably combustible declaration: 'The listener is winning on both counts. With *Tommy*, he got rock's first formal masterpiece and now, with the live album, he gets the definitive hard-rock holocaust.'[5]

Rolling Stone reviewed 'The Seeker' in April 1970. Like Cohn, John Mendelssohn found it lacking, mundane even, especially when compared 'to most everything from *Tommy* or the group's

live act'; but never mind, 'Bring on the live album,' he wrote.[6] Two months later his wish was granted, though it would fall to Greil Marcus to review *Live at Leeds* for *Rolling Stone*. He too, like Cohn, thought the band exhibited two personalities, rocker and intellectual. *Tommy*, he wrote, was an album of ideas, which 'writers felt compelled to write about, but for some reason it wasn't at all fun to read about, most likely because the ideas were already clear enough. *Tommy* was an album of ideas first and foremost; on record it didn't have much value as rock and roll.'[7] Its apparent 'profundity' was its attraction and fans bought it ('and bought Led Zeppelin to satisfy other sorts of needs').[8] *The Who Live at Leeds,* with its faux bootleg sleeve, reproduction of the 1964 Marquee poster and other pieces of memorabilia, was a 'tour-de-force of the rock and roll imagination'.[9] That said, and also noting the timely release, Marcus was not taken with the music, which he felt mimicked, rather than sped past, Led Zeppelin. The rock 'n' roll event of the 'My Generation' single had become an over-elaborate performance, running to fourteen minutes on the album.

'There's a lot of good music around these days – but very few events,' Marcus wrote in his review of *Leeds*.[10] He had once measured time by record releases, since the event of *Rubber Soul* say, but now he gauged time by such things as the National Guard shooting students at Kent State University in May 1970. Pop's ability to be the soundtrack for the times, to measure up to the day's political events, was being challenged. Only 'Summertime Blues' on the album truly represented The Who for Marcus, possibly because it did not 'belong' to the band like 'My Generation', which was not timeless, but changed; it was intimately part of the band's history and therefore could be discarded or abused. Cochran's song, on the other hand, was the 'grammar-book of rock and roll language' and 'The Who found a way to play it on their terms, let it form their

identity, and since they didn't create it there was never any need to reject it. Their performance here is glorious.' What the album documented, he concluded, was a moment of transition, 'the end of the first great stage of their great career.' What was to follow would depend on how Townshend translated the 1970s into rock and roll, 'a language that seems to speak most clearly when it stutters'.[11]

Between the release of 'The Seeker' and *The Who Live At Leeds*, Townshend gave yet another lengthy interview to *Rolling Stone*, conducted this time by Jonathan Cott. Townshend clearly shared similar concerns with Nik Cohn and Greil Marcus about where the band was heading to next, and he also shared their faith in rock 'n' roll's higher calling:

> I believe rock can do anything, it's the ultimate vehicle for everything. It's the ultimate vehicle for saying anything, for putting down anything, for building up anything, for killing and creating. It's the absolute ultimate vehicle for self-destruction, which is an incredible thing, because there's nothing as effective as that, not in terms of art, anyway, or what you call art.[12]

He spoke eloquently about the polarities of 'My Generation', its ability to attract and reject audiences: 'It repulsed those it was supposed to repulse, and it drew a very thick line between the people who dug it and the people who wouldn't dig it.' But what happens, he asked, when it was no longer the band's intention to repulse anyone, but to be inclusive 'to fuck everyone, as it were?' What happens when you confront an audience's preconceptions of the band? This was what *Tommy* did, he said. The opera was a twist, a turn that befuddled expectations, but now the expectation was for another *Tommy*, a trap Townshend was seeking to avoid. But

the question remained, 'what's next? Obviously we're not going to be able to make the record change immediately in nature and then present ourselves – ha *ha!* – out of the cupboard.'[13]

Once done, The Who's move along the cultural continuum – from pop towards the higher arts – was no longer repeatable. The transgressive effect of producing a rock opera, whether or not a gimmick, rapidly diminishes if reprised, but a retreat back along the continuum to the band's pop roots only produces a pastiche of past glories; 'The Seeker' was like, but was not, 'I Can See for Miles'. Townshend put it this way:

> 'The Seeker' [is] a bit like back-to-the-womb Who, not particularly very good, but it's a nice side, it's good because it's probably the only kind of thing we could do after something like *Tommy*, something which talks a little about spiritual ethics, blah, blah, blah, but at the same time is recapturing the basic gist of the thing.[14]

Cott suggested that the way out of this conundrum was for the band to embody what was going on, to reflect what's happening. Townshend agreed, but the line of the interview does not explore this and shifts to his involvement in the teachings of Meher Baba; the recording of *The Who Live at Leeds*; the death of Keith Moon's chauffeur Neil Boland, whom the drummer had accidentally driven over; Brian Jones's demise; Woodstock and Altamont; drugs, demo recordings and finished products. But what Townshend most wanted to do was make a film, something along the lines of the Stones's *Rock and Roll Circus*: 'a rock film which is not a documentary and not a story and not a comedy either but a fucking Rock Film. A film which is the equivalent of a rock song, only lasting an hour or longer.'[15]

What had been eating up Townshend's creative energies was the *Lifehouse* project, a concept that worked across media, especially music and film. In February 1971, in a dispatch from London for the *New York Times*, Nik Cohn explained where things were for the group in their preparation for making their first film, *Bobby*, with financing from Universal.[16] As with everything that surrounds *Lifehouse*, there's some dispute over its working title but, even if Townshend never called it 'Bobby', Cohn went for something that evoked *Tommy* in the most blatant manner.[17] Whatever the title, shooting was scheduled for the summer, with an American release expected by November. Townshend had given Cohn the scoop on the film and told him:

> It's a sort of futuristic fantasy, a bit science fiction . . . it takes place in about 20 years, when everyone has been boarded up inside their houses and put in special garments called experience suits, through which the government feeds them programs to keep them entertained.
>
> Then Bobby comes along. He's an electronics wizard and takes over a disused rock theatre, renames it the 'Lifehouse' and sets it up as an alternative to the government programs. Next he chooses a basic audience of about 300 people and prepares a chart for each of them, based on astrology and their personalities and other data; and from their charts he arrives at a sound for each of them – a single note or a series, a cycle or something electronic – anything that best expresses each individual.[18]

This was the concept, but what becomes clear from Cohn's article, and has been attested to numerous times since, was that there was no coherent narrative framework in which to house such a conceit.

On stage the role of The Who is to transmit these ideas, 'But they aren't the heroes, and neither is Bobby. The real centre is the equipment itself, the amps and tapes and synthesizers, all the machines, because they transmit the sounds: the hardware is the hero.'[19] For *Lifehouse*, Townshend seems to be re-imagining *Tommy* as less about a Messiah figure and more about pinball tables; about the means by which his spirituality was expressed. The concept appears, at least at this reductive level, as a rumination on McLuhan's theories about the media as an extension of man.

Whatever *Lifehouse*'s apparent shortcomings, in April 1971 The Who embarked on a series of concerts at the south London venue used by the Young Vic, an experimental theatre company, where Townshend would attempt to merge band and audience so that their interaction would go beyond performance, with each reflecting back the other. 'We aren't like superstars,' he explained 'we're only reflective surfaces. We might catch an energy and transmit it, but the audience doesn't take more from us than we take from them, not when the gig really works.'[20]

The influence of Meher Baba on Townshend's ideas was there in the mix, reported Cohn, but so was Townshend's involvement with his audience that 'goes right back to the Who's beginnings' when Mods gave their permission for the band to play and he learnt to project back the audience's sense of self.[21] Intriguingly, Andy Newman, frontman and piano player for Thunderclap Newman, was cast as Bobby and was expected to play the part at the Young Vic shows. But nothing of this project ever went quite to plan . . .

The story of why *Lifehouse* was abandoned has been told many times and in detail, especially when it comes to speculating on its shape and what might have been. Townshend clearly never completely lost faith in the project and in 1999 pulled together the *Lifehouse Chronicles*, a six-CD set that presented his original

demos, themes and experiments, arrangements and orchestrations alongside two radio plays. The boxed set was supplemented with a booklet that contained Townshend's musings, lyrics, a radio script and an overview by The Who biographer Matt Kent, which nicely encapsulates Townshend's concept and the problems he faced with conveying his idea to one and all. Ritchie Unterberger fills the first half of a three-hundred-page book on the topic in his detailed examination of the band's output from *Who's Next* to *Quadrophenia* and he still leaves the reader no more certain of what it was all about. What is known is that out of the debris of *Lifehouse* came an album that more than maintained The Who's status in rock's pantheon.

After the still-birth of *Bobby/Lifehouse*, The Who's studio follow up to *Tommy* was in all reality never going to be called anything other than 'Next'. 'What's next?' had been the defining question asked of the band for the past two years. The teaser from the album was a truncated version of one of its key tracks, 'Won't Get Fooled Again', and a launch party for the single and forthcoming LP was arranged at Keith Moon's country pile. In keeping with Townshend's and the band's virtual open access to music and underground journalists, a full contingent from *IT* turned up led by the rock 'n' roll revolutionary and social deviant Mick Farren. They got very drunk and cornered Townshend and laid on him a 'heavy rap' about the single's negative message: meet the new boss, same as the old boss.[22] A few days later, somewhat more sober, they sent a letter to Townshend setting out their position: 'Specifically the danger in the new single seems to be that it fails to differentiate between the megalomaniac and the courageous individual who is prepared to stand up and voice the sentiment "fuck you" to authority.'[23]

The issue they had with Townshend was about the leadership rock stars showed and the role models they were for today's youth, and with that came high responsibility. They wrote:

Since the days of the High Numbers you have progressively become more famous, successful and wealthy by playing fine and mighty rock music and by reflecting the power that this generation has discovered within itself. The Who have become a brand name for change and perhaps even a symbol with which kids who are fucked over in the streets can identify with.[24]

The letter writers, Chris Rowley, Mick Farren and J. Edward Barker, were not suggesting that Townshend and the band turn themselves into a 'youth guidance service' but they did want to know if he was shucking any sense of responsibility towards the kids and hiding behind the excuse he was a rock star in order to do nothing. They signed off by asking Townshend, as a 'self-realised man', what use was he 'gonna be to the community and the world in general?'

Townshend penned a considerate response. Both letters were published in a September edition of *IT*. His tone was friendly and intimate, but he ceded no ground to their arguments:

I suppose if I wasn't a cunt enough to be a Rock star I would be ... with you. The fact is ... I'm not with you. Neither in your neighbourhood nor frame of mind ... You remain frustrated, we reflect that frustration. You get pissed at people dying in campus warfare just like mum and dad used to die in France and Germany so we reflect that feeling of being pissed off ... The Who don't 'return' a positive attitude to youth because they get rich from their music. They REFLECT the negative attitude which a lot of kids are taking to the fight for power which is being waged in their name, but not on their terms.[25]

On the politics of 'Won't Get Fooled Again', he wrote that it was a personal song and a song that also 'screams defiance at those who

feel that any cause is better than no cause, that death in a sick society is better than putting up with it, or resigning themselves to wait for change.'[26] Power, he stated, belonged to the audience.

Mick Farren's response was to pan *Who's Next* as a retreat into the safety of the band's country homes; faced with The Who's flight into conformity his only recourse was to 'put on the "Ox" or "Can't Explain": and remember when the Who were the same as me and you'.[27] Perhaps what Farren wanted from The Who was the kind of clarion call to arms pitched by west London's Third World

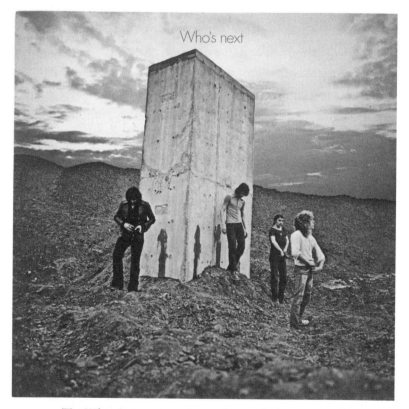

The Who give new meaning to the revolutionary cry of 'Up Against the Wall' on the sleeve of *Who's Next* (1971), and in the process piss off Mick Farren.

War, a group that had some affinities with Farren's old band The Deviants and other Ladbroke Grove reprobates such as The Pink Fairies. Their debut album was released in the same year as *Who's Next* and was avowedly political. This was rock as agitprop; it is there in the song titles, 'Working Class Man', 'Preaching Violence', 'Get Out of Bed You Dirty Red' and the album's single, 'Ascension Day', which begins with the protagonist loading a magazine clip and ends by declaring power to the people, the poor, the workers, to us all. Underpinned by Terry Stamp's chopper guitar, it hits hard and fast, punk rock before the fact, with lessons learnt at the school of The Who, but without their panache – which is to say their style. It lacks flash. Its aesthetic was graffiti on corrugated iron fencing,

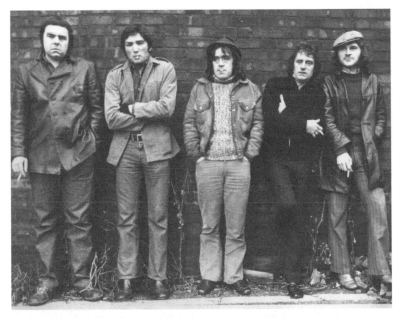

Third World War came from the same parts of west London as The Who. In 1970 Jim Avery (second from the left, with Terry Stamp to his right) told *The Guardian*'s Geoffrey Cannon that they wanted to 'recapture the fury that fired Pete Townshend to write numbers like "Substitute" and "My Generation"'.

cracked pavements and tower blocks in the rain as photographed by Roger Perry.[28]

Farren and Edward Barker would develop their ideas, or at least represent them, in the cartoon polemic *Watch Out Kids*, published in 1972.[29] It is a love letter to the transformative energy of rock 'n' roll and a rant against 'adult' culture, society and power. But it is hardly a coherent political manifesto; rather it is a set of lifestyle choices, with Melly's revolt into style re-figured as a rock 'n' roll revolution; more paean to the idea of a street-fighting cheetah in a good-looking leather jacket than a channelling of the anger inspired by the children of Marx and Coca-Cola who occupied the streets of Paris in May 1968 or the acts of resistance staged by the Black Panthers.

Whatever their differences, both Farren and Townshend displayed a remarkable belief in rock 'n' roll as an expression of youth culture that might be more than a provocation, another play of *épater la bourgeoisie*. Youth culture, however, was more pluralistic then either seemed to imagine or at least acknowledge. Neither party found anything positive to say about the new tribalism of Skinheads, Greasers and Rudys who, just over a year before the release of *Who's Next*, Cohn had surveyed for the *New York Times*. Of the three, the biggest group is the Skinheads, he reported: 'they've been multiplying like fleas, spreading and taking root throughout the country, until their numbers are now estimated at anything up to a million. Certainly, they've become the most dominant teen style since the original Mods, eight years ago.'[30] After describing their rituals and habits and the targets of their violence, he wrote, 'above all, they hate flash . . . They loath any kind of pretension, any attempt at individuality or style. Resolutely, they remain dumb, ugly and boorish.'[31]

The Skinhead held, Cohn wrote,

[an] especial hatred for Swinging London, all those mid-dle-class King's Road hippies with their long hair and scarves and kaftans, their easy words of love and peace. Such make-believe slumming, when the skinheads themselves are trapped in the real thing, appals them, insults them and makes them dream of revenge, a full-scale purge.[32]

Their music of choice is reggae, the 'total opposite' of the rock music beloved by King's Road hippies. The racial corollary to the Skinhead is the West Indian Rudy; they share a liking for the same music. They had been around for a while, Cohn informed his readers, but the Skinhead gave them a new profile, as did the reggae records in the charts.

In an article titled 'Skins Rule', Pete Fowler challenged the widely held belief that Marc Bolan and T. Rex were as popular as The Beatles. The boys from Liverpool had attracted a cross-generational and cross-gender audience, but T. Rex appealed mostly to teenage grammar school girls. If Bolan was to be as successful as the Fab Four then he would have to appeal to Skinheads, but he did not, and nor did previous generation groups like The Who and the Stones. Skinheads consumed their music at dances, not at rock concerts. Mapping the changes in their style, Fowler noted that braces and cropped hair had given way to

two-tone Trevira suits, and these in turn have given way to Crombies, and – for the girls – Oxford bags and checked jackets. But their attitude to music hasn't changed that much, nor has their attitude to football. On most Crombie jackets, there is the obligatory football club badge, as central to the

Skin's uniform as a pocket handkerchief. But on none of their clothes is there any sign of pop worship.[33]

The worry is that when pop went rock it fractured the universal teen culture that had supported the beat bands: 'The survival of Rock has depended on its position as the core of *Male* Teen Culture. But the bovver boys have rejected Rock's traditional status which explains the lack of vitality in British Rock in the early 70s.'[34] Fowler's analysis is superbly on point. Pop had fragmented, not just into distinct genres, but by age, gender and class. The Who's audience was symptomatic of these schisms, the band increasingly played to a maturing, male and middle-class constituency.

The third of Cohn's tribes, the Greasers, had also been around for a while: 'they're just the 1970 version of that time-honoured English figure, the Leather Boy. During the 1950s, he was known as the Teddy boy; in the early '60s, he became the Rocker; and now, after a couple of earlier attempts at revival, he's back yet again.'[35] Where once he was a 'natural expression of his time', now he was 'a self-conscious re-creation, a search for a lost Golden Age.'[36] Like the Skinhead, they are a revolt against hippie passivity and a return to hard physical fact, wrote Cohn:

> At any rate, the ballrooms are suddenly full of good hard rock again. Gene Vincent is making a comeback, Ronnie Hawkins has just arrived for a tour and future visits are planned by Chuck Berry, Fats Domino and Jerry Lee Lewis. The brand new dances are the jive and the jitterbug. Ponytails are back and so are tight blue jeans. Elvis Presley is worshipped afresh. And within a year it'll all have died down again, locked away for another decade, but, in the meantime, it's quite marvellous entertainment, a fine fast fling of a teen dream.[37]

The Greasers and rock 'n' roll revivalists were entertained not only by visiting, and visibly ageing, American rockers, but their own home-grown groups, mostly provincial (or at least that is the way they were made to seem), with Shakin' Stevens and the Sunsets, Wild Angels, Houseshakers, Rock 'n' Roll Allstars and Carl Simmons all having left a fairly significant legacy on disc, and many others playing the live circuit without much bothering the record labels.

These first-generation revivalists, or Teddy Boy rock 'n' rollers, rarely offered much in the way of original material and instead drew on the songbooks of Gene Vincent, Little Richard, Chuck Berry, Eddie Cochran, Buddy Holly, Johnny Burnette Trio, Jerry Lee Lewis and Carl Perkins, alongside some choice cuts from lesser Sun luminaries. The repetition across their albums is monotonous, as is the similarity in line-up, with guitar, electric bass and drums invariably augmented by sax squeals and pummelled piano keys, and the songs all hurled out at a terrific gallop. With the exception of The Sunsets debut, produced by Dave Edmunds (who subsequently rode high with his own contribution to the form with a cover of Smiley Lewis's 'I Hear You Knocking'), the recordings are at best of demo quality, mimicking the originals but hardly, if ever, holding their own. They were invariably released on budget labels, Contour and B&C for example, and shared rack space with pseudonymous combos like Warren Phillips and the Rockets, four-fifths of Savoy Brown.

Needless to say, their single releases did not bother the charts, offering a weak echo of the update given to rock 'n' roll's big beat by producers such as Tony Visconti with T. Rex or Mike Leander for Gary Glitter. Phil Wainman, Chinn and Chapman, Mike Hurst and Mickie Most also helped to put the stomp into the glam rock pastiches of 1950s teen iconography that paralleled the renaissance of the Teddy Boy.

Some of the revivalist album sleeves have designs that are less a resurgence of 1950s iconography – though they are that too – and more throwbacks to the Pop art imagery of the early 1960s. In the contemporary context of album graphics produced by companies such as Hipgnosis, best known for their Pink Floyd covers, these illustrations look decidedly anachronistic and often amateurish; pastiches of a Peter Blake painting that are out of time and out of place. Echoing to some extent Alloway's three phases of Pop art, George Melly discussed the collapse of the high and low versions, the fine art and the mass-produced Pop that occurred, he felt, during the second half of the 1960s:

> I can remember thinking of the prototype pop painting as something close to the hard mechanistic imagery of Peter Phillips: a hand-painted collage of pin tables, pin ups, car engines, highlights on plastic curves and art deco stencils. This for me was pop whereas now it's exactly this tendency which I feel has dated most.[38]

The problem was that Pop iconography aged as quickly as its referent: 'What amazed us in 1967 (*Sgt Pepper*) is already beginning to do no more than charm and what charms must eventually pall.'[39]

Little appreciated by rock critics, revival bands nevertheless peddled a compelling working-class identity that was displayed not only in their disdain for contemporary musical forms that were not built for getting pissed to, but in their anti-intellectualism. The Wild Angels' third album, released in 1972, *Out at Last*, depicts the band escaping from prison on the front of the sleeve and has police mug shots of them on the rear. Decca promoted the album with adverts that played on the image of them as illiterate thugs (or maybe, 'as any fule kno', an iteration of Ronald Searle's Nigel

Molesworth): 'Ya wanna stay alive? The angels is out an lookin ~~four~~ for kreeps hoo don't by there ~~allbum rekurde rey rekud~~ L.P.'

IN HIS REVIEW OF an Autumn 1968 San Francisco gig for the *New York Times*, Michael Lydon wrote:

> The Who play rock 'n' roll music. Not art-rock, acid-rock, or any type of rock, but an unornamented wall of noise that, while modern and electronic, has that golden oldies feeling... Townshend carries tapes of Cochran (killed in a car crash in 1960) wherever he goes. All four are big fans of what English pop fans call 'flash', the hard-edged charisma of fame, sex, power, and lavishly spent money.[40]

With *Tommy* and the *Lifehouse* project that 'flash' was in danger of getting lost. Whatever Mick Farren's response, the teenage wasteland rendered in *Who's Next* attempted to meet the challenge of communicating with a contemporary audience that could be recognized as kith and kin to Goldhawk Road Mods: fifteen-year-old school leavers, shop workers, clerks and factory fodder who would identify with, and applaud, the gesture of urinating on a monolith. For these kids, Townshend was saying, the new boss was always interchangeable with the old, that was just the fact of the matter. But did The Who any longer appeal to that audience of teenagers?

It was not just bands of a similar status to The Who that had come to rely on the student audience. According to Paul 'Legs' Barrett, the Communist Party card-carrying manager of Shakin' Stevens and the Sunsets, it was the college circuit that sustained them as a touring band; rocking clubs were not plentiful enough or sufficiently remunerative to support jobbing musicians. When

not sitting for, and getting stoned to, Colosseum or Gentle Giant, students, he wrote, liked to get wrecked and dance to rock 'n' roll. With its advanced use of synthesisers and Meher Baba inspired spirituality, primal screams and attack guitar, sentimentality and f-f-frustration, *Who's Next* deftly played to an audience of heads and head-bangers, thinkers and dancers – to the full gamut of students at the least. But what of those apprentices, who at work and on stadium terraces wore Doc Martens and boiler suits just like Townshend did in his anti-fashion, anti-rock star pose of the period?

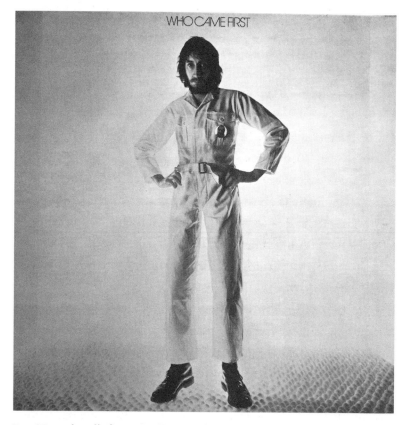

Pete Townshend's first solo album, *Who Came First* (1972), which pictures him in anti-rock star mode as a tender hooligan: standing on eggs, wearing Doc Martens, a white boiler suit and a Meher Baba button.

Even if they did not care for The Who, Townshend was unwilling to give up faith in that cohort.

Who's Next positioned the band on the right side of the divide between authenticity and commerce as laid out in the first edition of *Let It Rock* magazine, which was launched in late 1972. That divide separated the 'genuinely creative' from the 'merely fashionable and profitable'.[41] The journal intended to take 'seriously the idea of a rock tradition, stretching from the earliest days of rock & roll to now. This means regarding the music of the 1950s and '60s not just as material for nostalgia, but realizing that the sources of today's rock lie there'.[42] David Bowie and Elvis Presley shared the cover of the debut issue.

The revival, or at least one iteration of it, peaked with the London Rock and Roll Show that took place in Wembley, August 1972, and was headlined by Chuck Berry, Little Richard and Jerry Lee Lewis, with Bo Diddley, MC5, The Houseshakers and Gary Glitter further down the bill. Peter Clifton's film of the event captures the huge crowd of leather-jacketed rockers and drape-suited Teddy Boys intermixed with the nondescript and the non-aligned. Whatever the musical merits of the event, and the film suggests they were limited, the show was first and foremost the audience, a vernacular expression of youth culture, self-determined and defined.

That same summer of 1972, *Grease* made its Broadway debut, moving to London a year later. The musical codified and fixed the iconography of the revival. It commodified and reduced it and finally froze out those who had proselytized on rock 'n' roll's behalf. Released in 1973, George Lucas's *American Graffiti* furthered this process of ossification and exclusion as it opened the revival up to a mass audience. David Puttnam's 1973 production of Ray Connelly's screenplay *That'll Be the Day* did much the same thing but from a peculiarly vernacular perspective. This British vision was far darker and far more class-conscious than its American counterparts.

Keith Moon played a role in *That'll Be the Day* as the drummer in a band and Pete Townshend gifted a song to Billy Fury to sing as Moon's front man, Stormy Tempest. Meanwhile, John Entwistle killed time between Who projects and activities by releasing his third solo album, *Rigor Mortis Sets In* (1973), which carried the grave stone dedication 'In Loving Memory of Rock 'n' Roll 1950 – ∞: Never Really Passed Away Just Ran Out of Time'. Wrapped around cover versions of 'Hound Dog' and 'Lucille' was a set of songs rendered within the revivalist manner; it was an enjoyable 'Call Me Lightning'-styled romp or a 'Monster Mash' for the rock generation – a pastiche of a parody of a copy of the original that is now only half-remembered.

At the beginning of 1969 *The Guardian*'s rock correspondent reported on an exhibition dedicated to keeping rock 'n' roll alive. It was organized by Earl Sheridan, once of The Housebreakers and now president of the Rock 'n' Roll Appreciation Society. On trestle tables in St John's church hall, Stockwell, London, tributes were displayed to his heroes:

> The atmosphere was singular. It roved between that of a small archaeological museum, a grassroots European Catholic church (the kind that has postcards of saints pinned to a wall with doily surround) and a wake for a zombie. By its exhibition in South London, this sad trash took on strange meanings.[43]

The displayed artefacts and relics reduced rock 'n' roll, whether alive or dead, to history; a form of momento mori.

Towards the end of 1971, Nik Cohn was flown out to join The Who for what remained of their latest U.S. jaunt. The idea was for him to help brainstorm ideas around a film proposal and album with the working title *Rock Is Dead, Long Live Rock*, which Townshend

said would be about 'rock 'n' roll decadence in conflict with its youthful, idealistic roots'.[44] It would prove to be another aborted project, with the title song recorded in June 1972 but held back from release until 1974 on the *Odds & Sods* collection; it was the song gifted to Billy Fury in *That'll Be the Day*. In his autobiography, Townshend recalled asking Chris Stamp and Cohn to work on the movie treatment in secret with the idea that it 'present The Who in a simple, accessible way, in vivid, brilliant cameos'.[45] The Who would be used to 'explain why rock had happened'.[46] Townshend's hopes were realized in the introduction to the treatment, in which Cohn conceived of the band as a 'metaphor for Rock in general – their public, and their context, and their time'.[47] But Townshend's hopes were also dashed by the actual cameos Cohn created for each band member. It all made for 'sober reading' and Townshend did not share the treatment with the other three. He filed away Cohn's work and has kept it buried to this day.[48]

Cohn then turned to his own piece of rock 'n' roll revivalism and penned the text that accompanied Guy Peellaert's illustrations in *Rock Dreams: Under the Broadwalk* (1973), which more or less begins with an apology to the heroes of rock 'for the mutilation of their dreams and self-esteem'.[49] The illustrations and text of the first third of the book are the dark undertow that flows beneath the flood of golden oldies sets that hit the British market between 1972 and 1974, with their cute imagery of sock hops and soda shops or contemporary photographs of Teddy Boys shooting pool or posing with a buxom blonde and a chopped m'cycle – all presented with improved sound in electronically reprocessed stereo. *Rock Dreams* is about pop as a 'secret society, as an enclosed teen fantasy' dealing in 'images and obsession: Rock 'n' Roll romances'.[50] By the time the authors get to the late 1960s the dream has turned to ennui and boredom, the oneness of performer and audience has

Rock 'n' Roll is here to stay

EDDIE COCHRAN · FATS DOMINO ·
THE CLOVERS · THE VENTURES ·
JERRY LEE LEWIS · LONNIE MACK ·
SMILEY LEWIS · LARRY WILLIAMS ·
THE HOLLYWOOD ARGYLES ·
THURSTON HARRIS ·

C'MON EVERYBODY · ALLEY
OOP · GREAT BALLS OF FIRE ·
LOVE POTION NUMBER NINE ·
BLUEBERRY HILL · MEMPHIS ·
I HEAR YOU KNOCKING ·
SUMMERTIME BLUES ·
SHORT FAT FANNIE ·
LITTLE BITTY PRETTY
ONE · PERFIDIA ·
BE MY GUEST ·
SITTIN' IN THE
BALCONY ·
I WANT TO
WALK
YOU
HOME ·

United Artists rock 'n' revival collection, *c.* 1972; the '50s iconography of sex and juvenile delinquency is fixed but fluid enough to include a '70s take on Bardot, a custom motorcycle post-*Easy Rider* and a Teddy Boy (no doubt dressed by Malcolm McLaren).

dissipated, the decadent and the dissolute have replaced those who once peddled style. Bookended with images of Sinatra, the final picture, toupee in place, has him raising his glass in quiet salute to his unseen audience . . . 'I hope I die before I get old,' he says.[51]

IN THE ESSAY THAT accompanies 'The Director's Cut' edition of *Quadrophenia*, Townshend acknowledged the role Cohn had in helping him shape his ideas for the four-faceted character, Jimmy

– *Quadrophenia*'s Mod delinquent:

> I had commissioned Nik to deliver me a dispassionately
> observed model, having no idea what he would come up
> with, and it allowed me to move forward. Even so, I ended up
> with a question I don't think Nik was interested in trying to
> answer: if the four members of The Who were so desperately
> self-obsessed, insular and eccentric (even in their desire for
> normality), who was their most typical fan?[52]

For Townshend, the key idea presented by Cohn was that 'The
Who's four childhood psyches be combined into a single, passive,
character . . . called Tommy.'[53] This figure is detached, but always
watching:

> and – it seemed to me – desperately needing recognition, meaning,
> redemption, absolution and freedom. Nik's Tommy became my
> Jimmy, and all my character needed was to be granted a few days in
> which to find a way to recover from being a Who fan.[54]

In this telling, Jimmy is a stand-in for The Who's audience, those
who look to the band to find their identity and for a positive sense
of self to be projected back. In a 1965 interview, Keith Moon said,
'We call ourselves Mods, but it's not a disadvantage. The people who
come along identify with us. They look at us on stage and think
they're like us.'[55] Recognizing this reciprocal need, Townshend
looked back at his career as something that had been built out of
broken and then restated promises, hence rock is dead, long live
rock. 'The Punk and the Godfather' from *Quadrophenia* is where
this is best expressed. Daltrey takes the punk's or fan's role, accusing
the godfather or rock star of serial acts of betrayal, singing his part

with a dismissive sneer that foreshadows Johnny Rotten's rejection of the old order in 1976; they are both the punk with the stutter.

The premise of the rock 'n' roll revival was a fantasy that was based on the forlorn hope of returning to a pop ideal that existed before its fall, which is to say before the intellectual decadence of rock. In the late 1960s and early 1970s, rock 'n' roll assumed the mantle of a paradise lost, an age of golden oldies where, paradoxically, no one ever grew old. But as Nick Tosches wrote so eloquently in the preface to his own slice of revivalism, *Unsung Heroes of Rock 'n' Roll: The Birth of Rock in the Wild Years Before Elvis*: 'Rock 'n' roll is dead. Deader than Liberace. Deader than the papal penis. Dead.'[56] Dropping rock 'n' roll as now cheapened and besmirched by the revival, Townshend turned to his own foundation moment, the Mod culture of 1964. This return carried none of the unacceptable reactionary impulse of so much of the revival's ethos and, from the viewpoint of 1972, Mod carried an as yet unsullied teenage purity. In his long interview with *Rolling Stone* in 1968, Townshend pointed towards his seminal experience of Mod:

> It really affected me in an incredible way because it teases me all the time, because whenever I think, 'Oh you know, Youth today is just never gonna make it,' I just think of that fucking gesture that happened in England. It was the closest to patriotism that I've ever felt.[57]

As with *Who's Next*, *Quadrophenia* was a questing mix of social realism and spiritual self-realization. Like the protagonist in 'The Kids Are Alright', Townshend is desperate for peer group recognition and acceptance, while simultaneously attempting to manage a competing and conflicted desire to break away from the gang. Writing in 1971, two years before the release of *Quadrophenia*, critic

Gary Herman articulated something very similar when tracing the long-lived influence of Mod culture on Townshend, especially this tension between self and group:

> Above all, because Mods pursued the end of non-self-alienation, they also pursued collective experience. It is totally inaccurate to describe Mods as 'individualists', for they were only individualist in the sense that the whole group saw itself, and was seen, as a unit separate from the conformities of contemporary society.[58]

In responding to the alienation of work and repressive social regulation, Mods, Herman argued, showed

> real solidarity and a sense of collective experience that affected every moment of their daily lives. These two qualities echo themselves in many of the Who's earlier songs . . . No matter how far The Who have left their original sources of inspiration behind, the jubilation and the triumph of the collective mod experience always manages to reassert itself.[59]

Replicating Herman's point in an interview given to *Record Mirror* in September 1972, Townshend said, 'what I'm really trying to do is a kind of *Clockwork Orange* musically . . . There are so many tragic things involved with the Mods . . . it's got this incredible triumph in that the kid's an individual in the midst of a world where the individual doesn't exist.'[60] In contrast to the stripped-down mode of *Who's Next* and *Live at Leeds*, *Quadrophenia* was housed in an expensive gatefold sleeve that incorporated a photographic booklet. The black-and-white images gesture towards social deprivation, both in the setting of run-down and derelict terraced housing and an aesthetic that calls to mind Don McCullin's photographs

of London street scenes, but in the end this is all just background for the display of Mod attitude and style. Townshend's subject was teenage myth, not the reality.

Tracking the development of his ideas for the album, John Atkins alights on the possibility that the film *Bronco Bullfrog* had an influence on Townshend's thinking. It was an obscure picture at the time of its release in 1970 and it was not much better known when Atkins discussed the parallels between it and *Quadrophenia* in 2000.[61] Now readily available on Blu-Ray, Barney Platts-Mills's film is a fine examination of disaffected working-class youth at the turn of the decade. The teenagers' sub-cultural affiliations are little more than an odd gesture to contemporary trends shown in their choice of jeans, boots or haircut. A gesture only, because they are clearly without the economic wherewithal to buy a Crombie coat, Ben Sherman shirt or a pair of fringe and buckle stompers. The director was simply not interested in teenage style. The Who could offer nothing of value spiritually or materialistically to his subjects, and in turn it is far from clear that Townshend could take much from Platts-Mills's vision.

Quadrophenia was unapologetically a concept album, and was released in the same year as such weighty long-players as Pink Floyd's *Dark Side of the Moon*, Yes's *Tales from Topographic Oceans*, Jethro Tull's *A Passion Play* and Hawkwind's *Space Ritual*. As Atkins points out, 'In all these works, naturalism is eschewed in favour of fantasy, mock-fable, escapism, science fiction or downright muddleheaded pretentiousness.'[62] The matt-finished, grainy monochrome cover of *Quadrophenia* and its working-class Mod protagonist suggest something of a reaction against the grandiose gestures displayed by these behemoths of progressive rock. The Who, he argues, offered social realism in place of the fantastic, but *Quadrophenia* could be just as pretentious and otherworldly in its ambition and reach. The use of

elemental imagery, especially in the abundant references to water that accompany Jimmy's search for self-realization – his 'spiritual quest' as Atkins calls it – which has the power to wash away fear and doubt, or his pill-fuelled dissembling of identity, is a conceit every bit as fabulous as those of Floyd and Yes.[63]

In his review of the album, Charles Shaar Murray wrote, 'To say *Quadrophenia* is an affirmation of the strength of the human spirit is an invitation to accusations of pretension . . . but I'm afraid that that's the way it breaks down.'[64] He chips back at critics who would doubt the album's glories, who would call 'intensive listening to two years in the making double albums antithetical to the spirit of true rock and roll'.[65] In sum, he wrote, 'the early Who classics were straightforward expositions of an attitude, while *Quadrophenia* is an investigation of what went into constructing that attitude, and of its results.'[66] Dave Marsh made a similar point in his review in *Creem*. Pop history, he wrote, 'matters now, in a way it couldn't in 1965. We're not like that anymore, so why act like our troubles can be rocked away.'[67] In his interview with Shaar Murray, Townshend latched on to Bowie's *Pin-Ups* as a way to explain what was happening and why there was a turn to history in pop at this moment. *Quadrophenia*, he said, was about what has happened to the original Mod audience that followed The Who and has grown up with them; Bowie's album is doing the same thing but rather more directly. Where Bowie differs from the Who is that he's only been a star for the last two years, so if he 'feels the need to start talking about his past influences, then obviously the roots are getting lost'.[68] The discussion then focused on the intellectualization of rock and the critical backlash that followed, with Townshend pointing out the contradiction that those who do the denouncing use a matching level of intellect, 'And they're blaming [the rock star] for the fact that they've grown old.'[69]

In January 1974, the same month in which Shaar Murray's interview with Townshend was published in *Creem*, *Let It Rock* ran a 'Critic's Choice' spread. Thirty British and American rock critics told the magazine's readers which things about the music scene they liked best from the previous year. Along with Lester Bangs and Lenny Kaye, NME's Nick Kent liked Iggy and the Stooges, only he saw them as a call to arms rather than just a good night out: in 1974, 'hordes of deranged mutant-youth will spring up from the suburbs primed on Iggy Pop and wearing Keith Richards death-head face-masks to assassinate John Denver, James Taylor and Carly, and rock-writers who write turgid wank-analysis of Bob Dylan and Professor Longhair.'[70]

This was an example of the kind of thing Shaar Murray must have had in mind when he suggested to Townshend that some critics held fast to the idea of the rock star as 'noble savage'. Townshend countered that Iggy Pop (surely the most noble and savage of them all) had not grasped the fact that pop music was aimed at a fifteen- or sixteen-year-old kids and needs to 'contain a lot of tight, integrated, directed, pointed frustration'. He thinks The Sweet have almost grasped this, but they are out of time, ten years too late, but the Stooges will never grasp this idea, 'because inside they're old men'.[71] Townshend still held with the idea that the pop ideal must appeal to teenagers. He was one year shy of turning thirty, and the question of who were the old men in this game had become more acute.

Sometime in late 1975 or early 1976, Nik Cohn shifted base from London to New York. Along with illustrator James McMullan he was commissioned by *New York* magazine to provide a story on the emerging disco scene. 'The Tribal Rites of the New Saturday Night' was published in the June 1976 edition; screen rights were bought by Robert Stigwood. Norman Wexler wrote the screenplay and John Badham directed. The Bee Gees provided the key original

songs for the soundtrack, and John Travolta starred. *Saturday Night Fever* was released in 1977.

Cohn was expected to produce a piece of straight reportage on the Italian-American Brooklyn dance scene, but instead he turned in an impressionistic account that blurred the boundary between fact and fiction, inserting himself into the story as the man in a tweed suit. At the centre of the action is a character called Vincent. He was the 'very best dancer in Bay Ridge' – the ultimate Face:

> He owned fourteen floral shirts, five suits, eight pairs of shoes, three overcoats, and had appeared on American Bandstand . . . Everybody knew him. When Saturday night came around and he walked into 2001 Odyssey, all the other Faces automatically fell back before him, cleared a space for him to float in, right at the very centre of the dance floor. Gracious as a medieval seigneur accepting tribute, Vincent waved and nodded at random. Then his face grew stern, his body turned to the music. Solemn, he danced, and all the Faces followed.[72]

By his own admission, Cohn knew little about New York dance cultures, but he knew a great deal about Shepherd's Bush Mods and he translated this knowledge for his piece. 'All that I'd intended in my story was a study of teenage style. Even its fakery had been based on the belief that all dance fevers, at root, were interchangeable. Memphis in '55, the Goldhawk Road in '65, Bay Ridge in '77 – only the names, clothes and accents changed.'[73] In this scenario, attitude is a constant and style is a matter of modification.

The street gang that met each weekend at 2001 Odyssey are framed as Faces who, like their Goldhawk Road predecessors, are obsessed with self and clothes. Vincent was not a Ticket or a Number; he was a Face, one of the elite:

A tiny minority, maybe two in every hundred, who knew how to dress and how to move, how to float, how to fly. Sharpness, grace, a certain distinction in every gesture. And some strange instinct for rightness, beyond words, deep down in the blood: 'The way I feel', Vincent said, 'it's like we have been chosen.'[74]

Despite the scale of the Stigwood production, *Saturday Night Fever* told essentially the same tale as had been offered twenty years earlier in *Momma Don't Allow*: a narrative of class-based reinvention and self-determination, at least in those moments on the dance floor; and it provided the same spectacle produced by Lambert and Stamp in their film of The Who and Mod dancers at the Railway Hotel.

Early in 'Tribal Rites', in the middle of the tune 'The Bus Stop', Vincent, eighteen-years-old, soon to be nineteen, walks off the dance floor and slips outside. He slouches against a wall and sucks on an unlit cigarette. The man in the tweed suit approaches him, 'What's wrong?' he asks. 'And Vincent said: "I'm old."'[75]

CONCLUSION:
DON'T LOOK OVER YOUR SHOULDER

King Death had made himself redundant. Image had
taken him over so completely that his own secret self,
which he called Eddie, had lost all relevance. Alone
in his attic, he might continue to eat and sleep and
defecate, watch, dream and yearn. But he had no
meaning or function. Unless Seaton clapped and the
cameras rolled, he did not truly exist.

NIK COHN, *King Death*

The protagonist in Cohn's 1975 novel *King Death* is a hit-
man whose style and grace when dispatching a target is
serendipitously witnessed one day in Tupelo by an English
promoter. This Andrew Loog Oldham for the new media age
recognizes the next big thing when he sees it. The assassin, who
may or may not be Elvis's still-born twin brother risen again, is
marketed as 'King Death' and becomes a public sensation (another
Johnny Angelo or Tommy). His touch eventually fails him, he
becomes a pariah and disappears back into the shadows he came
from. In the late 1970s, The Who too were destined to play out
a set of pre-scripted moves; they, like King Death, became only
image. Except, here, there was no shadow for them to retreat into;
instead they were condemned to re-enact their own past in front
of their fans.[1]

Death was the theme of the April 1975 edition of *Let It Rock*. On the cover were images of Brian Jones, Jimi Hendrix, Janis Joplin, Buddy Holly, Sam Cooke and Otis Redding, with the headline asking, 'Is there Rock after Death?' Inside you got a handy 'Let it Rot Calendar of Death' along with a Simon Frith feature in which he wrote: '"Rock 'n' Roll will stand!" has become (defensively) "It's Only Rock 'n' Roll" and it's the retreat that's disillusioning, that has the smell of death.'² John Lennon's *Rock 'n' Roll* was one of the albums advertised alongside Chuck Berry's *St Louis to Frisco to Memphis* and yet another 'best of' Eddie Cochran, this one marking the fifteenth anniversary of his death. Alongside the revivalist album from the ex-Beatle, new product from an old rocker and yet more repackaging of a dead icon, six albums from Cream, Hendrix and Zappa, among others, were being marketed by Polydor as part of their budget line 'Rock Flashbacks' series of re-releases. Earlier in the year, Decca had been selling their collection of revenants, *Hard-up Heroes, 1963–1968*, curated by NME's Roy Carr and Charles Shaar Murray, which show-cased the early efforts of David Bowie, Rod Stewart, Eric Clapton and the like. Rock now had a history that could be resold along the same lines as the rock 'n' roll revival, which even then had not been milked dry. Inside the back cover of the magazine was a full-page advert for Ken Russell's *Tommy: The Movie*.

Earlier that year in *Let It Rock*, Gary Herman had returned to his favourite topic, The Who and Mods, giving a faintly depressing summary of the band's releases since the publication of his biography in 1971. Alongside *Leeds*, *Next* and *Quadrophenia*, he also noted the solo albums from Daltrey and Townshend, the three long-players from Entwistle and the one forthcoming from Moon, and listed seven singles and two compilations, *Meaty Beaty Big and Bouncy* (1971) and *Odds & Sods* (1974). Until this point in time, a central tenet of Mod – one that The Who held to all the way

through *Tommy*, and which was also true of the first phase of Pop art – was that they would be defined by change, by the transitory; they were rootless and were not beholden to the past; they could be relied on to shuck off yesterday's image in pursuit of the new as a means of reimagining the present. With *Quadrophenia* (and all the compilations) The Who's past became their present. The future tense evaporated from their repertoire.

In his piece on *Quadrophenia* for *Phonograph Review*, Greg Shaw remarked that Herman had written 'a whole book about Mod and, when it came time to put a title on it, his choice was clear cut, he called it "The Who".'[3] If this was even part way the case, there could be no surprise then that Herman was especially concerned with the band's latest studio outing in his overview, which he thought 'craftsmanlike' and 'unexciting'. *Quadrophenia* 'doesn't ring true as a simple Mod's tale. It's too overloaded with Townshend's self-conscious and arty interpretations; it's too much of what he thinks Mods should have felt.' The bigger problem, he wrote, was that the band had fragmented and had ceased to communicate directly with their fan base: 'Are we to assume that The Who are no more; that their isolation from audiences turned in on themselves and destroyed their own peculiar and special unity?'[4]

Four months later, in June, *Let It Rock* reviewed John Entwistle's fourth solo album *Mad Dog*, Keith Moon's first and the original soundtrack for the film *Tommy*. Their critic found himself in a fit of despair: 'there's no Who elpee here! Well, of course not – I mean there's no Who left, really. Will there ever be another Who elpee? Will it be as good/bad as *Tommy/Quadrophenia*? Do you care?'[5] Were The Who, after all they had achieved, now, like King Death, no more than a spectre, or might they once again reinvent themselves? Was the gap between the band and their fans unbridgeable or could the contract between them be renewed? Was rock heading

for an ignoble end, searching for its own King Death? Or might it yet be saved from itself?

Unlike Nik Cohn, who seemed to be content to kill off Dylan and the Stones (among others in rock's pantheon) and to then move on to new concerns, writers like Mick Farren and Nick Kent kept the search alive for rock 'n' roll excitement. Reviewing Lou Reed's eponymous debut solo album, Kent put the Velvet's main man alongside Dylan, Lennon, Brian Wilson and Van Morrison as among the greatest composers of the 1960s – all now, for one reason or another, either inactive or irrelevant. All except, that is, Reed, who with his 'gorgeous punk consciousness' and 'raw punk music' is still making records that can take their 'place alongside *Loaded*, *Teenage Head*, *Back in the USA*, *Killer* and a select few as standing for the continuation of the rock 'n' roll tradition in the 1970s'.[6]

In the June 1972 issue of *Frendz*, Kent lit on The Flamin' Groovies as that month's keepers of rock 'n' roll's true spirit after 'Chuck Berry left Chess to go to Mercury, Jerry Lee Lewis took up country music and Pete Townshend had started believing he was a genius.' The Groovies 'high energy punk consciousness rock a boogie' maintained that hoodlum line in rockin' tunes parlayed by the likes of ? and the Mysterians, The Seeds and Cannibal and the Headhunters: 'What those greasy rock revival bands who work the circuit in this country can never comprehend is that rock 'n' roll in its pure '50s form never really died.' The energy may have waned at times, wrote Kent, but it was there to the front in the early Stones, 'or those early vital Who tracks' and the Velvets. 'And now we're thick into the third generation rock comin' at ya straight from the frayed nerve-ends of the Teenage Wasteland.'[7]

Kent was working the same street as Lester Bangs and others at *Creem* magazine who had a predilection for romanticizing 1965 in the same manner as the rock 'n' roll revivalists latched on to 1955.

It was in 1963 that The Yardbirds spawned the Count Five and a thousand more garage bands eulogized in Bangs's seminal 1971 essay 'Psychotic Reactions and Carburetor Dung'.[8] Released late into 1972, Lenny Kaye's double-album *Nuggets: Original Artyfacts From the First Psychedelic Era, 1965–1968* further fuelled the nascent fascination with American punk bands. In Britain, the album gave support to rock critics' evermore frequent use of 'punk' to describe anything with a delinquent disposition that stood at odds to rock mainstream's increasing sophistication and self-awareness. More directly, it inspired record company backroom boys, especially Andrew Lauder at United Artists, to release British equivalents of Kaye's album. With *Mersey Beat '62–'64* and *Beat Merchants: British Beat Groups, 1963–1964*, Lauder compiled four LPs worth of reedy, frantic covers of American pop and R&B. The static from the original beat singles, when amplified by The Beatles and the Rolling Stones, was picked up by Kaye's and Bangs's garage bands, creating a perfect transatlantic loop of pop communication.

Lauder had been the head of United Artists' A&R department since the late 1960s and the person responsible for signing such notable underground bands as the Groundhogs, Man, Brinsley Schwarz and Hawkwind. In 1972 he bought The Flamin' Groovies to the UK and paired them in the studio with producer Dave Edmunds. If the band's two non-hits and work-permit problems temporarily ended their time touring England and recording in Wales, Lauder did not have to wait long before finding a replacement, Dr Feelgood. Signed in the early summer months of 1974, Dr Feelgood ignored the authentic blues parsed by the likes of Fleetwood Mac and Savoy Brown and went back a generation, filling out their set with songs such as 'I Can Tell' or 'Stupidity' that often owed more to versions by the Zephyrs or The Undertakers than to the tunes' original performers (Bo Diddley and Solomon Burke respectively). The blueprint for

the Feelgood's sound is there in its entirety on The Pirates' peerless 'My Babe' (backed with 'Casting My Spell', 1964). The British rock press lapped up the Feelgood's retrogressive pose: the first album defiantly recorded in mono, their minimalist aesthetic and aggressive stance; and they did it with an enthusiasm that matched their earlier disdain for the revivalists and despair over the excess of progressive rock. Responding to a question about the band backing Joe Meek's one-time star Heinz at the 1972 London Rock and Roll Show, Wilko Johnson, Dr Feelgood's guitarist, said:

> Teddy boys convinced us we didn't want nothing to do with classical rock 'n' roll . . . It was so mindless . . . it was based on a fiction . . . they wanted to hear a kind of music that never really existed. They thought if you didn't wear a drape suit, it wasn't classical rock 'n' roll, but no singers ever dressed like that. Chuck Berry never wore a drape suit. I used to love playing the old classics, but after a couple of gigs with teds I didn't want to know. We shied away from calling our music rock 'n' roll . . . we called it rhythm and blues instead.[9]

Across three Sundays in October 1975, the *Sunday Times Magazine* ran an A-to-Z 'Rock Report' that asked if there was 'intelligent life in Rock?' In what turned out to be the final issue of *Let It Rock*, Simon Frith began his review of *The Who By Numbers* with some thoughts on the *Times* entry on Pete Townshend, which noted that: 'His career has embraced both the most basic and honest side of rock and its most emptily pretentious.' Frith sets his sights on the cliché such comments had become – 'You got to understand the rules: basic = honest = good; complicated = pretentious = bad.' Any decline in The Who since those first few singles, he argued, was not because Townshend got pretentious,

'but because he got cynical – like any other surviving rock fan he won't get fooled again.' Rock will not save his life, Frith wrote, but sometimes Townshend can remember why rock once seemed so necessary.[10]

The Who by Numbers was not a triumphant return, Frith thought, but it is an album full of hope. He liked the 'old-style Mod frustration' in 'Slip Kid', the opening track. He worked his way through the album, identifying its unifying theme as the meeting of dreams with reality. By side two, 'Daltrey is singing with the confidence of age – Goodbye all you punks, stay young and stay high – a wry acceptance of the world, knowing and puzzled.'[11] The song is about playing the hand that fate dealt you, and that Nik Cohn would not have wished for you – to have lived beyond the age of thirty. The Who have grown old, they 'aren't a punk rock group,' wrote Frith, 'they're a skilled and fluent *band* . . . Townshend's task is to give an edge to this easy new Who – they ain't going to be punks any more but they could still be angry, could still tell us stories like no one else. It's gonna take good tunes though.'[12] Frith's reference to 'punk' seems prescient, an augury of what, with hindsight, we know to be just around the corner – only an ember, kept alive by Dr Feelgood, but ready to flare up and catch fire in 1976. Frith, however, is not a prophet; like Kent, he is using 'punk rock' within the limits his peers would recognize and understand.[13] In his liner notes for *Hard-up Heroes*, Roy Carr had sealed the immediate post-*Nuggets* meaning of the term when he described The Rockin' Vickers as the 'definitive British Punk Band Blackpool is still trying to forget'.[14] Punk signified yesterday not tomorrow.

The retrospective meaning of 'punk' was underscored in the same issue of *Let It Rock* as Frith's review of *The Who by Numbers*. Mick Houghton, in his article 'White Punks on Coke', noted that the term was being bandied around to describe any rock performer who camps

it up, such as Bowie, Jagger, Freddie Mercury or Iggy Pop; but 'they ain't punk rock,' he earnestly stated.[15] 'Punk' is a term that should be saved for the *Nuggets* generation of garage rockers, he argued, the 'first of the mid-sixties genres to be resurrected'.[16] The label is tricky to pin down, he wrote, but ? and the Mysterians, Shadows of Knight and The Leaves are exemplars of the form, which is 'less a style than a lack of style, defined by crude simplicity . . . Whatever else, the punk rock groups were people's groups – and that was important.'[17] If not punk, were The Who still a 'people's group'?

Also in that final edition of *Let It Rock*, bubblegum pop of various flavours was being gleefully theorized (and dismissed) as today's refashioned 'punk' music. Writing about the British glam side of the equation, under the subheading 'Seventies Punks', Gerald O'Connell predicted that glitter bands would share the same fate as '60s punk rock and become prized posthumously. More arrestingly, he speculated that the 'noise level [British bubblegum] espouses could easily create a generation of musical psychopaths for whom Black Sabbath would represent a cream-puff aberration.'[18]

In the 'Upfront' section of the magazine, Penny Reel reported on *Time Out*'s sponsorship of a series of gigs under the Charing Cross arches. The listing magazine's cover image featured Teddy Boys and the show's line-up included The Troggs (whose singer looks today like 'he owns the garage where he used to work as a punk mechanic'), Rocky Sharpe and the Razors ('a resplendent Edwardian requiem, weeded in crepe – who stole the show with their *West Side Story*-cum-Bermondsey routine') and The Count Bishops, a band with an ex-pat American singer and a name taken from a New York street gang, who mixed up high-octane covers of Chuck Berry, The Yardbirds and The Standells, which, on Mick Houghton's terms, would make them a punk rock revival group by any other name.[19]

The critical work being carried out through the varied use of the 'punk' tag is similar to that which had taken place in film culture and was then evolving to become part of the on-going academic validation of the topic. In 1968 the doyen of American film critics, Pauline Kael, published an essay, 'Trash, Art, and the Movies', wherein she espoused on the relative merits of an American Independent Pictures drive-in exploitation movie, *Wild in the Streets*, and Kubrick's *2001: A Space Odyssey* (both 1968).[20] The latter is sophisticated and erudite and appeals to the sensibility of educated adults; the former is infantile, pulpish and stupid. But trash film, argued Kael, has a vitality lost by the more refined and, in its ardent refusal to take things too seriously, it posed an affront to middle-brow good taste. Value can be found in pulp's illicit, outsider pleasures. This stance was less about any intrinsic value a film may hold and more to do with how critical positions are taken and then held.[21]

Critical discrimination based on a rejection of canons and a celebration of low taste goes back much further than Kael's intervention. Meyer Levin, writing in the 1930s, had discussed the pleasure he gained from the most elemental of cinematic experiences – watching 'punk pictures' in cinema's low-dives.[22] His stance was adopted by subsequent critics, among them Otis Ferguson, James Agee, Manny Farber and Jonas Mekas.[23] What these critics shared with the likes of Lester Bangs, Dave Marsh, Nick Kent and Mick Farren was a deeply felt antagonism towards a cultural status quo that they understood to be repressive, conservative and bourgeois. In 1975 in *Let It Rock*, in *Creem* or in the *NME*, the poles of the argument were punk versus prog rock.

Frith was correct, The Who were not punks. They were too old, too intelligent, too skilled to be that; but they had once been the fly in the ointment. The Who had beaten out trails for others to follow – bands who were younger, less learned and less skilled.

Zigzag magazine put punk on its front cover in May 1976 with a feature on Eddie and the Hot Rods, which ran under the heading 'Punk Rock Comes to Town'. Paul Kendall's enthusiastic coverage pulled in a now familiar retinue of punk attributes, not the least of which was having a set list based on a blend of R&B and punk numbers: 'Route 66', Sam Cooke's 'Shake', '96 Tears' and The Who's 'The Kids Are Alright'. Following the speed-freak rush of their debut single, 'Writing On The Wall', an original, Eddie and the Hot Rods' second single was a cover of Sam the Sham's 'Wooly Bully'. Despite this backward look, Kendall believed the band pointed to the future:

> In a time of economic recession, both financial necessity, and I think, the mood of the audience, dictates against extravagance of presentation and concept, and it is bands like Eddie and the Hot Rods and the Feelgoods who will survive, by doing something fundamental, and doing it with skill, style and energy, while those who seek to place themselves above their audience, with convoys of equipment and their grandiose schemes, will go down the dinosaur's way.[24]

The Hot Rods shot out of Essex in the slipstream created by Dr Feelgood, their name evoking any number of fantasy rock 'n' roll bands that might have a cameo in a 1950s nostalgia teen pic. The Hot Rods were not a strict rock 'n' roll revival band, they were third-generation rockers who, according to their manager, were riding on the mainline that had the MC5's *Back In The USA* as its departure and terminal station. And as Paul Barrett discovered when he tried to sell Shakin' Stevens and the Sunsets to Island's A&R man Richard Williams, second-generation revivalists were now truly out of date: 'Sorry,' the record company man tells him, 'I think you're too old. I'm gonna sign Eddie and the Hot Rods instead.'[25]

The Hot Rods debut single had been handled by Vic Maile, the go-to producer for pub rock bands. The disc had made little impression on the rock press or record buyers, so the band tossed around ideas for someone with a reputation to helm their next session, at which they had already decided to record 'The Kids Are Alright'. The band got their label to write to Pete Townshend, who replied in April 1976:

> Please stop trying to coerce me into producing Eddie and the Hot Rods. I'm desperately trying to sleep off the results of the last leg of the Who tour with a little meditative Mercedes buying.
>
> From the article you sent me they seem a particularly obnoxious little outfit destined for stardom. Three encores at the Marquee? If we had ever been asked to play an encore as early in our career I expect we would have split up.
>
> I don't want to be seen to be riding on a new group's wave. That manifestation would be affirmed if I were to produce their song as well as write it.[26]

Townshend's polite and playful rejection is charmingly self-reflective about his status as rock star – 'meditative Mercedes buying' – and the expectations placed on him in that role. That the Marquee was at the centre of the young band's career trajectory had not passed him by either.

The Hot Rods would get their first chart success with the *Live At The Marquee* EP, recorded in the long hot summer of 1976 and released the following autumn. Their road to fame would soon be eclipsed by the Sex Pistols, the bands' paths having crossed in the Soho club back in February of that year. *Zigzag*'s Kendall thought the Pistols had shown the Hot Rods a lack of respect when they

damaged the Essex boys' gear and drove out their audience. The
Sex Pistols are a 'joke band' he wrote.[27] That gig, via the pen of the
NME's Neil Spencer, gave the Pistols their first substantive media
coverage: 'Don't look over your shoulder, but the Sex Pistols are
coming.'[28] Spencer had missed most of the show, but saw enough
to get the idea,

> Which is . . . a quartet of spiky teenage misfits from the wrong
> end of various London roads, playing 60's styled white punk
> rock as unself-consciously as it is possible to play it these days,
> i.e. self-consciously . . . Next month they play the Institute of
> Contemporary Arts if that's a clue.[29]

Alongside their originals, the Pistols covered songs by the Small
Faces, The Creation, the B-side to Dave Berry's 'Crying Game' –
'Don't Gimme No Lip Child' – The Stooges' 'No Fun' and The
Who's 'Substitute'. The choice of covers was far more arch than the
Hot Rods; more self-conscious, as Spencer had it.[30] Like The Who at
the Marquee in 1964 and 1965, pushing their approach to borrowed
material beyond simply providing credible covers of Motown sides
(as The Action did), the Pistols moved things along. Respect for
the originals was not part of their agenda: 'Actually, we're not into
music,' one of the Pistols confided afterwards. 'We're into chaos.'[31]

The Sex Pistols were never entirely *sui generis*; Spencer had no
problem placing them within the day's punk rock mode while simul-
taneously mockingly suggesting they were also an art project (the
speculative ICA gig). Under the tutelage of Malcolm McLaren, a key
figure in dressing the rock 'n' roll revival from his Kings Road shop,
Let It Rock, the Pistols were working with someone acutely aware
of pop *and* of art history. McLaren's art school experience fuelled
his quick-witted understanding of the idea of creating situations,

and working with the New York Dolls had given him an appreciation of the radical potential of rock 'n' roll, as once promoted by Nik Cohn and delivered by The Who. Like Kit Lambert, as a pop impresario McLaren had larceny in mind; he also had a good memory (or a set of early Who clippings in his artist's portfolio). In April 1976, he wrote the band's first press release: 'Sex Pistols. Teenagers from London's Shepherd's Bush and Finsbury Park: "We hate everything."'[32]

In the rush of air produced by the Pistols in the first half of 1976, The Clash took a deep breath and struck a pose. Jon Savage writes, 'The Clash began . . . as a classic London mod-stutter group, every song a sped-up acrostic of The Who's "I Can't Explain".'[33] I first saw The Clash playing bottom of the bill at the Roundhouse on an autumn Sunday afternoon. The Kursaal Flyers, like the Feelgoods and the Hot Rods, an Essex combo, were the headliners. They were celebrating signing to CBS. Between them and The Clash were Crazy Cavan and the Rhythm Rockers – a rock 'n' roll revival band who had moved on from delivering the usual stock of golden oldies and were now rushing forward into the past with a very British version of Charlie Feathers-styled rockabilly. The audience was made up mostly of the disinterested and the nondescript in denim flares, a few hippies and a fair number of Teddy Boys who gave The Clash constant stick. They did this in good part because of the slogan 'Chuck Berry is Dead' that Joe Strummer had sprayed across his shirt, and because the paint-splattered charity shop clothes the band wore affronted the Teds' notion of sartorial correctness. As much as Strummer was killing off the rock 'n' roll revival with his stencilled declaration, he was also slaying his own personal past in the 101'ers, a band based on greaser rock 'n' roll laced with a Ladbroke Grove squatter's sensibility. However that confrontation between the Teds and Strummer presented itself, if you already had a copy of the first

The Eddie and the Hot Rods poster that appeared outside
London venues from the summer of 1976 – displacing the
remnants of The Who's *Maximum R&B* poster.

Ramones album it was pretty obvious which direction things were taking at that Roundhouse gig.

Punk's lineage with Mod was felt everywhere in those late months of 1976 and the first half of 1977. Punks versus Teds appeared like a replay of Mods versus Rockers. Short hair and straight-legged trousers went well with a return to the concise song form. Punks, knowingly or not, repopulated the clubs and alleyways in and around Soho through which journalists had once attempted to chase down Mod culture; leaning against the walls that Lambert and Stamp had previously littered with Maximum R&B posters. Those were now supplanted with the Hot Rods' equally stark *affiche* sourced from a 1950s American true crime magazine that featured a kid with a James Dean haircut threatening suicide by holding a pistol to his temple.

The acceleration of the everyday was aided by amphetamine sulphate powder, an often home-cooked, bitter alternative to purple hearts. Don Letts took the role of the scene's DJ – a post once occupied by Guy Stevens – playing Dub Reggae at the Roxy and, in his day job at ACME Attractions (a Kings Road emporium that had a scooter in the middle of its floor space) sold dead-stock Mod clobber. Having dropped the greaser pose, and now looking to shake some action as New Carnabetians, The Flamin' Groovies returned to the UK. On the sleeve of 'White Riot' (backed with '1977'), The Clash presented a montage of tower blocks and a clipping from *Generation X*. That book gave its name to Billy Idol and Tony James's band, while their debut single, 'Your Generation', attempted a direct confrontation with The Who's anthem. Meanwhile, The Jam laid their own irate path to 1979's full-blown Mod revival.

In a curious play with mirrors, Led Zeppelin bassist John Paul Jones recalled hanging out with Pete Meaden in Soho, his memories of the time now refracted through a post-punk filter that all but collapses the two subcultures:

The Sex Pistols make the latest claim to the streets in and around Soho: in Leicester Square and outside the Marquee in Wardour Street.

He took me to see the Who the first time down the Scene Club. It was brilliant, the Scene, smoky, loud, it was very punky in those days . . . The Flamingo was just funkier and jazzier; the Scene was all a bit white pop, more punk – what would become punk – and it was all pills.[34]

The Rolling Stones' formative years have been similarly filtered. Andrew Loog Oldham's first wife, Sheila Klein, remembered seeing the band for the first time, 'they looked like punks from another planet'; and Tony Meehan recollected working with the band in the studio, telling Oldham that the guitars were out of tune: 'He said "Great, isn't it?" He couldn't give a shit . . . It was image – he was selling an image and he did it very well. It was almost like punk.'[35]

Townshend would later confirm the Mod–Punk lineage by immortalizing a drunken Soho encounter with the Pistol's Steve Jones and Paul Cook in 'Who Are You'. Writing for *Rolling Stone* in November 1977, he gave his view of this moment in time:

When I listen to 'The Punk and the Godfather' on *Quadrophenia*, I come closer to defining my state three years ago. I was the Godfather. (When I met two of the Sex Pistols recently, I was in an appropriately raging, explosive mood, but I recognized their hungry, triumph-pursuant expressions and began to preach.)

In '73 and '74 I was the aging daddy of punk rock. I was bearing a standard I could barely hold up any more. My cheeks were stuffed, not with cotton wool in the Brando-Mafioso image, but with scores of uppers I had taken with a sneer and failed to swallow.[36]

In the early autumn of 1978, Keith Moon died. Drink mixed with prescription pills killed him. Townshend wrote that his death 'made me lose all logic. I was convinced that everything would be OK if we could only play, perform and tour.'[37] Fans no doubt felt the same way, but The Who as a creative unit would always be the lesser without Moon's contribution. He was no more replaceable than Townshend, Entwistle or Daltrey were. In his autobiography, Daltrey, like Townshend, recalled his resolve to continue, to not let Keith's death be the end: 'I was determined that the band should survive because of the music. And, of course, there was self-interest as well. It was my profession and my life.'[38]

Townshend's conviction and Daltrey's determination not to let things falter is understandable, but that which had originally driven The Who, the desire to flaunt convention, to remake one's world, to refuse the easy way, to contest what it means to be a pop product, that had all started to come to an end anyway around the time of *Quadrophenia*. The film adaptation of that album, and earlier of *Tommy*, with their spin-off soundtracks and books, along with albums like *Odds & Sods*, the Mod revival, an exhibition curated by fans on The Who's history at the ICA, the release of the documentary *The Kids Are Alright* in 1979 – they all had the cumulative effect of putting the band in suspended animation throughout the long second-half of the 1970s. Whatever the musical merits of *Face Dances* and *It's Hard*, these albums were never much more than product. This fact was underscored by having Peter Blake paint the cover for the former LP, the link between the Pop art band and the Pop artist lacked any frisson. The collaboration spoke neither to the pop moment, an excitement produced by the new, nor to pop's future; only to the past.

Reviewing 'Join Together' for *Melody Maker*'s 'Blind Date' column, self-styled Super Yob and Slade's guitarist Dave Hill

inadvertently anticipated this state of affairs when he said, 'To me the Who never have to be as good as their next single. They are established.'[39] Being established was what the early, Pop art Who set themselves in opposition to. Like any commercial product, obsolescence had been built into their concept of self. Renewing the contract between them and their audience was dependent upon movement, shucking off the past as dead weight, refusing the pull of tradition. Aspiring to the new had defined the band: '"My Generation" is spot on for the Who. For they ARE the generation. They're today and tomorrow, but never yesterday' was how a review in *Rave* magazine defined them in 1965.[40] In pop, age matters. After punk, The Who were the establishment, an institution. Rock was now a profession.

Pop's compulsion to repeat has been tracked by Simon Reynolds in *Retromania*. We live in an age, he argued in 2011, that has 'gone loco for retro and crazy for commemoration'. 'Could it be,' he asks, 'that the greatest danger to the future of our music is . . . *its past*?' Reynolds is something of a Cohn-ite, someone who believes in the pop explosion, 'a dynamic energy, creating the surge-into-the-future feel of periods like the psychedelic sixties, the post-punk seventies, the hip-hop eighties and the rave nineties.'[41] But everywhere he looks he finds only a counterforce of recycling, revival, re-makes and re-enactments. The pop volcano has been subsumed by its own lava and ash, a petrified history now confined to a display cabinet in the Rock 'n' Roll Hall of Fame, Inc.

If you understand pop history to be made up of small, short-lived, but seemingly significant events – The Beatles at the Cavern, Dylan going electric, The Who at the Marquee, the Pistols on Grundy – or landmark recordings like *Sgt Pepper* or *Tommy* that seem to signify a tectonic shift in the scene, then Mod or rock 'n' roll revivalists, or northern soul defenders of the true faith, can be easily dismissed as reactionaries searching for the certainties of

Promotional poster for *Quadrophenia* (1979, dir. Franc Roddam) – the film that helped spur the Mod revival.

yesterday and fearful of tomorrow. But a time frame that pays less attention to the fads and short-lived events that Cohn, for one, holds fast to, reveals that pop explosions have more in common with each other than any significant difference, as John Paul Jones inadvertently confirmed when he conflated the Mod and Punk scenes. At the very least, the pop moment is formed by, and has a stake in, the continuity of youthful non-conformity. Andrew Loog Oldham wrote: 'Nothing is original; it might *seem* to be, though, depending on your timing.'[42] Townshend at one point pondered on the idea of casting Johnny Rotten as Jimmy in the film of *Quadrophenia*; but they both agreed, he wrote, that 'he shouldn't play a tidy little Mod.'[43] The distinction between Mod and Punk, between Jimmy and Johnny, is style not attitude. And style, of course, matters. It is what pop is all about.

Youth rebellion and avant-garde provocation have, since the 1950s, been the common coin of an advertising industry that has assiduously absorbed and co-opted non-conformists, even as these artists and performers challenged the shibboleths, and refigured the boundaries, of contemporary pop culture. We consume pop on the basis that we are buying something new, something singular, something that does not wholly conform to the conventional, a style statement of resistance. But, for the most part, what we are really purchasing are regulated novelties; as much a contradiction in terms as the idea of the hip consumer. Regardless of pop's dependence on individuals or temporary creative collectives, the 'new' is a distinction we are willing to pay for that is determined by the pop industry much more than by any artist or subculture. Without industry intervention or appropriation pop activity would be held within a local orbit consisting of no more than those few hundred people who went to the Cavern or the Marquee.

The newness or originality, the novelty, of any mass-produced object is at best a fetish, a chimera that is pure surplus value. The Who's *Face Dances*, or any of their albums after *Quadrophenia*, had little in the way of the 'new' on which they could be marketed. The band was too familiar, too known to be sold as a novelty. Whether they liked it or not, The Who were now in the business of making heritage products, selling their fans the comfort of consuming the already experienced. The public clamour for what they are going to get anyhow, as cultural critic Theodor Adorno once put it.[44] By 1976 The Who's surplus value had migrated elsewhere, to punk. In their contradictory embrace and refusal of pop's history, the Pistols became the *new* Who even as they repudiated the comparison – *they* were now the band with built-in hate.

For the last forty years and more, The Who's legacy has been contained within a marketing and branding enterprise that replays

an iconography of roundels and arrows, Townshend's windmill arm forever frozen before the downward stroke, scooters and parkas, and 'hope I die before I get old' attitude that no one believes in any more than they do in any other advertising slogan. This enterprise hides and obscures what once made The Who true innovators within a pop industry when, even as they played the game, they refused its rules. Like advertisers, The Who absorbed and stole ideas from the avant-garde. But unlike ad-men they did not just pass on a diluted version to their audience, re-making the empty promise of self-transformation. Instead they spat back the lessons learned and started a new line of communication with their fan base.

The Who made the simple things complicated and the complicated simple; they put pop and art together in a set of couplings which rode the lines between authenticity and artifice, self-determination and co-option, the low and the high, the intolerant and the permissive. They set up a uniquely open dialogue between fan and star, which in their youthful and knowing, tender and violent way rewrote the language of pop. They did this with attitude and style.

In the dead space between *Quadrophenia* and *The Who By Numbers*, the band's back catalogue was promoted under the heading 'Who done it 1967–1974'. Beneath a 1965 picture of the band in all their Pop art finery there was a throwaway epigraph: 'From Shepherd's Bush Mods to time machine mystic travellers. The Who played longer, harder, and straighter, for the people, than anyone else.' Nik Cohn wrote that.

Who done it 1967-1974

"From Shepherd's Bush Mods
to time machine mystic
travellers. The Who played longer,
harder and straighter, for
the people, than anyone else."

NIK COHN

REFERENCES

INTRODUCTION: NIK COHN SAID

1 Kit Lambert quoted in John Heilpern, 'The Who', *Observer Colour Magazine* (20 March 1966), p. 12.
2 Tony Palmer, 'A Freakish Parable', *The Observer* (18 May 1969), p. 26.
3 Ibid.
4 George Melly, *Revolt into Style: Pop Arts in the 50s and 60s* (Oxford, 1989), p. 91.
5 Jonathan Aitken, *The Young Meteors* (London, 1967), p. 247.
6 Nik Cohn, 'Phil Spector: I'd Rather Be in Philadelphia', *Cream*, XIX (December 1972), pp. 10–13.
7 Derek Taylor, *As Time Goes By* (London, 2018), p. 180.
8 Melly, *Revolt into Style*, p. 91.
9 Simon Frith and Howard Horne, *Art into Pop* (London, 1987), p. 101.
10 Melissa L. Mednicov, *Pop Art and Popular Music: Jukebox Modernism* (London, 2018), p. 96.
11 Ibid., p. 97.
12 Nik Cohn, *Market* (London, 1965).
13 Ibid., p. 55.
14 Montague Haltrecht, *Sunday Times* (21 November, 1965), p. 33.
15 Cohn, *Market*, p. 141. When *Market* was published in paperback (Harmondsworth, 1970), Cohn excised this section along with nearly all the other parts that referenced contemporary culture. Perhaps by 1970 references to Proby or The Beatles read like anachronisms but, even if it aids the idea of the market as a place out of time, I think something is lost in the revised version and new readers should go first to the hardback edition.
16 Peter Laurie, *Teenage Revolution* (London, 1965), p. 7.
17 Nik Cohn, *Pop from the Beginning* (London, 1969), p. 227.

1 ATTITUDE AND STYLE: FOLK DEVILS AT THE RAILWAY HOTEL, HARROW

1 Charles Hamblett and Jane Deverson, *Generation X* (London, 1964).
2 Ibid., pp. 7–8.
3 Ibid., p. 9.
4 Paul Barker with Alan Little, 'The Margate Offenders: A Survey', *New Society*, IV/96 (30 July 1964), pp. 6–10.
5 Ibid.
6 Ibid., pp. 39–40.
7 Peter Laurie, 'So Young, So Cool, So Misunderstood – Mods and Rockers', *Vogue* (New York) CXLIV/2 (1 August 1964), pp. 68–9, 129, 135. In a far more entertaining manner, Tom Wolfe covered similar ground in 'The Noonday Underground', which was collected in *The Pump House Gang* (New York, 1969), pp. 75–88.
8 Laurie, 'So Young, So Cool, So Misunderstood', pp. 68–9, 129, 135.
9 Hamblett and Deverson, *Generation X*, p. 181.
10 Colin MacInnes, *Absolute Beginners* (London, 1980), p. 79.
11 See Peter Stanfield, *The Cool and the Crazy: Pop Fifties Cinema* (New Brunswick, NJ, 2015).
12 Dick Hebdige, 'Towards a Cartography of Taste, 1935–1962', in *Hiding in the Light* (London, 1988), p. 75.
13 Hamblett and Deverson, *Generation X*, pp. 137–8.
14 Andy Neill and Matt Kent, *Anyway Anyhow Anywhere: The Complete Chronicle of The Who, 1958–1978* (London, 2007), p. 46.
15 Colin MacInnes, 'Young England, Half English: The Pied Piper From Bermondsey', *Encounter* (December 1957), reprinted in *England Half English: A Polyphoto of the Fifties* (London, 1961), pp. 15–17.
16 George Melly, *Revolt into Style: Pop Arts in the 50s and 60s* (Oxford, 1989) pp. 56–7.
17 Ibid.
18 Ibid., p. 48.
19 Andrew Loog Oldham, *Stoned: A Memoir of London in the 1960s* (New York, 2000), pp. 213–14.
20 The (minor) importance of the 2i's in the story of The Who is that this is where Shel Talmy chose to hold an audition with them before he agreed to act as their producer; see Neill and Kent, *Anyway Anyhow Anywhere*, p. 46.
21 Johnny Black, *Eyewitness, The Who: The Day-by-day Story* (London, 2001), p. 23.

22 Ibid., p. 24.

23 Ibid., p. 36.

24 *Record Mirror* (11 July 1964), reproduced in Norman Jopling, *Shake It Up Baby! Notes from a Pop Music Reporter, 1961–1972* (Kingston upon Thames, 2015), p. 178. Jopling provides plenty of colour on the Meaden era.

25 Black, *Eyewitness, The Who*, p. 27.

26 Steve Clarke, *The Who in Their Own Words* (London, 1979), p. 37.

27 Tony Palmer, *Born Under a Bad Sign* (London, 1970), pp. 123–4.

28 Neither of the two major English-language biographies of Godard make any mention of him teaching at the Institute in the period Lambert studied there. Most probably Lambert's claim is just a bit of hip self-promotion, adding a little more cultural capital to his personal bank. Colin MacCabe, *Godard: A Portrait of the Artist at Seventy* (London, 2003) and Richard Brody, *Everything is Cinema: The Working Life of Jean-Luc Godard* (New York, 2008).

29 Andrew Motion, *The Lamberts: George, Constant and Kit* (London, 1987), pp. 286–7.

30 Ibid., p. 291.

31 Ibid., p. 294.

32 Peter Laurie, *Teenage Revolution* (London, 1965) p. 57.

33 Motion, *The Lamberts*, p. 309.

34 The first commercial release of The Railway Hotel footage, which had long been considered to be a lost film, was as part of the bonus material on the DVD of *Amazing Journey: The Story of the Who* (2007, dir. Paul Crowder). Outtakes can be seen in random moments in *Lambert and Stamp* (2014, dir. James D. Cooper) and in *The Kids Are Alright* (1979, dir. Jeff Stein). Though mute rushes of the film were held in the band's archive, a print with sound was only discovered in 2002. This copy had been sent to a Paris-based friend of Lambert's. The film was shot on 11 August 1964, as marked on the clapperboard images in the rushes. The much-bootlegged live tapes of The High Numbers were also recorded on this date. I am grateful to Andy Neill, who supplied information about the extant Railway Hotel footage (email to the author, 1 August 2018).

35 The Free Cinema Manifesto is reproduced in the unpaginated booklet that accompanies the BFI DVD collection of their films (2006).

36 Ibid.

37 MacInnes, *Absolute Beginners*, p. 61.

38 Ibid.

39 Ibid.

40 Nik Cohn, *Today There Are No Gentlemen: The Changes in Englishmen's Clothes Since the War* (London, 1971), p. 52.

41 For a survey of Mondo films see Mark Goodall, *Sweet and Savage: The World Through the Mondo Film Lens* (London, 2018).

42 Iain Sinclair, 'Primal Screen', *The Guardian* (9 September 2006), www.theguardian.com, accessed 5 July 2018.

43 *Carousella* has had a 2011 Blu-Ray release as part of the bonus material that supported the BFI's issue of *Primitive London*. Richard Wortley, *Skin Deep in Soho* (London, 1970).

44 The film's director, John Irvin, and producer, Tim Miller, provide a short overview of the post-production difficulties in the booklet accompanying the film's BFI Blu-Ray release.

45 One documented use of the film was when The Who played at the Shandon Dance Hall, Romford, 2 October 1964 (Neill, email to the author, 1 August 2018).

46 Richard Barnes, *The Who: Maximum R&B* (London, 1982), p. 36.

47 Richard Barnes, *Mods!* (London, 1979).

48 Gary Herman, *The Who* (London, 1971), pp. 30–31.

49 Compare this footage with the French television programme that investigated the Mod phenomenon and which heavily featured The Who, *Seize millions de jeunes – Mods*. Recorded in February 1965, it is quotidian and uninspired in its delivery. The band are filmed straight-on on the Marquee's stage without an audience. Kit Lambert looks suitably louche explaining Mods and Rockers to his interviewer; the shots of the kids getting pilled up are worth treasuring, but there is little excitement to compete with the Railway Hotel footage. The programme has been archived on Vimeo, https://vimeo.com, accessed 31 July 2018.

50 For an in-depth history of the celebration of pulp directors and films, see Peter Stanfield, *Maximum Movies – Pulp Fictions: Film Culture and the Worlds of Samuel Fuller, Mickey Spillane, and Jim Thompson* (New Brunswick, NJ, 2011).

51 Oldham, *Stoned*, p. 76.

52 Melly, *Revolt into Style*, p. 117.

53 Laurie, *Teenage Revolution*, p. 28.

54 Marshall McLuhan, *Understanding Media: The Extensions of Man* (London, 2001).

55 Laurie, *Teenage Revolution*, p. 26.

56 Neill and Kent, *Anyway Anyhow Anywhere*, pp. 70–71.

57 The geographic scope of Mod culture circa 1964 is very clearly delineated in Ian Hebditch and Jane Shepherd with Mike Evans and Roger Powell, *The Action: In the Lap of the Mods* (London, 2011).

58 Richard Williams, 'Ready Steady Go!', *The Independent* (3 April 1999), www.independent.co.uk, accessed 20 July 2018.

59 Ibid.

60 Stanley Cohen, *Folk Devils and Moral Panics: The Creation of the Mods and Rockers* (London, 1972), p. 186.

2 THE WHO PLAY POP ART

1 Peter Laurie, *Teenage Revolution* (London, 1965), p. 57.

2 Andrew Loog Oldham, *Stoned: A Memoir of London in the 1960s* (New York, 2000), pp. 77–8.

3 Nick Jones, 'Caught in the Act', *Melody Maker* (9 January 1965), n.p.

4 Ian Hebditch and Jane Shepherd with Mike Evans and Roger Powell, *The Action: In the Lap of the Mods* (London, 2011), p. 51.

5 Jon Savage supplied the transcript of his 2011 interview with Townshend, for which I am grateful.

6 Cited in Joe McMichael and 'Irish' Jack Lyons, *The Who Concert File* (London, 2004), p. 25.

7 Hebditch and Shepherd, *The Action*, p. 9.

8 Ibid., p. 47.

9 Ronnie Wood, *How Can It Be? A Rock and Roll Diary* (Guildford, 2015).

10 Hebditch and Shepherd, *The Action*, p. 46.

11 Tony Palmer, *Born Under a Bad Sign* (London, 1970), p. 123.

12 Jonathon Green, *Days in the Life: Voices from the English Underground, 1961–1971* (London, 1988), pp. 47–8.

13 Palmer, *Born Under a Bad Sign*, p. 117.

14 Green, *Days in the Life*, pp. 47–8.

15 *Melody Maker* (3 July 1965), p. 11.

16 John Heilpern, 'The Who', *Observer Colour Magazine* republished in John Perry, *The Who – Meaty, Beaty, Big and Bouncy: Classic Rock Albums* (New York, 1998), pp. 158–66.

17 Republished in Mark Francis, ed., *POP* (London, 2005), p. 198.

18 Lawrence Alloway, 'Pop Art: The Words', *Auction*, 1/4 (February 1962), pp. 7–9. Revised in *Topics in American Art Since 1945* (New York, 1975), pp. 119–22.

19 Ibid.

20 Ibid.

21 Ibid.

22 Ibid.

23 Ibid. See also Sasha Torres, 'The Caped Crusader of Camp: Pop, Camp, and the Batman Television Series', in *Camp: Queer Aesthetics and the Performing Subject: A Reader* (Edinburgh, 1999), pp. 330–43. Richard Kalina, ed., *Lawrence Alloway – Imagining the Present: Context, Content, and the Role of the Critic* (London, 2006), p. 26. For an expansive investigation of Alloway's film criticism, see Peter Stanfield, 'Maximum Movies: Lawrence Alloway's Pop Art Film Criticism', *Screen*, CDIX/2 (Summer 2008), pp. 179–93.

24 'The Clock King's Crazy Crimes' (first aired 12 October 1966).

25 Marchbank has the name of the show wrong, he means the *New Generation: 1964* show at the Whitechapel Gallery. The Gulbenkian sponsored the Tate show, which was extensive in its coverage of contemporary European and North American art. Green, *Days in the Life*, p. 63.

26 Andy Neill and Matt Kent, *Anyway Anyhow Anywhere: The Complete Chronicle of The Who, 1958–1978* (London, 2007), p. 67.

27 Patrick Kerr, 'Pop Scene', *Queen* (2 June 1965), p. 27.

28 Patrick Kerr, 'Pop Scene', *Queen* (16 June 1965), p. 18.

29 *Boyfriend* (3 July 1965), p. 26.

30 Heilpern, 'The Who' pp. 158–66.

31 Thomas Crow, *The Rise of the Sixties: American and European Art in the Era of Dissent* (London, 1996), p. 25.

32 *Melody Maker* (3 July 1965), p. 11.

33 Ibid.

34 George Melly, *Revolt into Style: Pop Arts in the 50s and 60s* (Oxford, 1989), p. 18.

35 Paul Johnson, 'The Menace of Beatlism', *New Statesman* (28 February 1964), republished in *New Statesman* (22–28 August 2014), p. 23.

36 Melly, *Revolt into Style*, p. 116.

37 Ibid., p. 65.

38 Dave Laing, *The Sound of Our Time* (London, 1969), p. 151.

39 Gary Herman, *The Who* (London, 1971), p. 39.

40 *Melody Maker* (3 July 1965), p. 11.

41 *Disc* (4 December 1965), pp. 8 and 10, www.thewho.info, accessed 12 December 2019.

42 Mario Amaya, *Pop as Art: A Survey of the New Super-realism* (London, 1965)

43 Ibid., p. 44. The concept was echoed by Melly in his 1966 discussion of Teds, whom he considered 'a new kind of criminal for whom violence was an end in itself and "crime" in the traditional sense neither obligatory nor even necessary', p. 32.

44 Neill and Kent, *Anyway Anyhow Anywhere*, p. 66.

45 Palmer, *Born Under a Bad Sign*, p. 131.

46 Legs McNeil and Gillian McCain, *Please Kill Me: The Uncensored Oral History of Punk* (New York, 1996), p. 35.

47 Olle Lundin and Kjell Malmberg, *The Who in Denmark and Norway and Finland* (Uppsala, 2006), p. 12.

48 Ibid.

49 Ibid., pp. 16–17.

50 Umberto Apollonio, ed., *Futurist Manifestos* (Boston, MA, 2001), p. 19.

51 Neill and Kent, *Anyway Anyhow Anywhere*, p. 100.

52 The manifesto is reproduced at https://monoskop.org/Gustav_Metzger, accessed 16 August 2018.

53 Miles, 'Interview with Pete Townshend', *International Times* (13 February 1967).

54 David Sheppard, *On Some Far Away Beach: The Life and Times of Brian Eno* (London, 2009), p. 34. For a superb investigation of the influence of an art school education on Eno and his colleagues in Roxy Music, see Michael Bracewell, *Re-make/Re-model: Art, Pop, Fashion and the Making of Roxy Music, 1953–1972* (London, 2007).

55 Ann Shearer, 'Art Limb from Limb', *The Guardian* (1 September 1966), p. 8. For a full account of the month-long event and its impact, see Kristine Stiles, 'The Story of the Destruction in Art Symposium and the "DIAS affect"', in *Gustav Metzger. Geschichte Geschichte*, ed. Sabine Breitwieser (Vienna, 2005), pp. 41–65.

56 Anthony Marshall, 'Still Life with Goanna?', *Book Source Magazine* (September 2010), www.booksourcemagazine.com, accessed 16 August 2018.

57 Nick Tosches, *Hellfire: The Jerry Lee Lewis Story* (New York, 1982), p. 145.

58 Palmer, *Born Under a Bad Sign*, pp. 132–3.

59 In his autobiography, he recalls a car trip to Brighton with Eric Clapton and Metzger, the latter was set to do the lights for the evening's show and chastises Townshend for not having kept up his attack on commercial pop: 'The gimmicks had overtaken me,'

he writes. Pete Townshend, *Who Am I* (London, 2012), p. 115. That
show was mostly likely at the Brighton Dome on 21 April 1967
when The Who topped a bill with Cream among the support acts.

60 Nick Jones, 'The Who, The Move, Pink Floyd: The Roundhouse,
 Chalk Farm, London', *Melody Maker* (7 January 1967), n.p.
61 Julian Palacios, *Syd Barrett and Pink Floyd: Dark Globe* (London,
 2015), p. 154.
62 Frances Gibson, 'Pop Scene', *Queen* (21 June 1967), p. 23.
63 Palmer, *Born Under a Bad Sign*, p. 133.
64 Ibid., p. 130.
65 *A Whole Scene Going*, BBC 1 (5 January 1966).
66 *London Sunday Citizen* (8 August 1965) cited in Herman, *The Who*,
 p. 94.
67 Palmer, *Born Under a Bad Sign*, p. 131.
68 Victor Bockris and John Cale, *What's Welsh for Zen: The
 Autobiography of John Cale* (London, 1999), p. 80.
69 Ibid., p. 77.
70 The best overview of the pop scene at this specific point in time
 is provided by Richard Williams, '1965: Annus Mirabilis', in *Long
 Distance Call: Writings on Music* (London, 2000), pp. 79–90.
71 Melissa L. Mednicov, 'Pink, White, and Black: The Strange Case
 of James Rosenquist's *Big Bo*', *Art Journal*, LXXIII/1 (Spring 2014),
 pp. 60–75.
72 Jon Savage interview with Townshend (transcript), 2011.
73 Perry, *The Who – Meaty, Beaty, Big and Bouncy*, p. 45.
74 Ibid., p. 44.
75 Michael Bracewell, *England Is Mine: Pop Life in Albion from Wilde
 to Goldie* (London, 1997), p. 80.
76 Jon Savage, *1966: The Year the Decade Exploded* (London, 2016),
 pp. 60–67.
77 Cited in Neill and Kent, *Anyway Anyhow Anywhere*, p. 76.
78 *Melody Maker* (3 July 1965), p. 11.
79 *Melody Maker* (26 March 1966), p. 7.
80 Simon Frith and Howard Horne, *Art into Pop* (London, 1987),
 p. 107.
81 Thomas Crow, *The Rise of the Sixties: American and European Art
 in the Era of Dissent* (London, 1996), p. 87.
82 Palmer, *Born Under a Bad Sign*, p. 130.

3 THE REAL POP ART NITTY GRITTY AT LAST, IN FACT; OR, WELL-PAID MURDER

1 'Blind Date: Pete Townshend', *Melody Maker* (November 1965), reproduced in Paul Anderson and Damian Jones, *The Fleur de Lys – Circles: The Strange Story of the Fleur de Lys, Britain's Forgotten Soul Band* (London, 2009), p. 43.
2 Nik Cohn, 'Pop Scene', *Queen* (29 March 1967), p. 15.
3 Ibid.
4 Ibid.
5 Patrick Kerr, 'Pop Scene', *Queen* (8 September 1965), p. 36.
6 Kevin Cann, *David Bowie, Any Day Now – The London Years: 1947–1974* (London, 2010), pp. 61–2.
7 A Wild Uncertainty also cut a cover of Townshend's 'La-La-La Lies' but it went unreleased at the time. It can be heard on YouTube, accessed 14 August 2018.
8 'Ealing Group Issue First Disc Today', *Record Retailer*; reproduced in the sleeve notes accompanying The Eyes, *Blink* (Bam-Caruso, 1983).
9 For the full story of John's Children, see Mark Paytress, *Bolan: The Rise and Fall of a 20th Century Superstar* (London, 2002), pp. 67–94. Simon Napier-Bell enjoyed the negative reaction of the observer to such an extent that over two decades after the event he reproduced the letter in the illustrated section of his autobiography, *You Don't Have to Say You Love Me* (London, 1998). He gave a full description of the 'riot', and its immediate aftermath in Chris Welch and Simon Napier-Bell, *Marc Bolan: Born to Boogie* (London, 1982), pp. 11–12.
10 Keith Altham, 'John's Children: First of the Anti-lust Groups', *New Musical Express* (18 March 1967), p. 12.
11 Nik Cohn, 'Pop Scene', *Queen* (9 November 1966), p. 40.
12 Rob Chapman, *Psychedelia and Other Colours* (London, 2015), p. 409.
13 Nik Cohn, 'Pop Scene', *Queen* (3 August 1966), p. 24.
14 Ian Hebditch and Jane Shepherd with Mike Evans and Roger Powell, *The Action: In the Lap of the Mods* (London, 2011), p. 114.
15 Spinning the original UK and U.S. pressings of 'How Does it Feel to Feel' back to back is an object lesson in Talmy's mixing skills, the choices he gave himself and the limits of what can be achieved in the disc-cutting process. The UK release sacrifices the top end to achieve a maximum punch with the bass, the U.S. version goes in the opposite direction. Both have merit.

16 The cult of The Creation obviously disagrees with me on this, see Sean Egan, *Our Music Is Red with Purple Flashes: The Story of The Creation* (London, 2004). Dismissing The Who in order to pump up the status of a writer's favourite is standard procedure when covering any of the freakbeat combos.

17 Nik Cohn, 'Pop Scene', *Queen* (2 August 1967), p. 16.

18 David Bowie recognized this influence when he covered 'See Emily Play' on *Pinups* (1973) and had Mick Ronson, Trevor Bolder and Aynsley Dunbar kick in, during the instrumental break, with their best Townshend, Entwistle and Moon impersonations.

19 Nik Cohn, 'Pop Scene', *Queen* (18 January 1967), p. 16.

20 Ibid.

21 Nik Cohn, 'Pop Scene', *Queen* (29 March 1967), p. 15.

22 Ibid.

23 Alan Freeman, 'The Truth About Our Generation', *Rave* (1 February 1966), pp. 16–19.

24 Dawn James, 'Who Knows', *Rave* (1 March 1966), pp. 6–7.

25 Patrick Kerr, 'Pop Scene', *Queen* (11 August 1965), p. 18.

26 Patrick Kerr, 'Pop Scene', *Queen* (2 February 1966), p. 28.

27 Anthony Haden-Guest, 'Dancing Chic to Chic', *Queen* (22 June 1966), pp. 42–4.

28 A good range of the media's coverage of the opening of Cheetah's is reproduced in Alfredo Garcia, *The Inevitable World of the Velvet Underground* (Madrid, 2011), pp. 30–50.

29 Haden-Guest, 'Dancing Chic to Chic', pp. 42–4.

30 Ibid.

31 Ibid.

32 The nascent London discotheque scene is covered in interviews with DJs Ian Samwell and Jeff Dexter in Bill Brewster and Frank Broughton, *The Record Players: The Story of Dance Music Told by History's Greatest DJs* (London, 2012), pp. 19–37.

33 *A Whole Scene Going* (BBC) was recorded on 5 January 1966.

34 'What the Stars Have To Say', *Rave* (1 November 1965), p. 50. 'Rave Gets Away', *Rave* (1 July 1965), pp. 24, 26–7.

35 Richard Williams, '1965: Annus Mirabilis', in *Long Distance Call: Writings on Music* (London, 2000), pp. 79–90.

36 Ibid.

37 Ibid., p. 140.

38 Nik Cohn, 'Pop Scene', *Queen* (30 March 1966), p. 20.

39 Nik Cohn, 'Pop Scene', *Queen* (28 September 1966), p. 28.

40 Nik Cohn, 'Pop Scene', *Queen* (17 August 1966), pp. 31–2.

41 Nik Cohn, 'Pop Scene', *Queen* (6 July 1966), p. 19.

42 Nik Cohn, 'Pop Scene', *Queen* (7 December 1966), p. 68.

43 Benny Green, 'Sound', *Queen* (31 July 1968), p. 18.

44 Nik Cohn, 'Pop Scene', *Queen* (4 January 1967), p. 16.

45 Ibid.

46 Ibid.

47 Ibid.

48 Alan Aldridge, *The Man with Kaleidoscope Eyes: The Art of Alan Aldridge* (New York, 2009).

49 In order of reference, the three Penguin novels are Michael Innes, *Operation Pax*; James Byrom, *Or Be He Dead*; and George Bellairs, *Corpse at the Carnival*. All published London, 1964.

50 Mary Holland, 'The Fantasy Merchants', *Queen* (3 January 1968), p. 22.

51 Ralph Steadman provided another caricature of The Who for Tony Palmer's *Born Under a Bad Sign* (London, 1970), p. 137. A photomontage with ink over and underlays, it uses the idea of a band exploding, complete with jagged pieces of a Union Jack coupled with a cut up of Townshend from the front of the *Observer Magazine*. In an inset portrait of him, Townshend's nose is formed by an image of him leaping with guitar. All this is to say that the caricature is a bit of a shoddy knock-off compared with the earlier illustration.

52 Nik Cohn, *Pop from the Beginning* (London, 1969), p. 90.

53 Nik Cohn, 'Pop Scene', *Queen* (22 June 1966), p. 18.

54 Richard Williams, *Out of His Head: The Sound of Phil Spector* (London, 1972), pp. 63–4.

55 Nabob, 'Tension in the Service of the Sad: Pete Townshend Meets Henry Purcell', https://onbaroque.com, accessed 12 September 2018.

56 Karen Linn, *That Half-barbaric Twang: The Banjo in American Popular Culture* (Chicago, IL, 1994).

57 Nik Cohn, 'The Love Generation', *Queen* (19 July 1967), pp. 25–31.

58 Nik Cohn, 'Pop Scene', *Queen* (19 July 1967), p. 16.

59 Ibid.

60 Nik Cohn, 'The Love Generation', *Queen* (19 July 1967), pp. 25–31.

61 Ibid.

62 Nik Cohn, 'The Love Generation', *Queen* (19 July 1967), pp. 25–31.

63 Nik Cohn, 'Pop Scene', *Queen* (7 June 1967), p. 19.

64 Nick Jones, 'Second Thoughts on Monterey', *Melody Maker* (1 July 1967), p. 5.

65 Ibid.
66 Nik Cohn, 'Pop Scene', *Queen* (19 July 1967), p. 16.
67 Nik Cohn, 'Pop Scene', *Queen* (3 January 1967), pp. 12–13.
68 Ibid.
69 Ibid.
70 Ibid.
71 Ibid.
72 Nik Cohn, 'Pop Scene', *Queen* (17 January 1967), p. 13.
73 Ibid.
74 Ibid.
75 Ibid.
76 Ibid.
77 Thomas Crow, *The Long March of Pop: Art, Music, and Design, 1930–1995* (New Haven, CT, 2014), p. 359.
78 Ibid.
79 Thomas Crow, 'The Absconded Subject of Pop', RES: *Anthology and Aesthetics*, LV/56 (Spring/Autumn 2009), pp. 5–20.
80 Thomas Frank, *The Conquest of Cool: Business Culture, Counterculture, and the Rise of Hip Consumerism* (Chicago, IL, 1997), p. 1.
81 Ibid., p. 4.
82 Ibid., p. 7.
83 Ibid., p. 12.
84 Ibid., p. 8.

4 ROCK 'N' ROLL WILL STAND

1 Tours for 1967–8 are lovingly detailed in McMichael and Lyons, *The Who Concert File*.
2 The Seth Man, Julian Cope's Head Heritage, www.headheritage.co.uk, accessed 16 October 2018.
3 Nik Cohn, *Pop from the Beginning* (London, 1969), p. 223.
4 Nik Cohn, 'Pop Scene', *Queen* (28 February 1968), p. 18.
5 Ibid.
6 Ibid.
7 The Who's travails in 1968 are covered by Andy Morten in 'Going to the Dogs', *Shindig!*, 41 (Summer 2014), pp. 60–69.
8 Nik Cohn, 'Pop Scene', *Queen* (5 June 1968), p. 28.
9 On his involvement with John's Children, see Jonathan Aitken, *The Young Meteors* (London, 1967), p. 78, in which Cohn revealed he had a 10 per cent stake in the band in return for 'advising them

on publicity'. See also Nik Cohn, 'Pop Scene', *Queen* (8 May 1968), p. 28. For an example of his positive coverage of Track and its artists see Nik Cohn, 'Pop Scene', *Queen* (27 September 1967), pp. 16–17.

10 George Sedden, 'Ego', *The Observer* (17 August 1969), p. 23.

11 Cohn, *Pop from the Beginning*, p. 9.

12 Ibid.

13 Ibid., pp. 227–8.

14 Ibid., p. 30.

15 Ibid., p. 133.

16 Ibid., p. 134.

17 Ibid., pp. 158–9.

18 Ibid., p. 139.

19 Ibid., p. 141.

20 Ibid., p. 143.

21 Ibid.

22 Ibid., p. 145.

23 Ibid.

24 Ibid., p. 146.

25 Ibid., p. 149.

26 Ibid., p. 163.

27 Ibid.

28 Ibid., p. 167.

29 Ibid., pp. 55–6.

30 Nik Cohn, 'Pop Scene', *Queen* (8 May 1968), p. 28.

31 Ibid.

32 Greil Marcus, ed., *Rock and Roll Will Stand* (Boston, MA, 1969).

33 Ibid., p. 9.

34 Ibid., p. 17.

35 Ibid., p. 24.

36 Greil Marcus, *Lipstick Traces: A Secret History of the Twentieth Century* (London, 1989), p. 93.

37 Ibid.

38 Marcus, *Rock and Roll Will Stand*, p. 143.

39 Ibid.

40 Ibid., p. 86.

41 Editorial, *Life* (June 1968), p. 4.

42 Ibid., p. 51.

43 Superb reproductions of many of the *Life* images, including unused studio shots of Daltrey and Townshend, are collected in Jonathan Kane and Holly Anderson, *Art Kane* (London, 2014).

44 *Life* (June 1968), p. 61.

45 Ibid.

46 Ibid.

47 Diane Houlton, 'You're Telling Us', *Rave* (1 February 1966), pp. 58–9.

48 Richard Goldstein, 'The New Rock', *Life* (June 1968), pp. 67–8, 70.

49 Nik Cohn, 'Pop Scene', *Queen* (19 June 1968), p. 19.

50 Norman Shrapnel, 'Waves of Meaning', *The Guardian* (18 August 1967), p. 5.

51 Ibid.

52 Nik Cohn, *I Am Still the Greatest Says Johnny Angelo* (London, 1967), p. 7.

53 Ibid.

54 Ibid., p. 178.

55 Ibid., p. 187.

56 Ibid., p. 191.

57 Cohn, *Pop from the Beginning*, p. 92.

58 Erica Crome, 'Freedom in Topcoats', *Queen* (4 December 1968), pp. 99–102.

59 Nik Cohn, *I Am Still the Greatest Says Johnny Angelo* (Harmondsworth, 1970).

60 Ibid., p. 107.

5 *TOMMY:* THE POPERATIC

1 Nik Cohn, *Pop from the Beginning* (London, 1969), p. 169.

2 Nik Cohn, 'British Rock: At Low Ebb', *New York Times* (24 November 1968), p. H2.

3 Ibid.

4 Ibid.

5 Ibid.

6 Ibid.

7 Ibid.

8 Nik Cohn, 'A Briton Blasts The Beatles', *New York Times* (15 December 1968), pp. H1 and 8. Respondents to his argument include James Calder and Howard Brick, 'Innovators: Beatles vs. Stones', *New York Times* (16 March 1969), pp. D33–5.

9 Ibid.

10 Ibid.

11 Nik Cohn, 'Tommy, The Who's Pinball Opera', *New York Times* (18 May 1969), p. D36.

12 Ibid.
13 Ibid.
14 Ibid.
15 Ibid.
16 Pete Townshend, *Who Am I* (London, 2012), p. 161.
17 Ibid.
18 Ibid., p. 162.
19 Jann Wenner, 'Rock And Roll Music', *Rolling Stone* (20 January 1968), pp. 14–15.
20 John Whitely, 'The Great Crusade', *Sunday Times* (22 March 1970), p. 56.
21 Ibid.
22 Isobel Murray, 'What Is Real Life?', *Financial Times* (19 March 1970), p. 30.
23 Jonathon Green, 'Arfur', *Friends*, 5 (14 April 1970), p. 39.
24 'This Is Arfur', *Queen* (23 October 1968), p. 43. She was also profiled across a three-page photo spread in an American magazine in early 1969. Cohn fancifully, I presume, claimed that Arthur Brown had started a fan club for her and, having been signed to Track Records with Kit Lambert producing, Bill Wyman had written her a song. Nik Cohn, 'Arfur the Teenage Pinball Queen', *Eye* (February 1969), pp. 21–3.
25 Nik Cohn, *Arfur: Teenage Pinball Queen* (London, 1970), p. 80.
26 Mark Wilkerson, *Who Are You: The Life of Pete Townshend* (London, 2008), p. 116.
27 Chris Welch, 'Tommy', *Melody Maker* (10 May 1969), n.p.
28 Uncredited, 'Tommy', *Melody Maker* (31 May 1969), n.p.; Lon Goddard, 'The Who at Ronnie Scott's', *Record Mirror* (10 May 1969), n.p.
29 Tony Palmer, 'A Freakish Parable', *The Observer* (18 May 1969), p. 26.
30 'Album Reviews', *Billboard* (31 May 1969), p. 52.
31 Geoffrey Cannon, 'Unpop Pop', *The Guardian* (8 May 1970), p. 8.
32 George Melly, *Revolt into Style: The Pop Arts in the 1950s* (Oxford, 1989), p. 133.
33 Ibid.
34 Charlie Gillett, 'Born to Sing the Blues', *Record Mirror* (14 June 1969), n.p.
35 Ibid.
36 Ibid.
37 Miles, 'Tommy', *International Times* (9 May 1969), n.p.

38 Ibid.
39 Miles, 'Pete on *Tommy #1*', *International Times* (23 May 1969), n.p.
40 Miles, 'Pete on *Tommy #2*', *International Times* (13 June 1969), n.p.
41 Graham Charnock, 'Tommy', *Oz*, 21 (May 1969), p. 31.
42 Ibid.
43 Ibid.
44 Peter Townshend, 'Born Under a Bad Sign', *Oz*, 21 (May 1969), p. 28.
45 Wenner, 'Rock and Roll Music', pp. 14–15.
46 'The Who Sell Out', *Rolling Stone* (10 February 1968), p. 20; 'It Happened in 1967', *Rolling Stone* (24 February 1968), p. 12.
47 Rick Sanders and David Dalton, 'Pete Townshend', *Rolling Stone* (12 July 1969), pp. 16–18.
48 Ibid.
49 Lew Harris, 'The Who Makes It Real', *Chicago Tribune* (30 May 1969), p. D6.
50 Ibid.
51 Pete Johnson, 'Magic Circus is Just That', *Los Angeles Times* (16 June 1969), p. C18.
52 Mike Jahn, 'Britain's High-decibel Group, The Who, Is Still Thundering', *New York Times* (8 June 1969), p. 79.
53 'Who's Rock Opera Earns Gold Record', *Billboard* (12 July 1969), p. 8.
54 Allan Parachini, 'Filling the Void; Who Records Rock Opera', *Los Angeles Times* (11 July 1969), p. D18.
55 John Mendelssohn, 'The Who Still Rocking the Music Scene', *Los Angeles Times* (21 September 1969), p. U16.
56 Ibid.
57 Ibid.
58 Ibid.
59 Albert Goldman, 'The Red Dawn of Revolt?', *New York Times* (30 November 1969), p. D30.
60 Ibid.
61 Ibid.
62 Ibid.
63 Albert Goldman, *Freakshow: Misadventures in the Counterculture, 1959–1971* (New York, 2001), p. xiv.
64 Ibid.
65 'Who's Farewell To *Tommy* Pulls 55G At Metopera', *Variety* (10 June 1970), p. 55.
66 Donal Henahan, '*Tommy* Is Poignantly Sentimental', *New York Times* (8 June 1970), p. 42.

67 Ibid.
68 Ibid.
69 Mike Jahn, 'The Who Brings Rock Opera Here', *New York Times* (21 October 1969), p. 41.
70 Ibid.
71 Gary Herman, *The Who* (London, 1971), p. 13.
72 Henahan, '*Tommy* Is Poignantly Sentimental', p. 42.
73 Ibid.
74 Ibid.
75 Ibid.
76 Ibid.
77 William Feaver, 'Art on the Sleeve', *London Magazine* (1 April 1970), pp. 62–9.
78 Melly, *Revolt into Style*, p. 158.
79 Feaver, 'Art on the Sleeve', pp. 62–9.
80 Ibid.
81 'History of the Roundhouse, 1960–70: An Arts Centre Emerges', www.roundhouse.org.uk, accessed 14 November 2018. A very ungenerous account of Arnold Wesker's initiative is given in Jeff Nuttall, *Bomb Culture* (London, 2018), pp. 55–8.
82 Feaver, 'Art on the Sleeve', pp. 62–9.
83 Ibid.
84 Ibid.
85 Colin MacInnes, *Absolute Beginners* (London, 1980), p. 65.
86 Tony Palmer, *Born Under a Bad Sign* (London, 1970), pp. 117–22.
87 Ibid.
88 Ibid.
89 Ibid.
90 Ibid.
91 Ibid.
92 Cannon, 'Unpop Pop', p. 8.
93 Richard Barnes and Pete Townshend, *The Story of Tommy* (London, 1977), n.p.
94 Ibid.
95 Derek Jewell, 'Sounds of Today', *Sunday Times* (18 May 1969), p. 59.
96 In a piece written for *Rolling Stone*, Townshend, with some understandable revisionism, I think, echoed and elaborated on the points he had made in the *Story of Tommy*: 'Tommy was never ever really meant to be as "heavy" as say, "My Generation." We joked as a group about *Tommy* being true opera, which it isn't, but the Who's

audience, and many of the rock press took it very seriously indeed. It was this seriousness that turned *Tommy* into light entertainment.' Pete Townshend, 'The Punk Meets the Godmother', *Rolling Stone* (17 November 1977), p. 57.

6 SEEKING THE DEFINITIVE HARD-ROCK HOLOCAUST; OR, THE NEW GOLDEN OLDIES

1 Nik Cohn, 'Finally, the Full Force of the Who', *New York Times* (8 March 1970), p. M2.
2 Ibid.
3 Ibid.
4 Ibid.
5 Ibid.
6 John Mendelssohn, 'Records', *Rolling Stone* (30 April 1970), p. 58.
7 Greil Marcus, 'Records', *Rolling Stone* (9 July 1970), p. 40.
8 Ibid.
9 Ibid.
10 Ibid.
11 Ibid.
12 Jonathan Cott, 'A Talk with Pete Townshend', *Rolling Stone* (14 May 1970), pp. 32–5.
13 Ibid.
14 Ibid.
15 Ibid.
16 Nik Cohn, 'The Who, From *Tommy* to *Bobby*', *New York Times* (7 February 1971), D28.
17 The concept was still being called 'Bobby', even as late as the release of *Who's Next*. See, for example, John Mendelssohn, 'Records', *Rolling Stone* (2 September 1971), p. 42.
18 Cohn, 'The Who, From *Tommy* to *Bobby*'.
19 Ibid.
20 Ibid.
21 Ibid.
22 The story of the party is told in Richie Unterberger, *Won't Get Fooled Again: The Who from Lifehouse to Quadrophenia* (London, 2011), pp. 144–5.
23 Chris Rowley, Mick Farren, J. Edward Barker and Pete Townshend, 'Letters', *International Times*, 122 (9–23 September 1971), pp. 8 and 19.
24 Ibid.

25 Ibid.
26 Ibid.
27 Mick Farren, 'Who's Next', *International Times*, 122 (9–23 September 1971), p. 19.
28 Roger Perry, *The Writing on the Wall* (London, 1976).
29 Mick Farren and Edward Barker, *Watch Out Kids* (London, 1972).
30 Nik Cohn, 'England's New Teen Style Is Violence', *New York Times* (29 March 1970), pp. 23 and 28.
31 Ibid.
32 Ibid.
33 Pete Fowler, 'Skins Rule', *Rock File*, ed. Charlie Gillet (London, 1972), pp. 1–26.
34 Ibid.
35 Cohn, 'England's New Teen Style Is Violence'.
36 Ibid.
37 Ibid.
38 Melly, *Revolt into Style*, p. 144.
39 Ibid., pp. 153–4.
40 Michael Lydon, 'The Who in San Francisco', *New York Times* (September 1968), n.p.
41 Dave Laing, 'Words and', *Let It Rock*, 1 (October 1972), p. 5.
42 Ibid.
43 Geoffrey Cannon, 'Rock 'n' Roll is Not Dead', *The Guardian* (14 January 1969), www.theguardian.com, accessed 20 January 2019.
44 Townshend, *Who Am I*, pp. 228–30.
45 Ibid.
46 Ibid.
47 Ibid.
48 Ibid.
49 Nik Cohn and Guy Peellaert, 'Acknowledgements', *Rock Dreams: Under the Broadwalk* (London, 1974), n.p.
50 Ibid.
51 Ibid.
52 Pete Townshend, 'Two Stormy Summers', *Quadrophenia: Director's Cut* (Polydor, 2001), pp. 7–8.
53 Ibid.
54 Ibid., pp. 19–20.
55 *Record Mirror* (7 March 1965).
56 Nick Tosches, *Unsung Heroes of Rock 'n' Roll: The Birth of Rock in the Wild Years Before Elvis* (London, 1991), p. vii.
57 *Rolling Stone* (17 September 1968), p. 17.

58 Herman, *The Who*, p. 32.

59 Ibid., p. 72.

60 Quoted in John Atkins, *The Who on Record: A Critical History, 1963–1998* (Jefferson, NC, 2000), p. 180.

61 Ibid., pp. 187–90. A contemporary review of the film in the underground press is roundly dismissive of its merits, Jerome Burne, *Friends*, 17 (30 October 1970), p. 20.

62 Atkins, *The Who on Record*, p. 187.

63 Ibid.

64 Charles Shaar Murray, 'The Who: Exorcising the Ghost of Mod', *Creem* (January 1974), pp. 36–41.

65 Ibid.

66 Ibid.

67 Dave Marsh, 'The Who: Quadrophenia Reconsidered', *Creem* (March 1974), pp. 35 and 74.

68 Shaar Murray, 'The Who: Exorcising the Ghost of Mod', pp. 36–41.

69 Ibid.

70 Nick Kent, 'Critic's Choice', *Let it Rock* (January 1974), p. 18.

71 Shaar Murray, 'The Who: Exorcising the Ghost of Mod', pp. 36 41.

72 Nik Cohn, 'Another Saturday Night', in *Ball the Wall* (London, 1989), p. 321.

73 Nik Cohn, 'Fever Pitch', *Guardian Weekend* (17 September 1994), p. 12.

74 Cohn, 'Another Saturday Night', p. 326.

75 Ibid., p. 322.

CONCLUSION: DON'T LOOK OVER YOUR SHOULDER

1 Nik Cohn, *King Death* (New York, 1975).

2 Simon Frith, 'The Day the Music Died', *Let It Rock* (April 1975), p. 29.

3 Greg Shaw, 'The Who's Mod Generation: *Quadrophenia*' *Phonograph Record* (December, 1973), n.p.

4 Gary Herman, 'Who's Where in the Seventies', *Let It Rock* (February, 1975), pp. 27–9.

5 Rocky Spain, 'Albums', *Let It Rock* (June 1975), p. 52.

6 Nick Kent, 'Lou Reed', *Frendz*, 29 (9 June 1972), p. 10.

7 Nick Kent, 'Flamin' Groovies Interview', *Frendz*, 30 (23 June 1972), pp. 14–15.

8 Lester Bangs, 'Psychotic Reactions and Carburetor Dung: A Tale of These Times', *Creem* (June 1971).

9 Mick Gold, *Rock on the Road* (London, 1976), p. 30.

10 Simon Frith, 'Albums: The Who By Numbers', *Let It Rock* (November/December 1975), p. 39.

11 Ibid.

12 Ibid.

13 An intriguing set of examples where 'punk' is used in a similar way, mostly by American critics prior to 1976, are pulled together by Jon Savage in 'Punk Etymology', in *Punk Is Dead: Modernity Killed Every Night*, ed. Richard Cabut and Andrew Gallix (London, 2017), pp. 288–307. For an etymology that goes back further in time, and which draws on film and pulp fiction examples, see Peter Stanfield, 'Punks! JD Gangsters', in *The Cool and the Crazy: Pop Fifties Cinema* (New Brunswick, NJ, 2015), pp. 135–61.

14 Roy Carr, sleeve notes *Hard-up Heroes* (Decca, 1974).

15 The heading reworked the punks on dope line gifted by The Tubes on their recent debut album; 'Coke' referring to the drink not cocaine.

16 Mick Houghton, 'White Punks on Coke' (November/December, 1975), p. 25.

17 Ibid.

18 Gerald O'Connell, 'Bubblegum Blitz', *Let It Rock* (November/December, 1975), pp. 23–4.

19 Penny Reel, 'Underneath the Arches', *Let It Rock* (November/December, 1975), p. 7.

20 Pauline Kael, 'Trash, Art, and the Movies', *Going Steady* (London, 1970), pp. 87–129.

21 Jeffrey Sconce, 'Introduction' in *Sleaze Artists: Cinema at the Margins of Taste, Style, and Politics* (Durham, NC, 2007), p. 7.

22 Peter Stanfield, *Maximum Movies – Pulp Fictions: Film Cultures and the Worlds of Samuel Fuller, Mickey Spillane, and Jim Thompson* (New Brunswick, NJ 2011), p. 27.

23 Readers interested in the long history of pulp film and film cultures should move quickly on to my book *Maximum Movies – Pulp Fictions*.

24 Paul Kendall, 'Punk Rock Comes to Town', *Zigzag*, 60 (May 1976), n.p.

25 Paul Barrett with Hilary Hayward, *Shakin' Stevens* (London, 1983).

26 Steve Crancher, *Eddie and the Hot Rods: Do Anything You Wanna Do* (Southend-on-Sea, 2008), p. 27.

27 Kendall, 'Punk Rock Comes to Town', n.p.

28 Neil Spencer, 'Don't Look Over Your Shoulder, but the Sex Pistols Are Coming', *New Musical Express* (21 February 1976), p. 31.

29 Ibid.

30 The Marco Pirroni CD which recreates his favourite singles that played on the Let It Rock and Sex shop jukebox is a composite of British rock 'n' roll (Vince Taylor), '60s punk rock (The Spades), freakbeat (The Creation), the pseudo-exotic (Johnny Hallyday) and the almost contemporary (Alice Cooper) – a set of templates for the Sex Pistols' repertoire. *Sex: Too Fast to Live Too Young to Die* (Only Lovers Left Alive, 2003).

31 Spencer, 'Don't Look Over Your Shoulder'.

32 The press release is reproduced in Johan Kugelberg, *God Save Sex Pistols* (New York, 2016), p. 48.

33 Jon Savage, 'Spit and Polish', *Guardian* Friday Review Section (24 September 1999), p. 2.

34 Oldham, *Stoned*, p. 78.

35 Ibid., pp. 220 and 232.

36 The story is told in Pete Townshend, 'The Punk Meets the Godmother', *Rolling Stone* (17 November 1977), pp. 54–9. The article looks back over the period since the release of Quadrophenia and gives Townshend's view of the pressures and fissures the band had been living through, and the impact of punk on his thinking.

37 Townshend, *Who Am I*, p. 309.

38 Roger Daltrey, *My Story: Thanks a Lot Mr Kibblewhite* (London, 2018), p. 266.

39 'Blind Date with Dave Hill', *Melody Maker* (24 June 1972), p. 36.

40 '*Rave* Forecasts the Hits', *Rave* (1 December 1965), p. 20.

41 Simon Reynolds, *Retromania: Pop's Addiction to Its Own Past* (London, 2011), p. ix.

42 Oldham, *Stoned*, p. 177.

43 Townshend, *Who Am I*, p. 310.

44 Theodor Adorno, 'On Popular Music', *Studies in Philosophy and Social Science*, 9 (1941), pp. 17–48.

SELECT BIBLIOGRAPHY

Aldridge, Alan, *The Man With Kaleidoscope Eyes: The Art of Alan Aldridge* (New York, 2009)

Alfredo Garcia, *The Inevitable World of the Velvet Underground* (Madrid, 2011)

Alloway, Lawrence, *Topics in American Art Since 1945* (New York, 1975)

Amaya, Mario, *Pop as Art: A Survey of the New Super-Realism* (London, 1965)

Anderson, Paul, and Damian Jones, *The Fleur de Lys – Circles: The Strange Story of The Fleur de Lys, Britain's Forgotten Soul Band* (London, 2009)

Atkins, John, *The Who On Record: A Critical History, 1963–1998* (Jefferson, MO, 2000)

Barnes, Richard, *Mods* (London, 1979)

—, *The Who: Maximum R&B* (London, 1982)

—, and Pete Townshend, *The Story of Tommy* (London, 1977)

Barrett, Paul, with Hilary Hayward, *Shakin' Stevens* (London, 1983)

Black, Johnny, *Eyewitness, The Who: The Day-by-day Story* (London, 2001)

Bracewell, Michael, *England Is Mine: Pop Life in Albion from Wilde to Goldie* (London, 1997)

—, *Re-make/Re-model: Art, Pop, Fashion and the Making of Roxy Music, 1953–1972* (London, 2007)

Brewster, Bill, and Frank Broughton, *The Record Players: The Story of Dance Music Told By History's Greatest DJs* (London, 2012)

Cann, Kevin, *David Bowie, Any Day Now – The London Years: 1947–1974* (London, 2010)

Chapman, Rob, *Psychedelia and Other Colours* (London, 2015)

Clarke, Steve, *The Who in Their Own Words* (London, 1979)

Cohen, Stanley, *Folk Devils and Moral Panics: The Creation of the Mods and Rockers* (London, 1972)

Cohn, Nik, *Market* (London, 1965)

—, *I Am Still The Greatest Says Johnny Angelo* (London, 1967)

—, *Pop from the Beginning* (London, 1969)

—, *Arfur: Teenage Pinball Queen* (London, 1970)

—, *Today There Are No Gentlemen: The Changes in Englishmen's*

Clothes Since the War (London, 1971)

—, *King Death* (New York, 1975)

—, *Ball the Wall* (London, 1989)

—, and Guy Peellaert, *Rock Dreams: Under the Broadwalk* (London, 1974)

Crancher, Steve, *Eddie and the Hot Rods: Do Anything You Wanna Do* (Southend-on-Sea, 2008)

Crow, Thomas, *The Long March of Pop: Art Music and Design, 1930–1995* (New Haven, CT, 2014)

Daltrey, Roger, *My Story: Thanks A Lot Mr Kibblewhite* (London, 2018)

Egan, Sean, *Our Music is Red with Purple Flashes: The Story of The Creation* (London, 2004)

Farren, Mick, and Edward Barker, *Watch Out Kids* (London, 1972)

Francis, Mark, *POP* (London, 2005)

Frank, Thomas, *The Conquest of Cool: Business Culture, Counterculture, and the Rise of Hip Consumerism* (Chicago, IL, 1997)

Frith, Simon, and Howard Horne, *Art into Pop* (London, 1987)

Goldman, Albert, *Freakshow: Misadventures in the Counterculture, 1959–1971* (New York, 2001)

Green, Jonathon, *Days in the Life: Voices from the English Underground, 1961–1971* (London, 1988)

Hamblett, Charles, and Jane Deverson, *Generation X* (London, 1964)

Hebdige, Dick, *Hiding in the Light* (London, 1988)

Hebditch, Ian, and Jane Shepherd with Mike Evans and Roger Powell, *The Action: In the Lap of the Mods* (London, 2011)

Herman, Gary, *The Who* (London, 1971)

Hoskyns, Barney, *Glam! Bowie, Bolan and the Glitter Rock Revolution* (London, 1998)

Jopling, Norman, *Shake It Up Baby! Notes From A Pop Music Reporter, 1961–1972* (Kingston upon Thames, 2015)

Kugelberg, Johan, *God Save Sex Pistols* (New York, 2016)

Laing, Dave, *The Sound of Our Time* (London, 1969)

Laurie, Peter, *Teenage Revolution* (London, 1965)

Lundin, Olle, and Kjell Malmberg, *The Who in Denmark and Norway and Finland* (Sweden, 2006)

MacInnes, Colin, *Absolute Beginners* (London, 1980)

McMichael, Joe, and 'Irish' Jack Lyons, *The Who Concert File* (London, 2004)

McNeil, Legs, and Gillian McCain, *Please Kill Me: The Uncensored Oral History of Punk* (New York, 1996)

Marcus, Greil, *Rock and Roll Will Stand* (Boston, MA, 1969)

—, *Lipstick Traces: A Secret History of the Twentieth Century* (London, 1989)

Marsh, Dave, *Before I Get Old: The Story of The Who* (London, 1983).

Melly, George, *Revolt into Style: The Pop Arts in the 1950s* (Oxford, 1989)

Motion, Andrew, *The Lamberts: George, Constant and Kit* (London, 1987)

Napier-Bell, Simon, *You Don't Have to Say You Love Me* (London, 1998)

Neill, Andy, and Matt Kent, *Anyway Anyhow Anywhere: The Complete Chronicle of The Who, 1958–1978* (London, 2007)

Oldham, Andrew Loog, *Stoned: A Memoir of London in the 1960s* (New York, 2000)

Palmer, Tony, *Born Under a Bad Sign* (London, 1970)

Paytress, Mark, *Bolan: The Rise and Fall of a 20th Century Superstar* (London, 2002)

Perry, John, *The Who – Meaty, Beaty, Big and Bouncy: Classic Rock Albums* (New York, 1998)

Perry, Roger, *The Writing on the Wall* (London, 1976)

Reynolds, Simon, *Retromania: Pop's Addiction to Its Own Past* (London, 2011)

Savage, Jon, *England's Dreaming: Sex Pistols and Punk Rock* (London, 1991)

—, *1966: The Year the Decade Exploded* (London, 2016)

Taylor, Derek, *As Time Goes By* (London, 2018)

Tosches, Nick, *Unsung Heroes of Rock 'n' Roll: The Birth of Rock in the Wild Years Before Elvis* (London, 1991)

Townshend, Pete, *Who Am I* (London, 2012)

Unterberger, Richie, *Won't Get Fooled Again: The Who From Lifehouse To Quadrophenia* (London, 2011)

Wilkerson, Mark, *Who Are You: The Life of Pete Townshend* (London, 2008)

Williams, Richard, *Out of His Head: The Sound of Phil Spector* (London, 1972)

—, *Long Distance Call: Writings on Music* (London, 2000)

ACKNOWLEDGEMENTS

This book would not have been written without the foresight of David Watkins, commissioning editor at Reaktion Books. He saw merit in an essay I wrote on The Who and Pop art that had been published in the *Journal of Popular Music Studies* (2017); the result was an invitation from him to consider a full-length effort. It has been a pleasure to take him up on the offer. I thank too the editors of that journal and my colleague Martin Hammer who first asked me to write on the topic for an exhibition he was curating on the arts in 1965. For related material on The Who and Nik Cohn, alongside information on other projects by the author, visit www.peterstanfield.com.

Play it loud Sidney x

PHOTO ACKNOWLEDGEMENTS

The author and publishers wish to express their thanks to the below sources of illustrative material and/or permission to reproduce it. Every effort has been made to contact copyright holders; should there be any we have been unable to reach or to whom inaccurate acknowledgements have been made, please contact the publishers, and full adjustments will be made to subsequent printings.

All images from the author's collection, except for those courtesy of AF Archive/Alamy Stock Photo, pp. 38, 58; Jim Avery, p. 199; Adam Beeson/ Alamy Stock Photo, p. 78; Chris Morphet/Getty Images, pp. 6–7; Ray Stevenson/Shutterstock, p. 234; Tracksimages.com/Alamy Stock Photo, p. 36; Trinity Mirror/Mirrorpix/Alamy Stock Photo, pp. 29, 142.

INDEX

Page numbers in *italics* refer to illustrations